RHYTHMIC FORM
IN ART

PLATE II

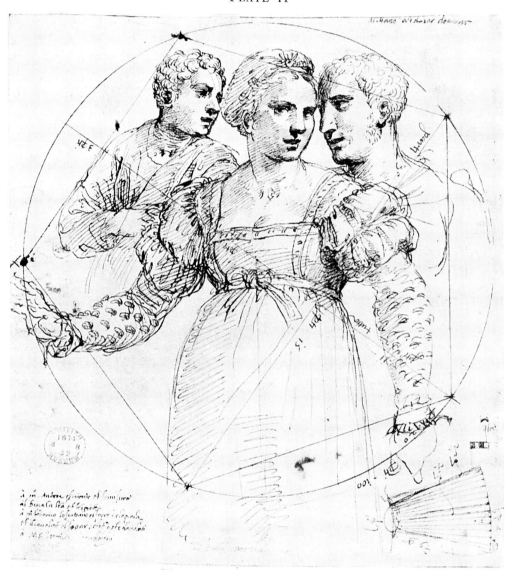

Peruzzi

GROUP OF THREE HEADS
(British Museum)

page 28

RHYTHMIC FORM IN ART

IRMA A. RICHTER

DOVER PUBLICATIONS, INC.
Mineola, New York

Bibliographical Note

This Dover edition, first published in 2005, is an unabridged republication of *Rhythmic Form in Art: An Investigation of the Principles of Composition in the Works of the Great Masters,* originally published by John Lane, the Bodley Head Limited, London, in 1932.

Library of Congress Cataloging-in-Publication Data

Richter, Irma A. (Irma Anne)
 Rhythmic form in art / Irma A. Richter.
 p. cm.
 An unabridged republication of Rhythmic form in art: an investigation of the principles of composition in the works of the great masters, originally published by John Lane, the Bodley Head Limited, London, in 1932.
 Includes index.
 ISBN 0-486-44379-5 (pbk.)
 1. Composition (Art). 2. Proportion (Art). I. Title.

N7430.R5 2005
701'.8—dc22

 2005047150

Manufactured in the United States of America
Dover Publications, Inc., 31 East 2nd Street, Mineola, N.Y. 11501

PREFACE

THERE are two rival tendencies in art, one of which makes for form and design, the other for light and colour. Although they complement each other they are not always found combined in the work of one artist or one school. They hold the field alternately in ever-changing rotation—the classic as opposed to the romantic, the Expressionist as against the Impressionist. Form and design have once more become the chief preoccupation of our modern artists. In an age when the metrical aspect of things dominates science, when mechanism and machinery surround us on every side, we have become familiar with geometric forms. Almost every device invented by the human brain and made by human hands is an example of applied geometry. It is natural, therefore, that artists have, so to speak, become engineers. The structure of a work of art is now all-important. The relations of shapes to one another are studied, and motives taken from nature are coherently composed. This tendency found an extreme interpretation in the Cubist movement, but can be traced in all modern work. The study of delicate and colourful effects of light which used to be the delight of Impressionists is no longer all-absorbing. Their sun has set, and with it has gone the predilection for the great masters of light and atmosphere.

The man whose work has contributed most to the turn of the tide was Cézanne.* The stimulus of his painting was prodigious. There is a saying which he often repeated and which admirably describes the tendency of his influence. " Il nous faut redevenir des classiques par la nature," and when asked to explain he said : " Imaginez Poussin refait entièrement sur nature. Voilà le classique que j'entends." Cézanne was fascinated by the classical tradition which Nicolas Poussin had acquired in Rome by studying the great masters of the Renaissance. Once more the star of Raphael stands in the zenith. The modern school has written rhythm on its banner. Its interest is centred in discovering the relation of shapes to one another and on welding them into a harmonious structure.

It is natural that modernists turn to the Italian school for guidance. During the fifteenth century an art flourished in Central Italy which had grappled successfully with problems similar to those which they have set themselves. In splendid succession one

* Emile Bernard, *Souvenirs sur Paul Cézanne*, p. 98, Paris, 1912.

great master after another had led the way in the evolution of form. History at no other time can record so brilliant a constellation of artists, who, belonging to one school of thought, persistently devoted their energies in one direction. No wonder Italian art has become the world's great school of form. Let us therefore study these great Italians, " not with the idea of getting a hint or two from the general look of their paintings, but with the intention of understanding the proportions, the measurements and the geometry upon which their external beauties are, so to speak, the final incrustation." * With these words the former Director of the National Gallery in London, who is himself a member of the modern movement, admonishes his fellow-artists. The idea that a geometric scheme should help us to interpret the masterpieces of the past will meet with many objections. Naturally a great work of art appeals to our senses as well as to our intellect. It partakes of the essence of a living personality and cannot be defined by a mathematical formula. It would be absurd to suggest that a knowledge of geometry can in itself alone produce great works of art. All that is contended for in these pages is that a geometric scheme formed the basis of the compositions of the great masters of classic art. It formed a part, but only a part, of their equipment. An artist and craftsman using the scheme need not be a mathematician himself, just as the draughtsman conforming to the rules of perspective is not necessarily a learned man. The science of these things, when once discovered by the great master minds, was handed down as a ready-made formula from teacher to pupil, and no scientific research was required on the part of the individual artist.

Some five years ago, working entirely from the painter's point of view, with the object of improving my sense of form, I examined reproductions of paintings by Piero della Francesca with the help of a pair of compasses and a ruler. In selecting this master I was guided by the consideration that he was a mathematician, and that, therefore, his work was more likely than that of other masters to conform to a geometric scheme, if it be true that such a scheme existed. I also studied Fra Luca Pacioli's book *De Divina Proportione* because the author was known to have derived his knowledge of geometry from Piero. After much searching and trying I one day applied the pentagon to a photograph of the fascinating and mysterious fresco in Arezzo, known by the name of Constantine's Dream, with very satisfactory results. Some time later, looking through a portfolio in the Print Room of the British Museum, I chanced upon a pen drawing attributed to Baldassare Peruzzi, the famous Sienese architect and painter. A group of three half-length figures was drawn inside a circle into which a regular pentagon was inscribed. The lines of the geometric diagram were annotated with measurements,

* See Charles Holmes, *Old Masters and Modern Art*, pp. 227–8, London, 1923

giving approximately their relative lengths. I realized with joy that here was a corroboration of my discovery. The artist had evidently intended by this drawing to demonstrate a geometric scheme, and the way in which the figures were placed inside the regular pentagon seemed palpable proof that it served as a diagram in compositions. (Plate II.)

Since then I have made many excursions into the art of the past, armed with my pentagon. It led me to Florence, to Chartres, to Athens and up the Nile Valley. The results of these researches are set forth in the following pages.

As might be expected, this book is not the first to deal with this fascinating subject. Various attempts have been made in recent times to discover the geometric scheme which was felt to underlie the works of art of the past. Theorists in æsthetics have traced geometric design in the works of nature ; for it was felt that nature and art both draw inspiration from the same creative source. The following is a list of the more important works which have come to my knowledge.

1. A. Zeising : *Die neue Lehre von den Proportionen des menschlichen Körpers.* Leipzig, 1854.

2. T. A. Cook : *The Curves of Life.* London, 1914.

3. F. M. Lund : *Ad Quadratum.* London, 1921.

4. Jay Hambidge : *Dynamic Symmetry* and *The Parthenon.* Yale, 1920 and 1924.

5. L. D. Caskey : *The Geometry of Greek Vases.* Boston, 1924.

6. E. Mössel : *Die Proportion in Antike und Mittelalter.* Munich, 1927.

7. M. C. Ghika : *Esthétique des Proportions* and *Le Nombre d'Or.* Paris, 1927 and 1930.

Although these books approach the question from different angles they all agree in giving paramount importance to the so-called " divine proportion " which also forms the basis of the scheme here submitted.

The works of Zeising and Cook trace the said proportion in formations of nature and touch upon its profound significance in works of art. The relation of my theory to Mr. Hambidge's is explained in the footnote on p. 47. The works of Lund and Mössel approach the subject from an architect's point of view. They corroborate my theory. While they give a very summary analysis of a great number of buildings, I have attempted a detailed description of one, taking into account the methods of construction and giving arithmetical proof of geometric measures. Moreover, this book offers a simple scheme which can conveniently be used for every kind of design. It will be shown that this scheme underlies the composition of some of the greatest paintings of the

Renaissance; that it was used by the Greek potter in designing his shapes, and by the architect of the Parthenon; and that it was familiar to the Egyptian craftsman. This scheme so universally applied has resemblance with an unwritten code of law. The reason why it was not published was probably due to the circumstance that it was kept secret. But my proof of its existence is backed by literary evidence. The scheme had mystic significance; and an attempt has here been made to explain the philosophical and religious conceptions connected with the proportioning of space in ancient times.

More than special acknowledgment and thanks are due to my sister, Gisela M. A. Richter, the curator of the Classical Department of the Metropolitan Museum at New York. Without her this book would never have been made. She helped me and guided me on questions of Greek art. She very kindly went through the work in manuscript form. I visited Athens in her company, and there had the wonderful experience of seeing the Parthenon day after day. I learned very much in two afternoons spent on the Acropolis in the company of Dr. Hill, the former director of the American School of Classical Studies at Athens, who knows every stone of the temple. His explanations of ancient methods of building were very illuminating and suggestive.

I owe a debt of gratitude to my friend Melian Stawell for reading through the chapters on Pythagoras and Timæus and for the help she gave me by her discussion of various points; and to my friend Edith M. Ellis for constant encouragement and for a day spent together at Chartres. My thanks are due to Bernard Adeney of the London Group for many helpful suggestions on the compositions of pictures.

To Mr. L. D. Caskey of the Museum of Fine Arts in Boston I am indebted for his generosity in lending me his carefully measured drawings of Greek vases.

I have also been aided by the following publications :

T. C. Penrose : *The Principles of Athenian Architecture*. London, 1888.
Sir T. L. Heath : *A History of Greek Mathematics* and *The Thirteen Books of Euclid*.
For quotations from Plato's *Timæus*, I have used the translation by R. D. Archer Hind.

In the pursuit of my studies I have been greatly helped and encouraged by my father, J. P. Richter, who gave me his valuable advice on questions of Italian art. I owe to him, also, many helpful suggestions and corrections in the text. It was indeed primarily at his suggestion and in his library that this book was written.

<div align="right">I. A. R.</div>

CONTENTS

CONTENTS

LIST OF ILLUSTRATIONS
(Classified)

GEOMETRY

GREEK VASE FORMS

PLANS OF THE PARTHENON

LIST OF PLATES

RHYTHMIC FORM
IN ART

CHAPTER I

a. *Architecture, Sculpture and Painting.*

THE conditions of artistic production in modern times differ from those prevalent in Florence before and during the Renaissance in more than one respect. The modern student who sets out to learn the art of painting is faced from the outset with a bewildering difference of opinion as to what constitutes art. There is no fixed tradition which he must follow, no apprenticeship which he must serve. In the museums he may study the art of all ages and all countries and he is free to take his choice. After having conscientiously followed a course of study in one art school, he may find in moving to another that his training is considered worthless and even destructive of any native talent he may have had. He feels isolated and must grope his way alone.

Moreover, his art enjoys the same freedom and isolation as he himself; for modern painting, unlike the art of former days, is self-contained and independent of architecture. A painter rarely has an opportunity of decorating a large wall surface, and he therefore need not adapt his compositions to architectural spacing. The size and proportion of his canvas are more often than not a matter of chance, and his artistic considerations do not go beyond the four corners of his frame.

Circumstances were very different in Florence. The Italian student could profit by an organized and collective experience, which had been handed down through generations from master to pupil. Moreover, architects, sculptors and painters worked in close association. Often one artist excelled in more than one art. Thus the painter Giotto also designed the Campanile, and the sculptures which decorate it. The sculptor Michelangelo painted the frescoes in the Sistine Chapel and raised the dome of St. Peter's; and when Leonardo da Vinci wrote to the Duke of Milan enumerating his qualifications he said: " I can give perfect satisfaction, and am equal to any other in architecture and the composition of buildings public and private. . . . I can carry out sculpture in marble, bronze or clay, and I can also paint, whatever may be done, as well as any other, be he who he may." *

* Leonardo's draft of the letter contained in the Codex Atlanticus in the Ambrosiana is reproduced in J. P. Richter, *Literary Works of Leonardo da Vinci*, II, under No. 1340.

One of Vasari's most attractive stories is that of the friendship between the architect Brunelleschi and the sculptor Donatello. He tells of their journey together to Rome for the purpose of studying ancient monuments. They measured the plans carefully, digging down to the foundations of partly covered ruins, so that interested onlookers thought they were searching for hidden treasure. On their return to Florence they produced some of their finest work together. There could indeed be no fitter decoration for Brunelleschi's architecture than Donatello's reliefs.

The charming Renaissance chapel of San Giacomo in the church of San Miniato near Florence was designed by the sculptor Antonio Rosellino. He fitted the tomb of a Portuguese Cardinal into one of the walls under gracefully draped curtains. The architectural setting of the monument effectively sustains the statuary. The vault of the chapel is decorated with four tondoes in glazed terracotta by Luca della Robbia. The two painters Alessio Baldovinetti and Antonio Pollaiuolo enriched the walls with frescoes. The interior, which four great artists have combined to make beautiful, appears to be moulded by one great master-mind into graceful unity. This chapel is but one example. The churches and palaces of Italy all tell the same tale of close co-operation between the arts.

Sculptors and painters, therefore, were accustomed to conceive their compositions as part of an architectural design. They were often employed to decorate walls and had to adapt their compositions to tectonic spacing, and therefore the same rhythm which determined the work of the architect penetrated also into the work of the painter and sculptor.

Therefore painters liked to enclose their pictures in architectural framework; they painted temples behind their figures and flanked their open squares with palaces and colonnades, they staged their scenes in lofty halls or in front of vaulted niches, and they seated their Virgin on an architectural throne. The frame of an altarpiece often took the shape of a semicircular arch supported on pillars so that the worshipper appeared to be looking through an archway into another part of the same interior where he was kneeling. These settings accentuated the rhythmic arrangement of the composition. Their function can be compared to that of choral songs in ancient Greek drama. By these means the art of painting, not wishing to throw off its dependence on architecture which had sustained it, seemingly kept up its connection also in easel pictures. However, the painting of architectural backgrounds was only a superficial manifestation of the interrelation. The connection between the arts went deeper.

b. *Painting and Music.*

In looking at a great painting of the Renaissance the eye is satisfied at once by its completeness and by the unity into which all details are coherently moulded. The care and attention of the artist were fixed on the adjustment of the whole. His composition holds together and seems to be pervaded by some mysterious rhythm. The question presents itself : What is this power of comprehending the whole which artists of the past had at their command ?

Was it an unconscious process ; and did they work thus without rule and measurement ? Was their sense of composition so developed that they produced these masterpieces out of hand, driven only by the creative genius within them ? The belief is current that the art of painting is the result of inspiration only, and that nothing in the way of law and order consciously applied must trammel the free improvisation of genius. Romantic enthusiasts on the one hand and contemptuous sceptics on the other assign the art of painting to caprice. According to them the painter works without method. He is supposed to follow a blind inner impulse and does not need to pay any regard to any laws.

Yet if this were true, the art of painting would differ from any other art, and would stand distinctively alone. Because, if the same were said of music, for instance, people would take another view. A piece of music was as a matter of course composed on an underlying mathematical division of time. However great the genius of the composer, he must nevertheless conform to the laws of harmony and rhythm. There cannot, therefore, be any objection on artistic grounds to the same principle being applied to painting. There is a close relationship between the two ; Leonardo has called music the sister of painting, and Michelangelo said : " Finally, good painting is a music and a melody, which intellect only can appreciate, and that with difficulty." A comparison between the two arts widens the outlook and reveals more clearly the fundamental ground which all arts have in common, and in trying to establish the principles of painting it is helpful to consider their correspondence with the principles of other arts.

Let us make one more comparison. Take the art which is simplest, poetry. The very existence of poetry depends on measure, be it hexameter or any other metre. The poet measures his words to fit the rhythmic beat of time ; and the artist draws his forms to fit the rhythmic division of space. What metre is to poetry, that proportion is to painting and the plastic arts.

The Neoplatonist Plotinus said : " What is it that impresses you when you look at something, attracts you, captivates you, and fills you with joy ? We are all agreed, I may say, that it is the interrelation of parts towards one another and towards the whole,

with the added element of beauty in colour, which constitutes beauty as perceived by the eye ; in other words, that beauty in visible things as in everything else consists of symmetry and proportion. In fact, nothing simple and devoid of parts can be beautiful, only a composite." *

The Greeks then were extremely sensitive to the beauty of fine proportions, and we may say of them that they had an eye for proportion just as we speak of people having an ear for music. To them artistic pleasure came through the sense of sight, and it seems to have moved them so deeply that it evoked ethical emotions. Our eyes have not had the training which the Greeks enjoyed for many generations, and we have but faint glimmerings where they saw clearly.

But however gifted with innate and instinctive taste they may have been, the supposition that they obtained their wonderful results without a definite method cannot be entertained. The proportions of their temples and monuments cannot be the result of mere instinct. Such a supposition is, moreover, refuted by the titles of numerous books on the theory of proportion written by ancient Greek architects and other artists.

No doubt an art cannot be learned by rules. It is conceivable that, as poets and musicians are born and not made, and as they at first instinctively apply what afterwards is seen to conform to the laws of harmony and rhythm, so artists and craftsmen may tend instinctively to select certain arrangements and proportions which conform to geometric rules ; and this instinctive faculty may have been developed by the practice on the part of generations of craftsmen in using the same proportions. But rules thus established by the practice of the great masters through the ages are fetters only to men of no genius ; " like that armour, which upon the strong is an ornament and a defence, upon the weak and misshapen becomes a load and cripples the body which it was made to protect." †

Many centuries later Leon Battista Alberti, the great Renaissance architect and humanist, gave a definition of beauty similar to that of Plotinus. He said that all beauty is the result of fine proportions.‡ According to him the parts must be related to the whole so that not the smallest particle can be added or taken away without disfiguring.

Thus the three fine arts which influence us through the eye, namely, architecture, sculpture and painting, have one quality in common on which their beauty depends, and this quality is " proportion." In painting and sculpture the representation of nature introduces a rival interest, which conflicts and sometimes obscures this fundamental

* *Ennead* I. 6. 1.

† As Sir Joshua Reynolds said in his First Discourse when speaking of " that false and vulgar opinion, that rules are the fetters of genius."

‡ *De Re Aedificatoria* IX, 5.

quality. But architecture is unhampered by the representational element, and its expression of beauty can be clear and unalloyed. For next to music it is the most abstract of arts and fine architecture has been compared to frozen music.

> Heard melodies are sweet, but those unheard
> Are sweeter; therefore, ye soft pipes, play on;
> Not to the sensual ear, but, more endear'd,
> Pipe to the spirit ditties of no tone.
>
> Keats, *Ode on a Grecian Urn*, II.

c. *Proportion in Space.*

Architecture is the science of fine proportions; while other artists may neglect them, an architect cannot possibly discard them. They are his only vehicle of expression; he has to deal with proportions all the time, from the laying out of his plan to the last detail of decorative moulding. A quotation from Vitruvius, the Roman writer on architecture, is apposite: " The design of a temple depends on symmetry, the principles of which must be carefully observed by the architect. They are due to proportion, in Greek ἀναλογία. Proportion is a correspondence among the measures of the members of a work, and of the whole to a certain part selected as standard. From this results the principle of symmetry. Without symmetry and proportion there can be no principle in the design of any temple." * In temple architecture the column, with its shaft, base, capital and entablature were moulded and related to form one harmoniously proportioned Order. The column thus forming a whole in itself, with parts proportionately related, was in its turn part of a greater whole, and was incorporated in the rhythmic spacing of the temple.

The composition of a picture was based on the same principle. Here the human figure takes the place of the column in architecture. Renaissance artists used a canon of proportion for the human figure which was based on Vitruvius,† and elaborated by Leonardo da Vinci and others. This canon is well known and has come down to us in writing. Its proportions are comparatively easy to realize, as they are based on simple numerical relations. Within the composition of a picture each individual figure constituted a whole with parts harmoniously related. But these figures were in their turn part of a greater whole. They were coherently moulded into large compositions and adjusted into the space of walls and frames. Could we but find the principle on which

* Vitruvius, *De Arch.*, III. 1.

† Lorenzo Ghiberti criticizes the canon by Vitruvius and gives preference to another canon which was known under the name of Varro and was also used. *Commentarii* III. See A. Zeising, *Neue Lehre von den Proportionen* for the various canons of proportions of artists.

this wonderful unity in the spacing of the greater whole was attained it might help us to a more intelligent appreciation of the art of the past.

Architecture, sculpture and painting not only have one quality in common which contributes to their beauty, namely, proportion, they also have one common sphere of action, namely space. The space of a work of art of the past was divided into harmonious proportions just as the various figures which it contained were built according to a canon of proportion. Space in these arts takes the place of time in music. As a melody is woven through the rhythmic beat of time a composition is traced into proportioned space.

In architecture the space thus proportioned into one harmonious scheme is circumscribed by the total length, width and height of the building; whereas in a picture the space is represented by the surface of the painting. Artistic Space should be conceived as containing a work of art just as a block of marble potentially contains a piece of sculpture, for it pervades the empty spaces as well as the plastic figures and shares with ether the quality of invisibility, intangibility and pervasion. It constitutes the unifying element in a work of art, for in it all things find their relative shapes and places. The method by which space in the works of art of the past was harmoniously proportioned will form the subject of this inquiry.

Several artists of the Renaissance have written on the subject of proportion from an artistic point of view. Lorenzo Ghiberti, Leon Battista Alberti, Vincenzo Foppa, and Leonardo da Vinci devoted much time to this study. But such of their writings as have survived deal with the proportion of the human figures and not of space. The case is different when we come to the mathematical treatises of Piero della Francesca and of Fra Luca Pacioli. Piero's *Libellus de quinque corporibus regularibus* dealt with geometric solids. The same subject forms an important part of the book by Fra Luca Pacioli, which was the most celebrated treatise on proportion of the time. Its author was an acknowledged authority on mathematics; and although not an artist himself he was in close communication with many distinguished artists. He studied under Piero della Francesca, whose ideas he was perhaps unjustly accused by Vasari of having published under his own name. Leonardo was his friend and designed the geometrical figures which illustrated his work. The treatise took the form of a lecture delivered to Ludovico Sforza, Duke of Milan, in 1498. It was published in Venice in 1509 under the title *De divina proportione*. The subject is better known by the name of " the golden section." This law, as usually stated, relates to the proportion of three magnitudes : " *The first part is to the second part as the second is to the whole or sum of the two parts.*" This seemed to him so wonderful a proportion that he attached mystic significance to it and compared the three interrelated terms to the Divine Trinity. We open the book with great

PLATE I

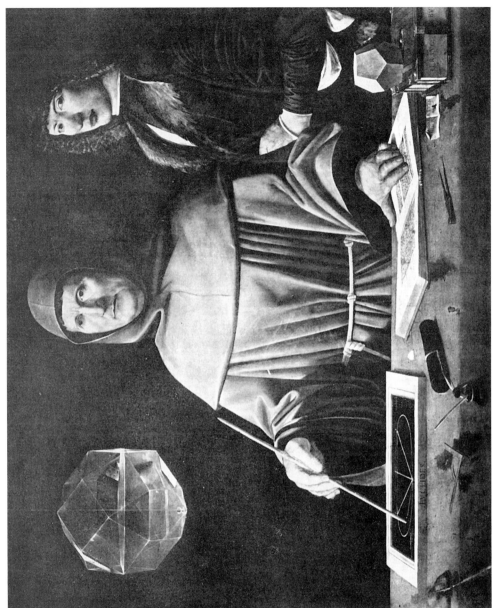

Jacopo de' Barbari?

Photo. Alinari

PORTRAIT OF FRA LUCA PACIOLI
(National Museum, Naples)

expectations; but we find nothing that was not known to the Greeks two thousand years before. Fra Luca's treatise is based on the Thirteenth Book of Euclid's *Elements*. We are referred back to the creative genius of the Greeks. In turning to them we are but following the footsteps of Italian Humanists. The science of geometry had not advanced since the fateful days when Rome had placed its conquering and crushing foot on the Hellenic world. Fra Luca knew this himself and paid tribute to the source of his knowledge when he let his portrait be painted with his hand resting on the Thirteenth Book of Euclid.* (Plate I.)

* Giovan Paolo Lomazzo, in his well-known *Trattato dell' arte* published at Milan in 1584, also acknowledged the debt to the Greeks, when at the opening of the 29th Chapter of the First Book he refers to a certain proportion which he does not specify: "The Greeks in imitation of antiquity searched out the truly renowned proportion wherein the exact perfection of most exquisite beauty and sweetness appeared, dedicating the same in a triangular glass unto Venus, the goddess of divine beauty whence all the beauty of inferior things derived."

CHAPTER II

PYTHAGORAS

THE divine proportion * was known to the Greeks long before the time of Euclid, who lived in Alexandria about 300 B.C. For Euclid but handed down to posterity the knowledge of his predecessors in a connected and logical series of propositions, and contributed little of his own that was original.

Greek geometry is as old as Greek philosophy; it begins with Thales, who lived about 585 B.C. and was one of the seven wise men. His native town Miletos became the home of those early Greek philosophers who inquired into the ultimate nature of matter.

Miletos lies on the mainland of Asia Minor nearly opposite the island of Samos, which was the home of Pythagoras (sixth century B.C.). Both Thales and Pythagoras are said to have studied geometry in Egypt, where they with great difficulty succeeded in securing access to the carefully guarded secrets of the Egyptian priesthood, which had been preserved and handed down from generation to generation during the course of thousands of years. We cannot tell how much of the early Greek geometry was of Egyptian origin, for the materials for our

FIG. 1.—THE STAR OF PYTHAGORAS.

* The term " divine proportion " is employed throughout this book for the sake of continuity and convenience. As far as can be ascertained it came into use during the Renaissance to denote the division of a line into the proportion which in classic times was called " the section "; during the last century the term " golden section " and later also " medial section " was used. Kepler uses the terms " sectio divina " and " proportio divina." Euclid therefore does not use the term " divine proportion." Two of his propositions set the problem of finding this proportion, and he gives a different description each time. In II. 11 he says: To cut a given line so that the rectangle contained by the whole and one of the segments is equal to the square on the remaining segment. And in VI. 30 he says: To cut a given finite line in extreme and mean ratio. Both these problems are equivalent in statement and require the division of a line in the divine proportion. The construction given in the first of these propositions is probably Pythagorean.

knowledge of Egyptian mathematics are very inadequate.* It seems certain, however, that the "divine proportion" was known to Pythagoras. There is a beautiful five-pointed star in which every line and part of a line are interrelated in the divine proportion (Fig. 1). This figure was at one time known by the name of Salus Pythagoræ, and we are told by Lucian † and the Scholiast to the *Clouds* of Aristophanes (609) that it was used by the mystic brotherhood of the Pythagoreans as a sign of salutation and as a symbol of health at the express desire of their master. Other evidence confirms the surmise that the " divine proportion " was known to Pythagoras. For the five-

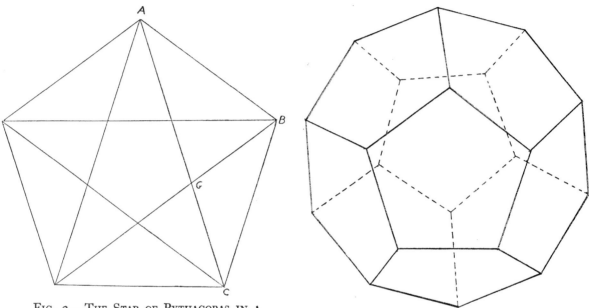

FIG. 2.—THE STAR OF PYTHAGORAS IN A
REGULAR PENTAGON.

FIG. 3.—THE DODECAHEDRON.

pointed star is very closely connected with the regular pentagon (Fig. 2), and twelve of these pentagons make up the dodecahedron (Fig. 3),‡ which is one of the five " cosmic solids " whose construction Proclus attributes to Pythagoras.§ Moreover, we are told that Hippasos, a Pythagorean, claimed the construction of the sphere with the twelve pentagons as his own discovery while it rightfully belonged to the master himself.‖ Therefore there seems to be little doubt that Pythagoras was already

* See T. Eric Peet, *The Rhind Mathematical Papyrus* on Egyptian mathematics, and page 43.

† Lucian, *A Slip of the Tongue in Salutation*, 5.

‡ The geometric solid lying on the book on the right side of the picture reproduced on Plate I is a dodecahedron.

§ Proclus, *Comm.*, p. 65. ‖ Iamblichus, *Vita Pythag.*, 88.

in possession of all the knowledge of geometry which, as we shall see, was used by artists for the spacing of their designs.

The interests of Pythagoras were not confined to the field of geometry. He was also devoted to music. One of his greatest achievements was the discovery of the dependence of musical intervals on numerical proportions. He found that the ratio of 2 to 1 between the length of strings of the same substance and at the same tension corresponds to the octave, the ratio of 3 to 2 corresponds to the fifth, and so on. We must try to picture to ourselves the joy and wonder with which this discovery was greeted in order to understand the importance given to numbers in Pythagorean philosophy. For here were two distinct worlds, that of sound and that of numbers, seemingly with no connection between them as far as our senses could perceive ; and yet the harmony of sounds, heard only by an ear musically trained, was evidently connected with simple and definite numerical relations. It seemed unbelievable, yet the truth of it could be tested on a simple string instrument. That " things are numbers " is one of the few sayings of Pythagoras which have come down to us.

Encouraged by his discoveries, he came to the conclusion that the principles of all existing things were based on mathematics, and that music was the clearest expression of mathematical laws. Harmony and proportion were interrelated and pervaded all things. To find the rhythm to which the whole creation moved and to live accordingly was the Pythagorean vocation. In the days when Greek philosophy was born there were as yet no specialists and the methods of experimental science were unknown. A wide field lay open to speculation ; and the philosopher was like a mystic poet, he divined the eternal order of things. The Pythagoreans set out with the idea that the whole creation was governed according to the mathematical principles which they had discovered, and they invented a cosmic system by deliberately applying their theories of harmony and proportion to astronomy, without, of course, being able to test their cosmos by experiment. They argued that things must be so, because they knew that harmony and proportion pervaded all things. Indeed their way of procedure resembles that of an artist. He also deliberately sets out to attune things into harmonies.

So the Pythagoreans conceived our solar system as consisting of ten spheres revolving in circles through space around a central fire. They believed that these spheres were separated from each other by intervals corresponding to the harmonic lengths of strings, and that their movement through space gave rise to sounds ; that those spheres which move slowly gave lower notes than those which move quickly, while those move most quickly which move at the greatest distance from the centre. The various sounds all combined into beautiful music, which was audible to the initiated only. The others

were not aware of the chime which was constantly playing as they were never in a position to contrast it with silence. The movement of the ten spheres was called " a dance," and the central fire around which they turned was sometimes called " the altar." These names are suggestive. The planets circled round the sacred source of all life as the Greek worshippers danced and sang the dithyramb round the altar of their divinity; and the rhythmic dance linked with the sounds of the never silent music was made the harmony of the spheres.

This beautiful conception partakes of the unity and coherence which goes to the making of a work of art. But it also had a religious significance, for at the goreanism was primarily a religion. Through religious devotion reinfor matical study its followers tried to conform their lives to the all-pervading rl considered this the best way of life, for they believed in the immortality c in its transmigration, and they hoped by understanding and drinking in harmony to achieve the purification of their souls. The Pythagorean according to Plato :

" God discovered and bestowed sight upon us in order that we might observe the orbits of reason which are in heaven and make use of them for the revolutions of thought in our own souls, which are akin to them, the troubled to the serene; and that learning them and acquiring natural truth of reasoning we might imitate the divine movements that are ever unerring and bring into order those within us which are all astray . . . and harmony, having her motions akin to the revolutions in our own souls, has been bestowed by the Muses on him who with reason seeks their help, not for any senseless pleasure, such as is now supposed to be its chiefest use, but as an ally against discord which has grown up in the revolution of our soul, to bring her into order and into unison with herself : and rhythm too, because our habit of mind is mostly so faulty of measure and lacking in grace, is a succour bestowed on us by the same giver for the same ends " (47).

Pythagoras, after extensive travels, settled at Croton in Italy, where he founded a widespread and influential brotherhood of his disciples. He chose his followers carefully and led them by graduated stages to the final revelation which was vouchsafed only to the select. We know little of his own thoughts, since he himself wrote nothing for fear that sacred knowledge might come into the possession of the profane.* Plato, who in

* So tradition will have it. According to Diogenes Laertius, Pythagoras wrote three treatises, which were kept secret. " Down to the time of Philolaos it was not possible to acquire knowledge of any Pythagorean doctrine, and Philolaos alone brought out those three celebrated books which Plato sent a hundred minas to purchase."—*Lives of Eminent Philosophers*, VIII. 6. 15. Hippasos is warned by a friend not to discourse publicly " a thing which Pythagoras deemed unworthy; for certain it is that when he entrusted his daughter with the custody of his memoirs he solemnly charged her not to give them to anyone outside his house," and although she could have sold the writings for a large sum of money, she would not, but reckoned poverty

many respects was a follower of Pythagoras, adopted the same attitude and wrote in one of his letters : " No serious man will ever think of writing about serious realities for the general public so as to make them a prey to envy and perplexity." *

There seems also to have been a superstition that ill might befall the man who divulged certain secrets ; and the story is told that Hippasos, " a Pythagorean, because he was the first to write down and publish the construction of the sphere from the twelve pentagons, perished by shipwreck for his impiety." †

Pythagoreanism was a creed, a cult, a religion that demanded utter loyalty from its adherents. In some respects the brotherhood was not unlike the order of the Knights Templars, except that the military ideal was entirely absent. They were similar also in their tragic end, for the brotherhood, like the Christian order, was extinguished in cruel persecution. Their influence and their exclusiveness roused the envy of their fellow-citizens. The story goes that a mob, instigated by a disappointed and jealous intruder, set fire to their house of assembly, and that the master perished in the flames with his disciples. The brotherhood never recovered after this catastrophe, but the philosophy of Pythagoras lived on in the minds of men. His followers surrounded their master with a halo of glory. His life and person became the centre of innumerable legends. Were not the strings of his cosmos attuned to the harmony of Apollo's lute ?

> . . . Look, how the floor of heaven
> Is thick inlaid with patines of bright gold.
> There's not the smallest orb, which thou behold'st,
> But in his motion like an angel sings,
> Still quiring to the young-ey'd cherubins ;
> Such harmony is in immortal souls ;
> But, whilst this muddy vesture of decay
> Doth grossly close it in, we cannot hear it.
> Shakespeare, *Merchant of Venice*, V. 1.

and her father's solemn injunction more precious than gold, for all that she was a woman." *Ibid.* VIII. 42. It has been suggested that the secrecy adopted by the Pythagoreans may have been due to their trying to hide the very awkward fact that the divine proportion involved incommensurable magnitudes, the existence of which seemed to ruin their whole doctrine that "things are numbers." See A. E. Taylor, *A Commentary on Plato's Timæus*, p. 365 f.

 * *Epistle* VII. 344c. † Iamblichus, *Vita Pythag.*, 88.

CHAPTER III

GREEK ART AND MATHEMATICS

μηδεὶς ἀγεωμέτρητος εἰσίτω. These words, inscribed over Plato's Academy, warned everyone who was ignorant of geometry not to enter. The study of geometry was considered to be the foundation of education. In their endeavour to understand the world, the Greeks were irresistibly driven to the sciences of exact reasoning. They loved geometry; it appealed to their logical minds. The world surrounding them was transient, and the fleeting images but mirrored things eternal. While everything was fluctuating, mathematical laws were immutable; they could be relied upon. Here was a safe road by which the seeker after truth could travel. It would lead him to the goal of his quest, and give him a rational solution of everything in heaven and on earth. The ever-changing and apparently chaotic world must have some permanent principle which shaped it. There must be some eternal order by which the cosmos was created.

Space is infinite, but nevertheless it can be defined and measured by geometry. The point is conceived as unity. It defines a place and can mark a centre in infinite space. A straight line drawn from this point denotes a direction; and it may terminate in another point and measure a distance. A line turned round a central point describes a circle on a plane. Finally, although space may extend into infinity, a circle turning on itself circumscribes space in a sphere. Thus, starting from a point which has no magnitude, a portion of infinity can be scooped and enclosed in a three-dimensional shape. The point, the line, the circle and the sphere constitute a progressive series in the evolution of geometric space. They make up what was known as a tetractys.* Theon of Smyrna,† in a commentary on Plato's mathematics, enumerated eleven different series, each of which was made up of four terms. There was the arithmetic progression of 1, 2, 3, 4, the sum of which makes 10.

There were the geometric progressions—

$$
\begin{array}{ccccc}
 & & 1 & & \\
 & 2 & & 3 & \\
 & 4 & & 9 & \\
8 & & & & 27 \\
\end{array}
$$

* Tetractys has been translated into " quaternion," a set or group of four.

† Theon of Smyrna was a philosopher and astronomer who lived at the time of Hadrian. His commentary

13

which were translated into geometry : the point, the line, the square, the cube ; and the point, the curve, the circle, the sphere. There were other tetractyses, as for instance the four seasons, the four elements, and the four ages of men. One series was devoted to the idea of growth, from seed into length, width and height ; and another ranged from thought to reason, opinion and sensation. The inclusion of such as these in the same list with purely mathematical series shows how the idea of rhythmic progression was universally applied. The oath of the Pythagoreans is recorded as being : " I swear by him who has transmitted to our souls the tetractys—the eternal source of all nature."

But let us return to the sphere, whose progressive evolution from the point has been described above. The sphere was considered by the Greeks to be the perfect shape. In its smooth and regular concavity the five regular solids can be inscribed. Much importance was attached to these solids in Pythagorean Cosmology.* They were thought to be the most beautiful shapes which matter can take, and they were therefore identified with the so-called elements. Euclid devoted the Thirteenth Book to them, proving that no more than five regular solids are possible and showing how to inscribe them into a sphere. The " divine proportion " plays an important part in the solution of these problems. Indeed it seems as if Euclid's science was meant to culminate in this book, which is the last of the *Elements*.

Before Euclid, Plato had already been interested in the subject. He made the Pythagorean Timæus the mouthpiece of a mythical account of the creation of the universe, which differed from the one in the Book of Genesis as the Greek conception of life differed from that of the Jew. The God of Greek philosophy created order out of chaos by introducing geometry into formless space. He shaped the four elements into regular solids. He related them to each other by means of beautiful proportions and inscribed them in a perfect sphere. By applying limit and measure to the formless all things of excellence were created in the visible universe.

In Greek philosophy these two opposites, the principle of measure, τὸ πέρας, and the formless, τὸ ἄπειρον, are made to play into one another in many ways. Symmetry, proportion, balance, moderation and harmony are all beautiful and excellent. They all spring from the union of the two. In the human mind the goddess of limit checks the wild passions by the law of moderation. In the world of sound the endless degrees of quick and slow, deep and high, are modulated into delightful harmonies by the law of measure. Formless space too is shaped, so to speak, into a thing of beauty by the same

on Plato's mathematics consisted of five books : I. Arithmetic, II. Geometry, III. Stereometry, IV. Astronomy, V. Music. Unfortunately only I, IV and V have survived. They have been translated into French by J. Dupuis, 1892. * See footnote, p. 30.

power. Geometrical proportions bring harmony into space. To achieve this was the work of artists and craftsmen. The architect designed his temple by the same principle according to which Plato's God ordered the universe. His work was tuned to the same harmony; it vibrated to the same rhythm, and was at once a part and a manifestation of an eternal design. The artist geometrician, therefore, inscribed his shapes into a sphere, using the " divine proportion." That is to say, he conformed his work to the perfect shape * by means of the perfect proportion.

In ancient times temple builders were not free to follow the dictates of their own fancy. Indeed, if they had been given the freedom in which the modern architects delight, they might not have considered it as great a boon as we are inclined to suppose; they would probably have felt at a loss. For their art was from time immemorial circumscribed by rules connected with religion; and the proportions which they used had cosmic significance. Thus in Egypt the fixing of the four corners of a temple was a sacred rite, in which Pharaoh himself was the chief actor. This ceremony is repeatedly described and illustrated on the walls of the temples of Karnak, Denderah and Edfu. The story is told in the language of Ancient Egypt. At Abydos there is an inscription relating to the building of a temple in the time of Seti I in which the star-goddess Sesheta, who is styled the mistress of the laying of the foundation stone, addresses the king as follows : " The hammer in my hand was of gold as I struck the peg with it, and thou wast with me in the capacity of Harpedonapt.† Thy hand held the spade during the fixing of its four corners with accuracy by the four supports of heaven." And in a document describing the building of the temple of Annu at Heliopolis we read : " Arose the king attired in his necklace and feather crown; all the world followed him and the majesty of Amenemhāt. The Kher-heb read the sacred text during the stretching of the cord and the laying of the foundation stone on the piece of ground selected for this temple." ‡

Much importance then was attached to the orientation of the temple, whereby the house of the god was related to the cosmic order. The king invested with the crown of Osiris proceeded to the site where the temple was to be built. He was accompanied by a goddess. They each held a stake, the two stakes being connected with a cord. This cord was aligned towards the rising star or towards the sun, as the case might be. When the alignment was perfect, the two stakes were driven into the ground by means of a

* See pp. 14 and 33.

† Egyptian engineers were called Harpedonaptai, rope stretchers, on account of the stretching of the measuring cord.

‡ See Sir Norman Lockyer, *The Dawn of Astronomy*, Chapter XVII, and T. Eric Peet, *The Rhind Mathematical Papyrus*, p. 32.

mallet. One boundary course of masonry parallel to the main axis of the temple was built along the line marked out by this stretched cord.

Sir Norman Lockyer and Mr. Penrose * were convinced after careful investigation that the stars were observed for heralding sunrise, like a clock which gave warning, so that on special feasts the priests should have timely notice for preparing the ceremonial. It is obvious that the light from the sun or star towards which the temple was thus aligned would penetrate the axis of the temple from one end to the other in the original direction of the cord.

Greek temples generally faced eastwards. The chryselephantine statue in the Parthenon was lighted up by the sunrise on the feast to the goddess in August.

Christian builders in the Middle Ages followed the ancient practice, but they reversed the position. They liked to turn the apse of their cathedrals towards the rising sun and the entrance westwards.† Thus, when the gigantic rose window of stained glass in the façade is illuminated by the evening sun it sets the whole interior aglow and almost appears to be the source of light itself.

Vitruvius ‡ gives a simple method for determining the orientation. The ground was levelled, a pole was fixed in the centre and a circle described around by means of a stretched cord. The midday shadow of the pole determined the direction of the diameter from North to South. The direction of East to West was then obtained by dividing the circle into four parts. It will be shown below that the plan of a temple was inscribed in a circle. The preliminary process employed for the orientation of the building towards the sun could therefore also form the basis for the laying out of the plan.

* See Sir Norman Lockyer, *ibid*., Chapter XXXVIII.

† A rule to this effect occurs in the middle of the third century in the *Apostolic Constitution*, Book II, c. 57. ‡ *De Arch.*, I. 6.

CHAPTER IV

MATHEMATICAL DEFINITIONS

PLATO has given a very telling description of the function of proportion in the *Timæus* (31 c.). He says, " It is not possible for two things to be fairly united without a third, for they need a bond between them, which shall join them both. The best of bonds is that which makes itself and those which it binds as complete a unity as possible, and the nature of proportion is to accomplish this most perfectly ; for when of any three numbers one is the mean term so that the first is to the middle as the middle is to the last, and conversely, as the last is to the middle so is the middle to the first, *then*, since the middle becomes first and last, and the last and first both become the middle, thus of necessity all will come to be the same, and being the same with one another all will be unity."

In view of the importance attached to geometric proportion in art, it is necessary to say a few words on the subject, and to describe more fully the nature of the " divine proportion," which constitutes a particular case of geometric proportion.*

a. *Geometric Proportion.*

A good way of finding the mean proportion between two distances is to make use of the following proposition of Euclid : " In a right-angled triangle, if a perpendicular be drawn from the right angle to the base dividing the base into two sections, the perpendicular is the mean proportion between the two sections." (Euclid VI. 8, corollary.)

Fig. 4. $AB:BD::BD:BC.$

Fig. 5. Therefore if A B and B C be two straight lines, and it is necessary to find a mean proportional between them, we join A B and B C so as to make one straight line, A C.

On A C we describe a semicircle.

From B we draw B D perpendicular to A C.

* Readers had better be warned that this chapter may seem like some pages taken out of Euclid's *Elements*. It was written because I felt bound to give some account, however brief, of the propositions involved in the present argument ; knowing that it would be readily skipped by readers who would find it elementary or tedious. They are advised to proceed to the chapter on the pentagon and decagon, which contains all the explanations needed.

Then A D C is a right-angled triangle because the angle in a semicircle is a right angle. (Euclid III. 31.)

Therefore B D is the mean proportional between A B and B C. (Euclid VI. 8.)

$$A B : B D : : B D : B C.$$

b. *Divine Proportion.*

When A B = B C + B D as in Fig. 6, the three lines are related in the divine proportion.

The following construction provides a simple way of dividing a line into the divine proportion.

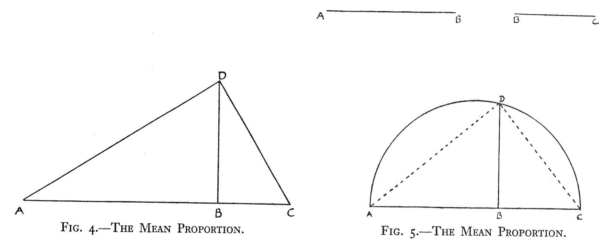

FIG. 4.—THE MEAN PROPORTION. FIG. 5.—THE MEAN PROPORTION.

Fig. 7. In order to find the divine proportion of a given line O W.

From centre O with radius O W describe a circle.

Divide the circumference into four equal parts at W, N, E and S.

Bisect O E at A.

From centre A, with radius A N, describe a circle cutting O W at B.

So that A N = A B.

Then O W is divided at B into the divine proportion.

Moreover, O B is the side of a regular decagon inscribed in the circle, and N B is the side of a regular pentagon inscribed in the circle.

The divine proportion deals with incommensurable lengths, and it cannot therefore be accurately expressed by simple numbers. If the relation is expressed arithmetically the terms would be approximately :

$$1 : \cdot 618 : : \cdot 618 : \cdot 382.$$

c. *Geometric Progression.*

In a geometric progression each succeeding term is produced by multiplying the preceding one by a fixed quantity. A geometric proportion can be extended so as to form a geometric progression; in the case of the divine proportion each term is ·618 times as large as the preceding term :

$$\ldots . \; 4\cdot236, \; 2\cdot618, \; 1\cdot618, \; 1, \; \cdot618, \; \cdot382, \; \cdot236 \; \ldots .$$

FIG. 6.—THE DIVINE PROPORTION. FIG. 7.—THE DIVINE PROPORTION.

The series can be continued indefinitely running upwards and downwards from 1, which stands for the length of the original line. The progression founded on the divine proportion is distinguished from other geometric progressions by a quality which makes it a convenient scale of measurement for artistic purposes, each term being made up of the sum of the two preceding terms, so that the series can be continued by addition and subtraction when once the relation between two terms is established.

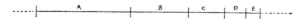

FIG. 8.—THE GEOMETRIC PROGRESSION.

Fig. 8. In Fig.

$A = B + C$	$E = C - D$
$B = C + D$	$D = B - C$
$C = D + E$ and so on.	$C = A - B$ and so on.

Fig. 9 is derived from Fig. 6 and contains a double geometric progression of lines, related in the divine proportion :

O A . O B . O C . O D . O E . O F . O G . O H . . . and
A B . B C . C D . D E . E F . F G . G H

Each line bears the same proportion to its predecessor as the line following bears to it. The design is suggestive of the Greek fret and imitates spiral formations in nature, which are the result of continued proportional growth.*

Theories about mathematical progressions were in favour during the Renaissance. Thus Leonardo applied them to perspective and established the fact that objects of equal size receding from the eye at intervals corresponding to the arithmetic progression 1, 2, 3, 4 . . . decrease in size according to the harmonic progression 1/2, 1/3, 1/4 . . . †

FIG. 9.—THE GEOMETRIC PROGRESSION.

Here again the relation with music is evident, and in Plutarch's treatise on music ‡ these progressions are fully explained. In Raphael's fresco of the School of Athens the two progressions are ostentatiously displayed on a board in front of Pythagoras by a youthful disciple.

d. *The Divine Progression. Table of Arithmetic Values.*

	Decreasing from 1.	Increasing from 1.
1	0·6180	1·6180
2	0·3820	2·6180
3	0·2361	4·2361
4	0·1459	6·8541
5	0·0902	11·0902
6	0·0557	17·9443
7	0·0344	29·0344
8	0·0213	46·9787
9	0·0132	76·0132
10	0·0081	122·9919
11	0·0050	199·0050

* T. A. Cook, *The Curves of Life*, London, 1914.

† Leonardo's original text contained in the Ashburnham MS. I. 12b is reproduced in J. P. Richter, *Literary Works of Leonardo da Vinci*, under No. 99. ‡ Περὶ μουσικῆς. Not certainly by Plutarch.

The diameter of a circle is to the diagonal of the inscribed regular pentagon as :

$$1 : 0.951$$

The diameter of a circle is to the side of the inscribed regular pentagon as :

$$1 : 0.5878$$

e. *Pentagon and Decagon.*

There are two regular polygons which are intimately related to the divine proportion : the pentagon and the decagon. Both these figures can be inscribed into a circle, and the proportion is thereby introduced into the circle.

The regular pentagon.

The diagonals of the regular pentagon cut one another in the divine proportion and its sides are equal to the major section of the diagonals. (Compare Euclid XIII. 8.)

Fig. 10. Describe a regular pentagon by dividing the circumference of a circle into five equal parts at A B C D E and joining these points.

If the five diagonals of the pentagon be joined the Pythagorean star is formed.

FIG. 10.—THE REGULAR PENTAGON IN A CIRCLE.

We are at once struck by its beautiful proportions. In some mysterious manner the whole figure is pervaded by the divine proportion.

Take, for instance, the diagonal A, C.

$$A C : A G . : : A G : A F : : A F : F G.$$
$$A C : F C . : : F C : G C : : G C : F G.$$

Moreover, the sides of the pentagon are related in the divine proportion to the diagonals, because

$$A G \text{ and } F C \text{ are both equal to } A B.$$

And of course all the five diagonals and all the five sides are similarly proportioned.

By the intersection of the diagonals a second smaller regular pentagon F G H I K is formed nearer the centre.

Fig. 11. If the diagonals of this inner pentagon are joined, a third pentagon L M N O P is formed which is in the same relation to the second as the second is to the first.

A succession of concentric pentagons can thus be described containing an endless series of proportioned relations.

Moreover, the process can be reversed.

The sides of the pentagon can be produced until they meet to form the star. The points of the star are joined to form the larger pentagon, whose sides are again produced to form a larger star, and so on indefinitely.

These are very simple and entertaining ways of playing with the divine proportion and we begin to understand why the five-pointed star was favoured by the Pythagoreans.*

The geometricians of the ages that followed were interested in the problems that arose from the description of regular pentagons into and about circles and the description of circles into and about regular pentagons. They are dealt with in the Fourth Book of Euclid's *Elements*.

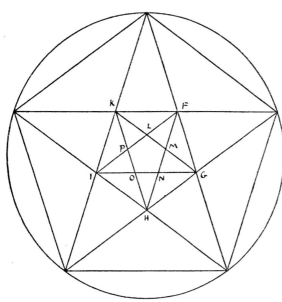

FIG. 11.—THE PENTAGRAM IN A CIRCLE.

Boethius, writing at the beginning of the sixth century A.D., refers to them.†

In the Middle Ages mention is made of the five-pointed star. Campanus, writing towards the end of the thirteenth century, deals with the sum of its angles. ‡

A book by an unknown author in French about 1276 draws attention to the importance of the pentagram and pentagon. § We find the pentagram inscribed into some of the

* Mystical and magical properties were assigned to the pentagram at an early date. In Jewish symbolism it stood for Solomon's seal; in Christian symbolism, for Christ and His salutiferous cross. In the Middle Ages it was used as a stonemason's sign and it was later adopted by the freemasons. It frequently occurred as a symbol of witchcraft, surviving in popular superstition as a device of which the interpretation in bygone days was lost. It formed an integral part of the magic circle which was drawn to protect the magician from evil spirits. In Goethe's *Faust*, Mephistopheles was prevented from leaving Faust's study because the pentagram was engraved in the doorway. (Part I, line 1394.) † Friedlein edition, p. 389.

‡ See M. Cantor, *Vorlesungen über die Geschichte der Mathematik*, II. 103–4.

§ See Ch. Henry, *Sur les deux plus anciens traités français d'algorisme et de géométrie* in *Bulletino Boncompagni*, XV. 56.

drawings in the famous sketchbook of the thirteenth-century architect Villard de Honnecourt in the Bibliothèque Nationale.

Bradwardinus, Archbishop of Canterbury (c. 1290–1349), begins his book on speculative geometry with interlaced triangles (figuris angulorum egredientibus).* The famous German mathematician Regiomantanus (1436–76) was interested in the angles of the five-pointed star. †

Charles de Bouvelles (1470–1553), who wrote on geometry both in French ‡ and in Latin, gives an illustrated description of the regular pentagon, showing that by drawing the diagonals another smaller pentagon is formed nearer the centre, and that by producing the sides of the pentagon a five-pointed star is formed. §

A problem which attracted much attention during the Renaissance was the construction of a regular pentagon with compasses set at a given distance, which was to remain unchanged throughout the performance. (See L. Olschki, *Geschichte der neusprachlichen Wissenschaften*, 1918, I. pp. 427–31.) Both Leonardo and Dürer were interested in the subject. Dürer's construction of the regular pentagon is the same as the one given in the *Geometria Deutsch*, an old German guide-book of applied geometry for the use of stonemasons and craftsmen. It is described in Dürer's treatise on practical geometry published in 1525 under the title of *Instruction in the Measurement with the Compass and Ruler of Lines, Surfaces and Solids, for the use of all lovers of art*. The construction of the regular pentagon given by Dürer was much discussed by the mathematicians of the sixteenth century, and Pietro Antonio Cataldi, who was a member of the Academy of Design in Florence, devoted a separate treatise to the subject : P. A. Cataldi, *Trattato geometrico dove si essamina il modo di formare il pentagono sopra una linea retta, descritto da Alberto Durero*, Bologna, 1570. Galilei in his lectures on military architecture said, " Il modo di descrivere il pentagono lo piglierem da Alberto Dürer."

The regular decagon.

The radius of the circle is related to the side of the inscribed decagon in the divine proportion. (Compare Euclid XIII. 9.)

Fig. 12. Divide the circumference of a circle into ten equal parts at A B C D E F G H I K and join these points.

A regular decagon is described.

Join the five diameters and let O be the centre.

* M. Cantor, II. pp. 114–15. † M. Cantor, II. p. 277.

‡ *Livre singulier et utile touchant l'art et pratique de géometrie* (1542 ; other editions 1547, 1551, 1557, 1608).

§ M. Cantor, II. pp. 380–81.

The radius O A is related to the side of the decagon A B in the divine proportion, and each of the ten radii is similarly related to each of the ten sides. (Compare Euclid XIII. 9.)

If B and E are joined, B E is a diagonal of the decagon and is related to the radius in the divine proportion.

Therefore in a regular decagon, the side is to the radius as the radius is to the diagonal.

Fig. 13. This figure shows four concentric circles. The radius of the second circle O A″ = A′ B′, the side of a decagon inscribed in the first circle.

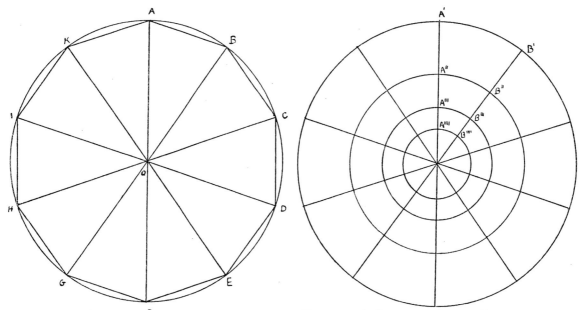

FIG. 12.—THE REGULAR DECAGON IN A CIRCLE. FIG. 13.—A SERIES OF CIRCLES RELATED IN THE DIVINE PROPORTION.

The radius of the third circle O A‴, = A″ B″, the side of the decagon inscribed in the second circle.

And again the radius of the fourth circle O A″″ = A′″ B‴, the side of the decagon inscribed in the third circle.

The radii of the four circles are related in the divine proportion. (Compare Euclid XIII. 9.)

$$\mathrm{O\ A' : O\ A'' :: O\ A'' : O\ A''' :: O\ A''' : O\ A''''}$$

and the diameters and circumferences of these circles are similarly related.

The process can be continued indefinitely and a progressive series of circles described whose radii are related in the divine proportion.

What was said of the previous design can be said also of this one. It is a very convenient way of introducing the divine proportion inside the circle. The design is so simple. It is suggestive of waves extending in ever larger circles when a pebble is thrown on the still water of a pond. But we may go one step further. We may regard these circles as sections of spheres. The figure then has three-dimensional significance. It represents both the plan and the cross-section of a progressive series of concentric spheres with radii related in the divine proportion.

The series may be continued towards the centre until the spheres, ever diminishing, become so infinitesimally small as to be hardly distinguishable from a point, or they may extend outwards in rhythmic progression, ever increasing until they enclose the stars.

The idea of concentric spheres fascinated many a philosopher. It was adopted by astronomers to explain the motion of the planets. Eudoxos, a contemporary of Plato, invented a beautiful theory of twenty-seven or more concentric spheres; * while the later Ptolemaic system conceived nine spheres concentric with the earth, which was fixed at the centre.

* Simplicius, *Commentary on Aristotle, De Caelo*, II.

CHAPTER V

RHYTHMIC DIVISION OF SPACE IN ART

THE geometric figures which were described in the last chapter lend themselves exceedingly well to artistic purposes. In Fig. 13 the divine proportion is registered along the radii and shapes the successive areas or compartments enclosed between the radii accordingly. This figure may therefore be used for simple linear measurement as well as for spacing. We have here a supple and precise instru-

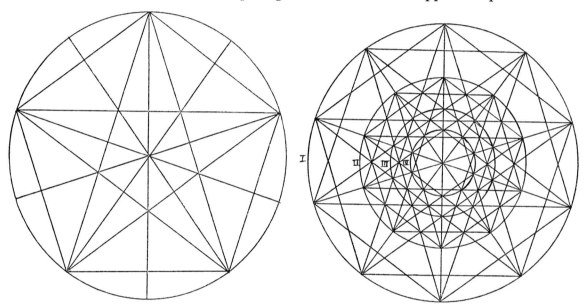

FIG. 14.—THE REGULAR PENTAGON AND DECAGON IN A CIRCLE.

FIG. 15.—A SERIES OF CIRCLES WITH PENTAGONS INSCRIBED.

ment by which the sizes and the positions of figures can be harmoniously related to one another in a composition. In Fig. 14 a regular pentagon is inscribed in a circle and the circumference is divided into ten equal parts by the five diameters. The geometric properties of Figs. 10 and 12 are here combined. Every line and every section is a term in a progressive series, and everywhere the divine proportion dominates. The five-pointed star of Pythagoras stands out clearly from the network of lines.

Fig. 15 is an extension of Fig. 14. It represents a progressive series of four concentric

circles with pentagons inscribed. The number of circles may be increased or diminished to suit the artist ; and the size of the circles can be adapted to any given space.

It will be shown below that Figs. 14 and 15 formed the basis of artistic compositions. They are well adapted for this purpose, because a composition is generally grouped around a centre, and balanced on either side of a central axis. Let us in this connection review briefly the principles of balance in pictorial composition as set down by the well-known theorist Denman W. Ross ; for it will help us to realize the usefulness of our diagrams.

As a rule a composition is balanced on the vertical axis. Sometimes the balance is symmetrical and sometimes it is unsymmetrical. A symmetrical balance is created by taking any arrangement and inverting it, so that it and the inversion are seen side by side, right and left of the vertical axis. Unsymmetrical balance is less obvious, but the following general rules may be observed :—(a) Equal forces of attraction balance on opposite directions at equal distances from the centre. (b) Unequal forces of attraction balance in opposite directions but at distances which are inversely proportional ; that is to say, a large shape some distance away from the centre may be balanced on the opposite side by a smaller shape which is placed nearer the centre. (c) Inclinations are balanced on the vertical axis ; for instance, an inclination to the right is counterbalanced by an inclination to the left on the other side of the axis. (d) When a composition is balanced on the vertical central axis, the centre which lies on the axis may be shifted up or down with all the forces of attraction balancing on it.*

Some familiar works by great masters are reproduced below with our diagram printed over them. As a rule the diameter of the largest circle was made equal to the width of the picture. It was then found that the height of the picture is often equal to a measure composed of sections of the same diameter. It will be seen that the compositions are spaced around the centre of the circles and that the movements follow the direction of the geometric lines. The size of the figures and other important measures correspond to the lengths of the radii. In religious pictures the nimbi and aureoles are related to the diameters or radii of the circles (see p. 93).

In architecture and pottery the same diagram served for proportioning both plan and elevation. By this device compositions were knit together and proportions regulated. One harmonious scheme pervaded the whole structure. By describing his design into these related concentric circles the artist placed it, so to speak, into proportioned space, just as a musician composed his melody into the rhythmic beat of time.

The theory must not be pushed too far. If Giotto could draw a perfect circle with a

* Denman W. Ross, *Drawing and Painting*, 1912, pp. 73-79.

free sweep of his hand,* he could surely also balance his compositions without the aiding lines of geometry. Many artists would probably follow the laws of proportion and composition approximately without resorting to diagrams. Thus Carel Van Mander, writing in the seventeenth century, refers to the scheme being used in a general way, saying that many painters took special care to inscribe their compositions in a circle (see p. 117). Others would be more accurate. There is an Italian pen-drawing in the British Museum which seems to prove that the diagram of Fig. 14 was used as described. Three half-length figures are drawn into a circle into which a regular pentagon is inscribed. The lines of the geometric diagram are annotated with measurements indicating approximately their relative lengths. It evidently was the artist's intention to demonstrate a geometric scheme, and the way in which the pentagon is placed over the three figures shows that it served as a diagram in artistic compositions. (See Plate II.†)

Moreover, the figure was known, and there are repeated references to it in classic literature. For Plato referred to it in the *Timæus*, and playfully suggested that God used it to paint the universe, and Plato's numerous commentators wondered what he meant (see p. 34).

* Vasari, *Vite*, ed. Milanesi, I. 383. † See frontispiece.

CHAPTER VI

TIMÆUS

THE *Timæus* was written at the end of Plato's life and differs both as regards form and subject-matter from his earlier work. While in his former dialogues Sokrates figures as the teacher in a circle of friends, who contribute to the discussion and sift the argument together ; in the *Timæus* the revered Sokrates is found among the respectful listeners, and the part of the chief spokesman is given to Timæus, a distinguished Pythagorean, well known in Plato's time. A high tribute is thus paid to Pythagoras, in whose spirit the whole work is conceived. Moreover, there is no room for discussion, for as soon as Timæus begins to speak the dialogue turns into a monologue, and talking like a seer who divines the eternal order of things, he proceeds without interruption to give an account of the Creation, which reads like an epic poem, and which in grandeur of conception has resemblance to the Pythagorean theory of the harmony of the spheres.

The dialogue opens in a mythical strain with the story of Atlantis. We are told of an island, situated beyond the pillars of Herakles, of which the civilization was far superior to anything that the Greeks had attained. The countries stretching along the coast of the Mediterranean Sea as far as Egypt were subject to it. And all this wonderful world, representing thousands of years of human effort and development, was submerged into the sea in one single frightful day and night by floods and earthquakes. Egypt alone survived the general catastrophe ; for being without rain the country was not visited by floods. Thanks to this circumstance it was the only country where the old traditions were not submerged, and they were carefully preserved and handed down from generation to generation by the priesthood.

This story, suggestive as it is of the continual warfare between the blind forces of nature and the powers of law and order, forms a fitting background to what follows. Indeed the stage could not have been more appropriately set for a drama which opens with the inquiry : " What is that which is eternally and has no becoming, and again, what is that which comes to be and is never ? "

a. *Creation by Geometry.*

The parts of the *Timæus* which concern us here are contained in paragraphs 31 to 34 and 49 to 55. They deal with the configuration of the four elements and with their spatial distribution inside the sphere. Indeed this chapter of the Creation is a pictorial representation of geometry at work on the great problem of shaping the universe. It may strike many readers as fantastic. Yet in the opinion of a great modern scientist " the way in which the elements are built out of molecules corresponding in their configuration to the regular solids, and the explanation of their transmutation into one another based on the geometric construction of these figures, has resemblance to the scientific theories of to-day." *

The four elements were separated out of the primitive matter, and were formed into molecules corresponding in shape to the first four regular solids.† These molecules were so small that they could not be discerned by the eye. Fire took the shape of the tetrahedron, earth that of the cube, air that of the octahedron, and water that of the icosahedron.‡

FIG. 16.—SIX EQUILATERAL TRIANGLES ABOUT A POINT.

* See R. W. Livingstone, *Legacy of Greece*, 1921, p. 83. † 53-55.

‡ The five regular solids, known also under the name of Platonic solids, have for centuries fascinated philosophers and artists. They are regular polyhedra, having their faces all equal regular polygons and all their solid angles equal. The origin of the speculations about them can be traced in the theorem, attributed to the Pythagoreans, that the plane around a point is completely filled by six equilateral triangles or by four squares (Figs. 16 and 17). The sum of the faces of a solid angle must therefore be less than this combination, that is to say, it must be less than four right angles, or less than 360°. But a solid angle must have at least three faces. Therefore solid angles can be built with the following regular polygons :

I. With equilateral triangles.

Since each angle of an equilateral triangle is 60°, we may form a solid angle by combining either three, four or five equilateral triangles. Therefore three regular solids can be bounded by equilateral triangles.

II. With squares.

Since each angle of a square is 90°, we may form a solid angle by combining three squares ; but not more

The faces of these four solids are either equilateral triangles or squares. Each of the squares, which formed the cube, and each equilateral triangle, which went into the composition of the tetrahedron, octahedron and icosahedron, was composed of a number of right-angled triangles, which constituted the elementary forms of all material things, and which were conceived as lying around a point in a plane, which they completely fill.

FIG. 17.—FOUR SQUARES ABOUT A POINT.

The square was formed (Fig. 23) of four right-angled isosceles triangles ; and the equilateral triangle was composed of a particular scalene right-angled triangle, which

than three squares can be combined to form a solid angle. Therefore only one regular solid can be bounded by squares.

III. With regular pentagons.

Since each angle of a regular pentagon is 108°, we may form a solid angle by combining three regular pentagons. Not more than three pentagons can be combined to form a solid angle, and therefore only one regular solid can be bounded by regular pentagons.

IV. With other regular polygons.

Since each angle of a regular hexagon is 120°, no solid angle can be formed by combining regular hexagons ; and therefore no regular solid can be bounded by hexagons and no regular solid can be bounded by regular polygons of more than six sides.

Therefore not more than five regular solids are possible.

Figs. 18–22 display the number and the shape of the faces of each of the five regular solids. In order better to visualize the shapes, models may be made by drawing these diagrams on cardboard and cutting them out along the outer line.

FIG. 18.—THE FACES
OF A TETRAHEDRON.

FIG. 19.—THE FACES OF A CUBE.

FIG. 20.—THE FACES OF AN
OCTAHEDRON.

FIG. 21.—THE FACES OF AN ICOSAHEDRON.

FIG. 22.—THE FACES OF A DODECAHEDRON.

Timæus regards as very beautiful * (Fig. 24). Fire, air and water were all combinations of this scalene triangle and they could therefore by dissolution transmute and pass into one another. Earth, which was formed by the square, was the only element composed of isosceles right-angled triangles ; and differing from the other elements in geometrical composition it could not transmute into these but always remained itself.

Moreover, each of the four elements had a special region assigned to it within the all-inclusive sphere of the universe. They were arranged in four concentric layers. Earth occupied the centre ; surrounding it was a layer of water, then came a layer of air and finally a layer of fire.

This arrangement would seem to correspond with the following passages :

" Now God found the four elements without order either in relation of each thing

FIG. 23.—THE SQUARE DIVIDED INTO
RIGHT-ANGLED TRIANGLES.

FIG. 24.—THE EQUILATERAL TRIANGLE
DIVIDED INTO RIGHT-ANGLED TRIANGLES.

to itself or of one to another, and he introduced proportion among them in as many kinds and ways as it was possible for them to be proportionate and harmonious " (69).

" . . . And he set air and water between fire and earth, making them as far as possible exactly proportional, so that fire is to air as air is to water, and as air is to water, water is to earth. Thus the body of the universe was created out of four elements being brought into concord through proportion . . . and God fashioned it as one whole and assigned to it its proper shape. To that which is to comprehend all bodies in itself that shape seems proper, which comprehends in itself all shapes that are. Wherefore he turned it of a rounded and spherical shape, having its boundary surface in all points at an equal distance from the centre. This being the most perfect and regular shape " (32–33).

However, the molecules of the four elements could not remain in the regions thus assigned to them inside the sphere, because they were continually shaken out and mixed

* An isosceles triangle has two sides equal ; a scalene triangle has no two sides equal.

by the rotation of the sphere; and as the various elements came into contact with each other they transmuted according to the character of their " atomic triangles." It was, however, the nature of each atom to try and return to the region originally assigned to it. That was so to speak its law of gravitation (56–58).

By these combinations and transmutations, and by these movements to and from the centre the manifold and various forms of matter were created.

Account was given above of four regular solids. There remained a fifth, the dode-cahedron. It was considered to be the most beautiful of the five because most like the sphere. It comes next to the sphere in capacity, and it shares with the sphere the quality of being able to contain the other four solids.* The question presents itself : What function was ascribed to the dodecahedron in Plato's cosmos ? After having assigned a regular solid to each of the four elements, Timæus continues : " Whereas a fifth figure yet alone remained, God used it to paint ($\delta\iota\alpha\zeta\omega\gamma\rho\alpha\phi\hat{\omega}\nu$) the universe " (55). The meaning of this passage has given rise to much speculation, because Plato gives no further details nor explanations. Later Greek philosophers,† however, assign the dodecahedron to the fifth element, which they call ether or heaven. In turning to the writings of Aristotle ‡ we find that he also makes a distinction between the four elements of earth, water, air, and fire on the one hand, which are described as belonging to the transitory world, while the ethereal fifth element is a thing apart. It is described as the only divine element in matter. In Orphic religious ideas ether was conceived as the pure empyrean substance from which the soul of man derives. His body is of the earth, but his soul is " from the celestial element." § " Man is the child of earth and starry heaven." ‖ Also according to Plato the immortal soul soars into heaven, but the mortal drops her plumes and settles on earth.¶ To Plato the fifth solid may therefore also have stood for something apart.**

* According to Pseudo-Plutarch (*Plac.* II. 6) the dodecahedron was the symbol of the sphere of the universe. Philolaos in Stobaius (I. 10) calls it the cargoship of the sphere.

† Xenokrates, Speusippos, Simplicius, the Epinomis. See Zeller, *History of Philosophy*, I. 373, II. 1, 951. 1923. ‡ Aristotle, *De cælo*, I. 2–3.

§ $\dot{\alpha}\pi'$ $\alpha\dot{\iota}\theta\acute{\epsilon}\rho\sigma$ $\dot{\epsilon}\rho\rho\acute{\iota}\zeta\omega\tau\alpha\iota$. Quoted by Gruppe, *Griech Myth*, p. 1035.

‖ $\tau\acute{\iota}s$ δ' $\dot{\epsilon}\sigma\acute{\iota}$; $\pi\hat{\omega}$ δ' $\dot{\epsilon}\sigma\acute{\iota}$; $\gamma\hat{\alpha}s$ $\upsilon\acute{\iota}\acute{o}s$ $\mathring{\eta}\mu\iota$ $\kappa\alpha\grave{\iota}$ $\dot{\omega}\rho\alpha\nu\hat{\omega}$ $\dot{\alpha}\sigma\tau\epsilon\rho\acute{o}\epsilon\nu\tau\sigma s$. Inscription on a gold tablet from Eleuthernai in Crete. The same passage occurs on an Orphic Tablet, probably of the third century, B.C., found at Petelia in South Italy, and now in the British Museum. H. Diels, *Die Fragmente der Vorsokratiker*, II. p. 175. ¶ *Phædrus*, 246.

** It is interesting in this connection to note that according to modern scientific research the pentagonal formation is distinct from other forms of symmetry in that it occurs in organic nature only. F. M. Jaeger in his *Lectures on the Principles of Symmetry*, 1917, p. 195, says : " A certain preference for pentagonal symmetry both in the case of animals and of plants seems to exist, a symmetry closely related to the important ratio of the golden section and unknown in the world of inanimate matter."

See also Prof. D'Arcy Thompson, *On Growth and Form*, 1917, p. 480.

But keeping a discreet silence about this part of his theory, he passes on to another line of argument and does not proceed to split the faces of the dodecahedron into elementary rectangular triangles, as he had done in the case of the other. However, various references in classic literature show that the pentagon lends itself to a similar treatment to the square and that of equilateral triangle, and that the solution of the problem was known. Plutarch says that the twelve pentagons of the dodecahedron are each made of thirty elementary triangles (*Platon. Quæst.* V), and that these triangles differ from those of the other four regular solids (*De Defectu Oraculorum*, XXXIII); and "Alkinous" speaks of each pentagon being divided into five isosceles triangles and each of the latter into six scalene triangles (*De Doctrina Platonis*, C. XI). If these instructions are carried out, Fig. 25 is obtained.* The pentagon is here divided into thirty right-angled triangles; and regard is paid to the conception that these triangles must lie around points in a plane, which they completely fill.† But this figure is familiar. The five-pointed star of Pythagoras stands out prominently in the network of lines; and the whole con-

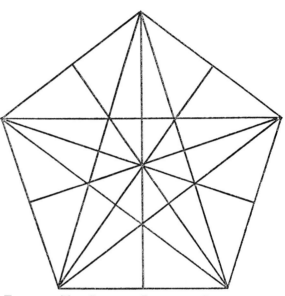

FIG. 25.—THE REGULAR PENTAGON DIVIDED INTO RIGHT-ANGLED TRIANGLES.

struction is, in fact, a repetition of Fig. 14 which was described on p. 26 as a useful instrument for the rhythmic division of space.

Plato did not conceive of the universe as a geometric shape only; he conceived it as a living body inhabited by a spirit: " God made its surface smooth and even, everywhere equally distant from the centre, a body whole and perfect out of perfect bodies. And God set soul in the midst thereof and spread her through all its body, and even wrapped the body about with her from without, and he made it a sphere in a circle revolving, a universe one and alone; God made soul in birth and in excellence earlier and elder than body, to be its mistress and governor, and he framed her out of the following elements

* Fra Luca Pacioli described this figure in his *De Divina Proportione* (C. 55) but the illustration accompanying his text is incorrect, the composing triangles not being rectangular. He ascribed the dodecahedron to heaven: " As heaven is the receptacle of all things, so the dodecahedron is the place of abode of the first four regular solids." On the authority of "Alkinous" he identified the twelve faces of the dodecahedron with the signs of the Zodiac. † Sir Thomas Heath, *The Thirteen Books of Euclid*, II. 98.

and in the following way. From the undivided and ever-changeless substance and that which becomes divided in material bodies, of both these he mingled in the third place the form of substance in the midst between the Same and the Other, and taking them, three in number, he blended them into one form, forcing the nature of the Other hard as it was to mingle into union with the Same " . . . (34–35).

The terms " the Other " and " the Same " stand for the principle of unity and the principle of difference ; and from the blending of the two emerges substance, a blending made in a proportion as definite as musical and mathematical harmony.

" Now after that the framing of the soul was finished to the mind of him that framed her, next he fashioned within her all that is bodily and drew them together and fitted them middle to middle. And from the midst even unto the ends of heaven she was woven in everywhere. Now the body of the universe has been created visible, but she is invisible, and she, even the soul, has part in reason and harmony. And whereas she is made by the best of all whereunto belong reason (λόγος) and eternal being, so she is the best of all that is brought into being. Therefore, since she is formed of the nature of Same and of Other and of Substance of these three portions blended, in due proportion divided and bound together, and turns about and returns into herself, whenever she touches aught that has manifold existence or aught that has undivided, she is stirred through all her substance, and she tells that wherewith the thing is the same and that wherefrom it is different, and in what relation or place or manner or time it comes to pass both in the region of the changing and in the region of the changeless that each thing affects another and is affected " (37).

The soul appears as a mediation between the spirit and sensuous nature, in that it receives the eternal truths from the former, but lives its life in the latter. Similarly, in Plato's theories of the State and of Nature, opposites are connected by intermediate links and all phenomena arranged in a graded series. The beautiful becomes a connecting link between pure spirit and the sensuous world, inasmuch as order, proportion and harmony dominate both worlds and give also to the latter a share in divinity.

b. The " Timæus " in Christian Cosmology.

The *Timæus* seems possessed of some mysterious power of regeneration. None of Plato's dialogues had greater influence on the development of philosophy. It was at all times looked upon as the gospel of Platonism, and was constantly quoted and studied wherever Platonic ideas took root. Although conceived as a myth, it was its fortune from the very first to be treated as if it were a scientific treatise.

The story is profound and its meaning often obscure. But mysticism and obscurity did not deter students ; on the contrary, they contributed to the fascination, and constituted a fruitful source of speculation. Endless commentaries were written ; indeed, the controversy about the interpretation of certain passages has continued through the ages down to the present day.

Platonists and the philosophers of the school of Alexandria delighted in elucidating and amplifying the ideas of their master. They deduced from his writings the doctrine of the divine triplicity.* The Christian doctrine of the Trinity appeared to have been in some respects foreseen by Plato in the *Timæus*.†

In the Byzantine paintings of Mount Athos he appears amongst the Pagans who had a partial knowledge of the truth. He is represented as an old man with a long beard who seems to be uttering the following words, painted on a scroll in his hand : " The old is new and the new old, the Father is in the Son and the Son is in the Father. The Unity is divided into Three, and the Trinity reunited into One." These are not the actual words of Plato, but they are here attributed to him as representing his teaching.

Writing in the second century A.D., Justin Martyr claimed Plato as a Christian before Christ, and Athenagoras called him the best of the forerunners of Christianity. There is indeed a natural affinity between Christian thought and Platonism, and during the early and formative period of the Church the philosophic side of Christian speculation was continuously under Platonic and Neoplatonic influences. To prove this we need but mention a few authorities. Clement of Alexandria (end of second century), his disciple Origen, and Gregory of Nazianzus (fourth century) were imbued with Platonism ; and so was Augustine, whose thought dominated the Western Church. At the end of the fifth century the Neoplatonic writings of the Pseudo-Dionysius gained currency in the Christian world under the name of Paul's Athenian convert, Dionysius the Areopagite.

With Christian Platonists the *Timæus* took rank as a scientific and theological authority along with the Book of Genesis. According to Origen the universe is to be thought of as an immense living being which is held together by one soul, the Logos of God, and all existence is drawn upwards towards God by a kind of centripetal attraction which is unconscious in the lower and half-conscious in the higher organisms.

Early Christian writers adopted the theory of the four elements, subordinating it to the story of the Creation in the Book of Genesis. In the opening sentence : " In the beginning God created heaven and earth," the term " earth " was interpreted as standing

* Jules Simon, *Études sur la Théodicée de Platon et d'Aristote*, p. 149.

† See A. N. Didron, *Christian Iconography*, II. p. 1 f. ; P. H. Wicksteed, *The Reactions between Dogma and Philosophy*, p. 262.

for all the four elements—earth, water, air and fire—as contrasted with heaven. The theory then passed into the dogmatic system of mediæval theology in such a form that heaven was considered a fifth element apart from the four others.*

The theory was also applied to the constitution of the human body,† which, in accordance with the teaching of Greek medicine, was composed of the four elements. Origen identified earth with the flesh, air with the breath, water with the moisture and fire with the heat of the human body.‡ It was thought that when the soul leaves the body the several elements were dissipated and returned to their kind, but that by divine power they would on the day of resurrection be gathered together again even if no burial had been accorded.§

Therefore, in the opinion of Christian communities the martyrs of Lyons and Vienne, who in the year 177 were burnt and whose ashes were scattered into the River Rhone, were nevertheless sure of a bodily resurrection,|| and Gregory of Nazianzus ¶ gives expression to the same idea when he says : " If you wish, let my body be consumed by fire, and scatter its ashes into the air or throw it on to the rocks or let it rot in rivers or in rain. I shall nevertheless not be forgotten ; for on the last day all will be gathered together from the ends of the earth by the wish of God."

During the Middle Ages the extent of knowledge of ancient philosophy was limited by the fact that till the twelfth century the West was ignorant of Greek, and possessed no philosophical works in the Greek original. In translations they had only some works of Aristotle, and the *Timæus* of Plato in the version of Chalcidius (sixth century). The first centuries of the Middle Ages chiefly followed Neoplatonism.

During the time when the great cathedrals were being raised in France, Chartres was a centre of a school of philosophy which stood for the revival of Platonism. Bernard of Chartres was the most distinguished Platonist scholar at the beginning of the twelfth century. His writings were indeed little more than a poetic interpretation of the *Timæus*. However, after the twelfth century all of the Aristotelian writings gradually became known by the devious path of the Mahometan world. They stirred the minds of Christian scholars, and it was felt that Aristotle's carefully elaborated system with its scientific technique must be incorporated in the Christian order. This task was undertaken by the great scholastic philosophers, particularly by Albert the Great and Thomas Aquinas,

* John of Damasc., *De fid. orthod.*, II. 5.
Thomas Aquinas, *Summa Theol.*, Pt. I. qu. 66, arts. 1 respons. ad 2.
† Plato, *Philebus*, 52. Ferdinand Piper, *Mythologie der christlichen Kunst*, I. 2, p. 90.
‡ Origen, *De resurrect.*, Opus I, p. 36. § Minucius Felix, *Octav.*, c. 34.
|| Euseb., *Hist. Eccl.*, V. i. p. 210, ed. Read.
¶ Gregor. Naz., *Carm. ad se ipsum per interrog. et respons*, v. 21, Opus II, p. 914.

PLATE III

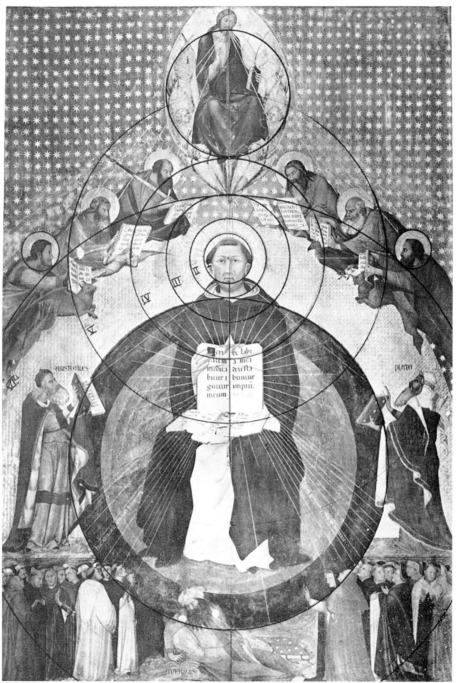

Traini

Photo. Alinari

ST. THOMAS AQUINAS
(Santa Caterina, Pisa)

his famous disciple. Henceforth both Plato and Aristotle were considered necessary to the perfect philosopher.*

The importance which mediæval scholasticism attached to both philosophers is illustrated in a picture by Traini in the church of Santa Caterina at Pisa, where St. Thomas Aquinas is represented with books on his lap whence luminous rays are streaming down on the Christian people below. Plato and Aristotle are standing on either side holding up books from which rays converge on the head of the saint. Above, Christ is seen sending forth similar rays. Rays also converge from the writings of the four evangelists, of St. Paul and of Moses towards the head of the Saint. The works of the two Greek philosophers were manifestly acknowledged sources of inspiration. (Plate III.)

Platonic ideas found expression in Christian iconography. We find an interesting illustration of the theory that the four elements were assigned to a series of concentric rings in a fresco by Pietro di Puccio in the Campo Santo of Pisa, where God the Father is represented as holding a large circular disk, which is divided into a series of concentric circles. The innermost circle is assigned to the earth ; then follow three rings marked water, air and fire respectively in the order assigned to them in the *Timæus ;* and these are followed by the rings of heaven. Below this picture the artist wrote a sonnet of which the first verse is as follows :

> " Voi che avvisate questa dipintura
> Di Dio pietoso sommo creatore
> Lo qual fe tutte cose con amore
> Pesate, numerate ed in misura." †

Also the conception that the universe was a sphere found its way into Christian iconography. We constantly meet with it in pictures and illuminations, where a globe is placed in the hands of the Deity and sometimes beneath the feet.

St. Thomas Aquinas accepted the Ptolemaic astronomical system with its nine concentric spheres and superimposed epicycles which had superseded the earlier invention of twenty-seven or more spheres by Eudoxos. Dante, in whose work the theology and philosophy of the Middle Ages found poetic expression, gives a description of ten concentric spheres of heaven both in the *Convivio* and in the *Divina Commedia.* Nine spheres are conceived as revolving round the earth as centre, and a tenth sphere, the motionless

* Albertus Magnus, Liber I, Metaphysicorum V, XV.
† " Ye who see this image of God,
 The Merciful High Creator,
 Who by his love fashioned all things
 With due weight, order, and measure."
 See Vasari, *Vite I*, p. 513, ed. Milanesi.

empyrean, the heaven of flame, the divinest heaven, the heaven of rest encircling and containing all. Thus the astronomical spheres of the Greeks were enshrined in a Christian heaven.

The thirteenth century is characterized by an alliance between Aristotelianism and Catholic theology. For Dante, although he frequently cites Plato, Aristotle comes first ; he is " il maestro di color che sanno," * the master of those who know.

Petrarch, on the other hand, heralding the dawn of the Renaissance, enthroned Plato in the place of philosophical supremacy.

> " . . . vidi Plato,
> Che 'n quella schiera andò piu presso al segno
> Al quale aggiunge a chi dal Cielo e dato.
> Aristotele poi, pien d'alto ingegno." †

c. *Plato and the Renaissance.*

While Aristotle was generally held in greater favour by scholastics of the Middle Ages, Plato was more highly esteemed during the Renaissance ; for Florence, at that time the fountain-head of æsthetic culture, espoused his cause. The council for the reconciliation of the Greek and Latin Churches which met at Ferrara in 1438 and moved to Florence in the following year brought many a Greek scholar to Italy. Among these was the venerable Georgius Gemistus, an ardent Neo-Platonist, who at the instigation of Cosimo de Medici wrote a treatise comparing the rival systems of Plato and Aristotle and giving preference to the former. After returning to his own country, he died, at Mistra some years later. His ashes were brought to Italy by Sigismondo Malatesta, when, in command of the Venetian forces in the Morea, he captured Mistra from the Turks in 1465. Meanwhile, the seeds that Gemistus had sown in Florence bore fruit. Cosimo de Medici resolved to make his city the centre of Platonic learning. In 1463 he commissioned Marsilio Ficino to translate Plato's *Dialogues* into Latin, and gave him a farm near his Villa at Careggi and a house in Florence that he might devote himself to his work at ease.

Cosimo died the year after, and as he lay on his death-bed, Marsilio comforted his last hours with readings from Plato.

" He quitted life soon after I had read with him Plato's book on the origin of the

* *Inferno*, IV. 131.

† " I saw Plato,
 Who in that band walked nearest to the ensign
 Of Wisdom, a favour by heaven bestowed.
 Then came Aristotle, of high intellect."
 Trionfo della Fama, III. 4–7.

universe, as though now in very deed to possess the fullness of that good, which he had tasted during our conversation." *

The country-place at Careggi became the centre of a Platonic Academy which attracted men of letters from all over Italy. An outstanding figure among these was Pico della Mirandola, a younger son of an old Lombard house, who came to Florence in 1479 at the age of seventeen. His great beauty and his enthusiasm won him the heart of Lorenzo de Medici. After much study and many wanderings, he conceived the idea of harmonizing Christian theology and pagan philosophy—undertaking this gigantic task with the light-hearted confidence of youth. The problem was essentially the same as that on which the great scholars of the Middle Ages had worked with the difference that, whereas the older thinkers had but imperfect knowledge of ancient philosophical writings, Pico had access to the great intellectual acquisitions of the Renaissance. His erudition was drawn from the most diverse sources. He had studied Aristotle, Plato and the Neo-Platonists. He was at home in Scholasticism and in occult science. In 1486 he challenged the world at Rome to a philosophical tournament concerning his nine hundred conclusions. But the Church declared thirteen of these heretical. Pico retired to a villa near Fiesole and there he composed his *Heptaplus*, or Discourse on the Seven Days of Creation, in which he attempted to reconcile the *Timæus* with the Book of Genesis. It was published in 1489.

In common with nearly all mediæval speculation, Pico placed the earth in the centre of the universe ; around it the sun, the moon and the stars revolved. His world was planned like that circular map in the fresco of the Campo Santo at Pisa, described above (see p. 39). The consummation of the Creation was man—" The interpreter of Nature." " It is a commonplace of the schools," says Pico, " that man is a microcosm, in which we may discern a body mingled of earthly elements and ethereal breath." †

The *Heptaplus* was dedicated to Lorenzo the Magnificent, who, himself an ardent student, once expressed the opinion that without the study of Plato neither good citizenship nor enlightened understanding of the Christian doctrines was possible. ‡

The art of the time has a similar tendency to effect a reconciliation between the Christian and the pagan worlds. In the background of his picture of the Madonna in the Uffizi, Michelangelo represented the pagan world, and with it the unveiled human form, a narrow channel dividing it from the Christian foreground ; and the child-figure of the Baptist is seen leading the way across from one world to the other.

The monk Luca Pacioli identified his God with Plato's deity, when, explaining the

* Marsilio Ficino, *Opera*, Basle, 1576, I. p. 649.

† *Heptaplus*, Prohemium. ‡ Valori, *Vita Laurentii Medicis*, Florence, 1847, p. 164.

title of his treatise *De Divina Proportione*, he affirmed that the proportion stood for both Unity and Trinity; and then proceeded: " As God brought into being the celestial virtue, the fifth essence, and through it created the other four solids, namely, the four elements earth, water, air and fire, and formed out of these all natural objects; so our sacred proportion gave shape to heaven itself, in assigning to it the dodecahedron, or the solid of twelve pentagons, which cannot be constructed without our sacred proportion. As the aged Plato described in his *Timæus*." *

We are therefore not surprised to find that, when Raphael painted his great fresco of the School of Athens in the Vatican, he represented Plato holding the *Timæus* in his hand (see Plate XXI). The book thus found a place of honour inside the palac eof the Pope, in accordance with the important part which it had played in Christian cosmology.

* Chapter V.

CHAPTER VII

EGYPT

WE have shown above by various references in classic literature that the divine proportion was known to Pythagoras in the sixth century B.C. There are no written records by which we can trace it still further back to its origin. We know, however, that Pythagoras derived his geometry from Egypt. Egypt according to Eudemus and Herodotos * was the birthplace of this science, which arose from the need of surveying the lands inundated by the floods of the Nile ; hence the name geometry, " the measuring of the earth." The men entrusted with these tasks must have attained great proficiency for the Greek philosopher Demokritos to boast that " no one in his time could surpass him in constructing figures with lines and in proving their properties, not even the Harpedonaptai † of Egypt." ‡ But we know as yet very little about Egyptian mathematics. An ancient text in the British Museum dated about 1600 B.C. and known by the name of the " Rhind mathematical papyrus " § constitutes our principal source of knowledge. Here among other things, such as practical hints for the measurement of volumes and areas, we also find notations on the proportions of pyramids and other monuments with sloping sides, the height of the monument being invariably taken as the starting-point of calculations. For want of further evidence Egyptologists are now inclined to believe that the ancients exaggerated the debt of the Greek mathematicians to Egypt. But the belief which is generally held, that for the Egyptians geometry was merely an auxiliary to surveying, may have to be revised, for it does not take into account the construction of the artistic monuments in the country, which reveal a deeper insight into mathematics. On these carved blocks of stone we can trace the divine proportion back to the very dawn of civilization. This comes as a revelation ; for in the history of mathematics, founded on written documents alone, such ancient derivation has never been suggested.‖ Was

* Proclus, p. 65. Herodotus II, 109.
† See p. 15, footnote. ‡ Clemens Alexandrinus, *Stromata*, ed. Potter, I, 357.
§ T. Eric Peet, *The Rhind Mathematical Papyrus.*
‖ The division of the circle by five diameters does not seem actually to occur on Egyptian reliefs or paintings. M. Cantor at least looked for it in vain in the representation of wheels, etc. However, Horapollon, a Greek writer of the fifth century A.D., mentions that a five-pointed star served as a hieroglyphic

43

the divine proportion adopted unconsciously by the sculptor or was he using it deliberately? We begin to wonder from where and how it came there.

The Egyptians were in possession of a powerful and monumental style, that later ages have not surpassed. Their relief work developed to a high degree of excellency by a long training in the carving of hieroglyphics; for their figurative writing was not merely a useful accomplishment, as writing is in our days, but took the form of decoration on their walls.

a. Plate IV. *Tombstone of an Egyptian King.* (Louvre.)

Carved in limestone. Total height: 1·45 m.; height of base: ·45 m.

This stele dates back to about 3200 B.C. It was erected at Abydos by the second successor of Menes, the founder of the first Dynasty, who is said to have built Memphis and to have united the ancient kingdoms of Upper and Lower Egypt under one sceptre. We are here taken back to the very beginning of history.

The falcon was the symbol of Horus, the deity from whom the dynastic line claimed to have sprung; and therefore the Pharaoh, representing in his hallowed person the ancient deity, bore the name of Horus. The names of the kings of the first Dynasty on their tombs at Abydos are almost exclusively " Horus Titles " in place of personal names. The king's title on this stele was " the snake," and a snake is carved on the so-called Horus banner. The pattern underneath it represents the doorway of the king's palace.

The geometric diagram consists of a progressive series of five concentric circles related in the divine proportion, the total height of the stele being taken as the diameter of the largest and first circle of the series. It will be found that the height of the field on which the design is carved measured on the right side = the diameter of circle II and that the width of the same field = the diameter of circle III, so that these three measures form a progressive series related in the divine proportion. The height of the base of the stele = the radius of circle II. The height of the stele above the base = radius I plus radius III.

The vertical axis of the design is shifted somewhat to the left to make room for the

sign for the number 5; and recent research has verified this striking fact to be true for the Græco-Roman period. M. Cantor, *Vorlesungen über die Geschichte der Mathematik*, 1922 edition, pp. 84, 109–10; Horapollon, *Hieroglyphica*, Lib. I. 13. In excavating an Ionian camp in Egypt Sir W. M. Flinders Petrie found the neck of a jar on which a five-pointed Pythagorean star is incised. The neck is sealed with the royal cartouche of Amasis (572–528 B.C.). (See *Ten Years' Digging in Egypt*, 1893, p. 60.)

PLATE IV

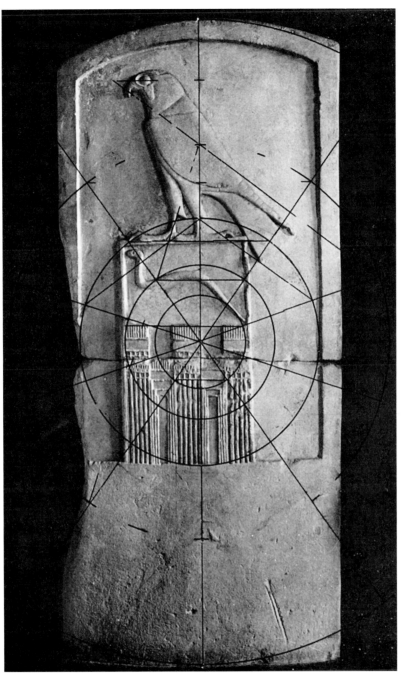

First Dynasty *Photo. Giraudon*

TOMBSTONE OF AN EGYPTIAN KING

(Louvre)

PLATE V

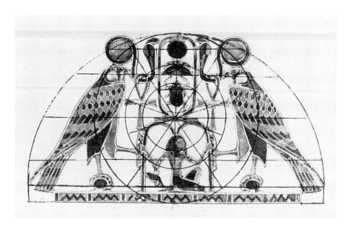

PECTORAL OF SENNSERT II
(Metropolitan Museum of Art, New York)

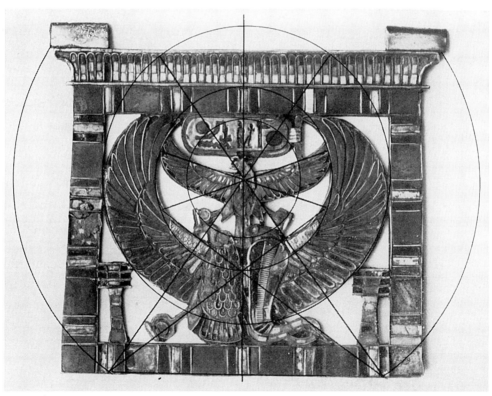

Photo. Archives Photographiques

PECTORAL OF KHAMUASIT
(Louvre)

falcon's tail on the right. The width of the falcon's pedestal, measured within its frame = radius of circle III; the gap between it and the outside frame corresponds to the radius of circle IV on the right side and to the radius of circle V on the left side. So that these three measures and the height of the base form a progressive series of four terms related in the divine proportion.

The height of the pedestal of the falcon = the diameter of the pentagon inscribed in circle III.

The height of the " king's palace " = the diameter of the pentagon inscribed in circle IV.

The height of the field on which the snake is carved = the diameter of the pentagon inscribed in circle V. So that these three measures are related in the divine proportion. The length of the snake = the diameter of the pentagon inscribed in circle IV.

The height of the falcon equals radius III plus radius V and is related in the divine proportion to the distance between the two outside claws of the bird, while the distance between the claws of its left foot forms the third term in this series. Thus the whole arrangement seems to conform to a geometric scheme based on the divine proportion.

b. Plate V. *Pectoral of Senusert II.* (Metropolitan Museum of New York.)

Total height: 4·5 cm.; total width: 8·2 cm.

The geometric diagram is based on a progressive series of four circles related in the divine proportion.

The total height = the diameter of circle I.

The diameter of the outer semicircle = twice the diameter of a pentagon inscribed in circle I and corresponds to the total width.

The distance between the standing legs of hawks = the diameter of circle I.

The height of the two looped amulets is related in the divine proportion to their width.

The height of the king's cartouche = radius I and its width equals half that radius.

The length of the plinth is related in the divine proportion to the height of the centrepiece.

The diagonals of the diagram correspond with the horizontal divisions of the pattern.

This piece of jewellery forms part of the " Treasure of Lahun " which was discovered by Sir W. M. Flinders Petrie in 1914, in the tomb of Sat-Hathor-Ant, an Egyptian princess, probably the daughter of Senusert II of the twelfth Dynasty who

reigned from 1906 to 1887 B.C., and near whose pyramid at Lahun she was buried. It is in perfect preservation and is perhaps the finest known example of Egyptian inlay with cut stones.

" In the centre is the king's cartouche, Kha-kheper-Ra. This is supported by the squatting man holding notched palm-branches, the group-symbol of a million years. From his right elbow hangs the tadpole, the hieroglyph for 100,000. Flanking these are the Horus-hawks, standing on the symbol of eternity, and wearing the solar-disk with uræus from which hangs the *ankh*. The whole design would then express the wish that the Sun-god may grant an eternity of years of life to the king." *

PLATE V. *Pectoral of Prince Khamuasit.* (Louvre.)

The geometric diagram is based on a progressive series of four concentric circles related in the divine proportion.

The diameter of the smallest circle corresponds to the length of the cartouche.

The next circle of the series fits into the outspread wings of the vulture ; while the third circle encloses these wings and corresponds to the total width of the design within the framework.

The outer circle determines this framework.

The pectoral belonged to a son of Rameses II of the XIX Dynasty, who reigned 1330 B.C.

In both these pectorals the various symbolic elements are combined by precise craftsmanship into compositions which partake of the distinction and monumental quality inherent in Egyptian art. The geometric foundation of the design contributes not a little to this effect.

* Guy Brunton, *Lahun I*, p. 28. London, 1920.

CHAPTER VIII

THE GREEK VASE

a. *Vase Forms.*

THE geometry of Athenian vases has recently been the subject of much controversy among American archæologists. The late Mr. J. Hambidge, who has devoted much study to the question, developed a theory according to which Greek design was connected with the areas of certain rectangles derived from the square.* One of these rectangles is based on the divine proportion and another is closely related to it. He was supported in this theory by Mr. L. D. Caskey, the curator of classical antiquities of the Museum of Fine Arts in Boston, by Prof. Denman Ross and others, while Prof. W. B. Dinsmoor of Columbia University and Prof. Rhys Carpenter were leaders of the opposition. Thanks to the interest which was thus aroused, a number of Greek vases were carefully measured and analysed, and it is owing to this circumstance that I was able to procure the measurements of the six vases of the Museum of Boston, which are reproduced below. They are selected from the number of vases which were subjected to careful analysis according to Mr. Hambidge's theory in L. D. Caskey's book, *The Geometry of Greek Vases*,† Boston, 1922. Mr. Caskey very kindly lent me his original, carefully measured life-size designs for my purpose.

Even before the publication of Mr. Hambidge's book, Monsieur Edmond Pottier ‡ had drawn attention to the beautiful proportions of the Greek vase, which seemed to him to partake of the character of Greek statuary. He remarked : " Les proportions

* For expositions of Hambidge's theories cf. J. Hambidge, *Dynamic Symmetry, the Greek Vase*, 1920; *the Diagonal*, 1919–20, edited by J. Hambidge.

† In his analysis of Greek works of art Mr. Hambidge generally used the so-called " whirling square " rectangle and the $\sqrt{5}$ rectangle. The sides of the " whirling square " rectangle are related to each other in the " divine proportion." In a series of three circles related in the " divine proportion," the radius of the second circle is to the sum of the radii of the first and third circles in the same proportion as the sides of the $\sqrt{5}$ rectangle are to one another. The theory here submitted is therefore related to Mr. Hambidge's careful analyses; it has, however, the advantage of a more universal and simpler application which makes it perhaps more adapted for the use of artists. The proportions of the $\sqrt{2}$ and $\sqrt{3}$ which Mr. Hambidge only uses very occasionally may be obtained by inscribing into a circle a square or an equilateral triangle, as the case may be. We have seen above (pp. 42–44) that these two figures formed part of the cosmology of Plato's *Timæus*. This part of Mr. Hambidge's theory may therefore also be considered as related to circle geometry. ‡ Catalogue des Vases Antiques du Louvre, 1906, Vol. III, p. 659.

des vases, les rapports des mesures entre les différentes parties de la poterie parraissent avoir été chez les Grecs l'objet de recherches minutieuses et délicates. Du même atelier on voit sortir des coupes qui, pour être semblables en apparence, n'en sont pas moins différentes par les nuances appréciables de structure. Je crois qu'un examen attentif du sujet menerait à des observations intéressantes sur ce qu'on pourrait appeler la géométrie de la céramique grècque." *

Greek vases offer unique opportunity for study. Their relatively small size facilitates the taking of exact measurements and they can therefore be conveniently analysed.

The making of pottery was one of the first artistic occupations of primitive man and dates back to the Neolithic age. Painted sherds of this period were found in Crete and Thessaly. The material out of which vessels were built no doubt contributed in educating a sense of form ; for clay is an ideal substance for modelling and positively invites plastic manipulation. Thus long before the days of monumental architecture, ceramics had paved the way towards an appreciation of formal arrangement. The potter's wheel was known in Greece since Minoan times ; and the beautifully articulated shapes of Athenian vases are the result of many centuries of gradual evolution, in which a dozen or so of strongly individualized types were created according to the various functions of vessels. Each type of vase has a long history of its own and is a study in itself.

Although vessels were no doubt first made for domestic purposes they soon acquired also religious significance as urns and as appurtenances of religious cults. They were placed in tombs, where they lay outside harm's way for centuries, and thus it came to pass that, while the mighty Greek temples built of gigantic blocks of stone are now lying in ruins, the fragile pottery is emerging out of the ground in comparatively good condition.

The Athenian vase, which is thus raised from the dead, was an object on which the potter had devoted much care. Its harmonious build and the thin walls of clay bear witness to the perfection of his workmanship. The shape is a composition of various forms, fitted together. The bulging body admirably expresses the function of containing. Its shape is derived from the sphere. The foot is conceived as a base which has to sustain the whole structure. The inward curve of the neck leads on to the outward bend of the lip which opens like a funnel to receive contents. A circular lid is sometimes provided with a knob for lifting in the centre, from which the form radiates outwards and downwards like a protecting roof. The handles are shaped for holding or carrying.

* Quoted by Mr. Hambidge and Mr. Caskey.

Thus every part has a distinctive shape of its own, expressive of the service it has to perform and varying according to the type of vessel. Moreover, all elements are balanced symmetrically round the vertical axis and co-ordinated into a harmonious whole. The interrelation of these subdivisions gives to the Greek vase the properties of an architectural building. The plan consists of a series of concentric circles of various sizes. For, with the exception of the handles, which are so to speak but finishing touches, each vase is built out of an infinite series of circles of clay which rise from the potter's wheel and whirl round one central axis. The lofty Amphora, the expanding Kylix and the elegant Kantharos are all formed by circles on the revolving wheel. Their distinctive shapes depend solely on the varying sizes of these circles of clay, the lengths of whose diameters are regulated in accordance with a design representing the elevation of the vase. Thus, while the architect has to map out both plans and elevations for his work, the potter need only be concerned with the latter. He can control the entire shape by referring to a drawing of its elevation.

The idea of a pot shaped on a rapidly turning wheel appealed to people's imagination and the process is often mentioned in ancient literature.*

Thus the author of Περὶ Διαίτης says :

"Potters turn the wheel, which moves neither backwards nor forwards and at the same time imitates the rotation of the universe, and on this same wheel as it whirls they make things of all kinds, no one of them like another, from the same materials with the same tools." †

And Plato :

"If a skilful potter had made the vessel smooth and rounded and well baked, like some of the fine two-handled jars which hold six choes—if he should ask us about such a vessel as this, we should be obliged to agree that it was beautiful." ‡

And Ecclesiasticus :

"So does the potter sitting at his work, and turning his wheel round with his feet, who is always painstaking with his task, and all his work is done by number." §

In the following diagrams an attempt has been made to apply measures derived from a progressive series of circles, related in the divine proportion, to six Greek vases. It will be seen that the results are very satisfactory. In each case an outstanding measure-

* The following three quotations are taken from G. M. A. Richter's *The Craft of Athenian Pottery*, pp. 90–91 and 100. † Hippokrates, Littré, VI. p. 494, para. 22.
‡ *Hippias Maior*, p. 288 *d*. § xxxviii. 29.

ment of a vase is taken as the diameter of one of the circles of the series; and it is shown that the other chief measurements correspond to the diameters and radii of circles of the same series or to simple combinations derived therefrom. In the text the measurements of heights and widths are scheduled separately. The latter represent the lengths of the diameters of the circles built around one axis on the potter's wheel, and if these circles were actually described they would constitute the plan of the vase. It will be seen that the proportions of plan and elevation are very intimately related.*

* With the help of a pair of dividers the measurements of the diagrams can be easily verified.

Fig. 26. Neck Amphora. Inv. 01·8059. Boston. Caskey, p. 54.
Height, 0·3425 m. Diameter, 0·213 m.
Black-figured technique.

The height of the Amphora is taken as diameter of circle I. The other measurements are taken from the radii and diameters of a series of four circles related to circle I in the divine proportion.

Heights.

Total height of vase = diameter of circle I.
Height to shoulder = 1 × diameter of circle III.
Height of neck and lip = diameter of circle IV.
Height of body = diameter of circle II plus $\frac{1}{2}$ of radius of circle III, i.e. distance A B.

Widths.

Total width = diameter of circle II.
Diameter of lip = diameter of circle III.
Diameter of shoulder = radius of circle IV plus $\frac{1}{2}$ radius of circle II, i.e. distance C D.
Diameter of bottom of body = radius of circle III.
Diameter of foot = diameter of pentagon inscribed in circle III.

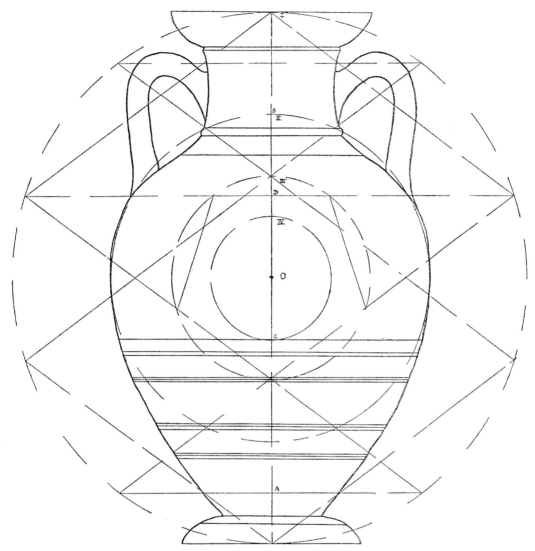

FIG. 26.—NECK AMPHORA.

51

Fig. 27. Oinochoe with Trefoil Lip. Inv. 99·527. Boston. Caskey, p. 134.
Total height, 0·25 m. Diameter of body, 0·154 m.
Black-figured technique.
The total height is taken as diameter of circle I. The other measurements are taken from the radii and diameters of a series of five circles derived from circle I and related in the divine proportion.

Heights.

Height to top of handle = diameter of circle I.
Projection of handle above lip = $\frac{1}{2}$ of radius of circle II.
Height to shoulder = radius of circle I plus $\frac{1}{2}$ of radius III.

Widths.

Diameter of body = diameter of circle II.
Width of mouth = $\frac{3}{4}$ of diameter of circle II.
Width of spout = diameter of circle V.
Width of handle = radius of circle IV.
Diameter of shoulder = radius of circle II.
Diameter of bottom of body = radius of circle IV plus $\frac{1}{2}$ of radius II, *i.e.* distance A B.
Diameter of bottom = radius of circle III plus $\frac{1}{2}$ of radius of circle II, *i.e.* height of pentagon inscribed in circle III, or distance C B.

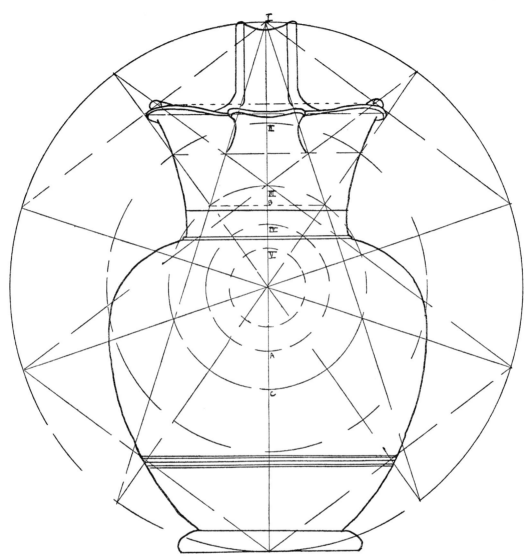

FIG. 27.—OINOCHOE.

Fig. 28. Kylix. Inv. 01·8057. Boston. Caskey, p. 176.
Height, 0·11972 m. Width, 0·3875 m. Diameter of bowl, 0·312 m.
Red-figured technique.

The total width of the Kylix is taken as diameter of circle I ; and the other measurements are taken from the radii and diameters of a series of four circles derived from circle I and related in the divine proportion.

Heights.

Total height of vase = radius of circle II.

Widths.

Total width = diameter I.
Diameter of bowl = radius of circle I plus radius of circle II.
Projection of each handle = $\frac{1}{2}$ of radius of circle III.
Diameter of foot = radius of circle II.

The design of the Kylix fits well into the diagram of concentric circles as shown in our figure.

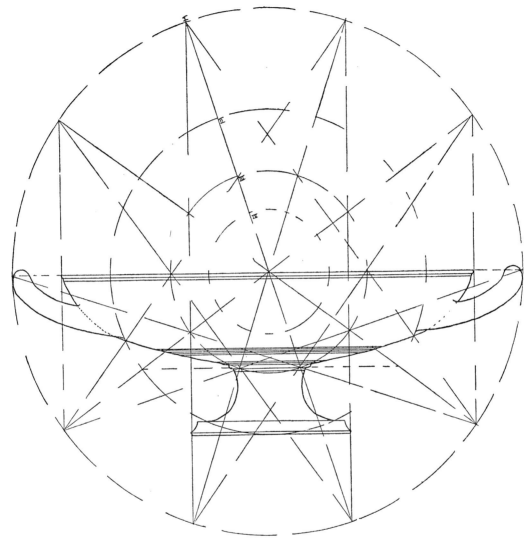

Fig. 28.—Kylix.

Fig. 29. Kantharos. Inv. 95·36. Boston. Caskey, p. 162.
Total height, 0·241 m. Height of bowl, 0·093 m.
Total width, 0·270 m. Diameter of bowl, 0·1885 m.
Assigned to the Brygos painter.
The height of the bowl is taken as diameter of circle IV.
The other measurements are taken from the radii and diameters of a series of five circles derived from circle IV and related in the divine proportion.

Heights.

Height to top of handles = diameter of circle II.
Projection of handles above lip = radius of circle III.
Height to lip = radius of circle II plus radius of circle IV.
Height of stem = radius of circle III.
Height to upper line near bottom of bowl = half of radius of circle I.
Height to junction of handles = radius of circle II.

Widths.

Total width = radius of circle I plus radius of circle III.
Diameter of bowl = 2 × diameter of circle IV.
Diameter of ridge near bottom of bowl = radius of circle II.
Diameter of stem near junction with bowl = radius of circle V.
Diameter of foot = $\frac{1}{2}$ of radius of circle I.

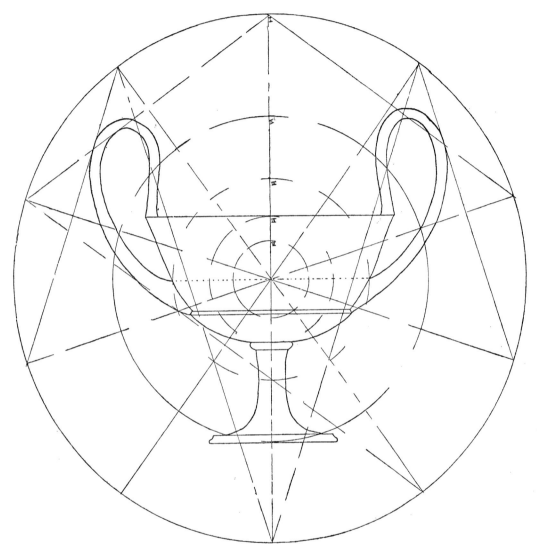

Fig. 29.—Kantharos.

Fig. 30. Kantharos. Inv. 01·8081. Boston. Caskey, p. 165.

Total Height, 0·1535 m. Height of bowl, 0·111 m. Width (handles), 0·222 m.

The whole vase, except for one moulding of the base, is covered with a fine black varnish. It is of very delicate workmanship.

The total width is taken as diameter of circle I.

The other measurements are taken from the radii and diameters of a series of four circles derived from circle I and related in the divine proportion.

Heights.

Total height including handles = radius of circle I plus radius of circle III.

Height to lip = radius of circle I.

Height to ridge near bottom of bowl = radius of circle IV.

Height of body = radius of circle III plus $\frac{1}{2}$ of radius of circle I, *i.e.* distance A B.

Widths.

Total width = diameter of circle I.

Diameter of lip = radius of circle I plus $\frac{1}{2}$ of radius of circle II, *i.e.* distance C D.

Diameter of bowl at lower junction of handles = radius of circle I.

Smallest diameter = diameter of circle III.

Diameter of foot = radius of circle III plus $\frac{1}{2}$ of radius of circle I, *i.e.* distance A B.

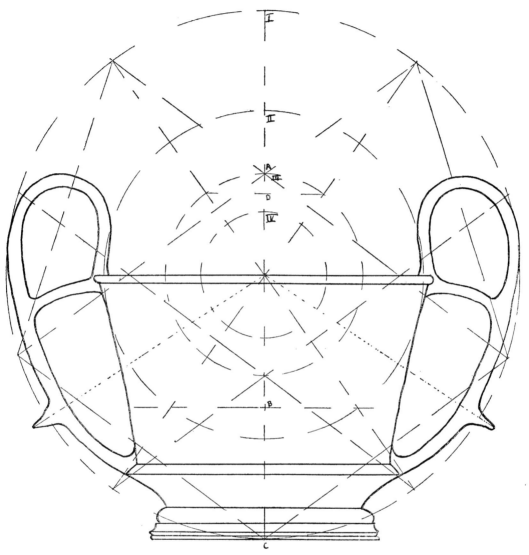

FIG. 30.—KANTHAROS.

Fig. 31. Pyxis. Inv. 93·108. Boston. Caskey, p. 226.
Height to top of knob, 0·178 m. Diameter of lid, 0·15 m.
Red-figured technique.
The width of the lid and of the projecting ridge near the bottom of the Pyxis are equal. This distance is taken as diameter of circle I. The other measurements are taken from the radii and diameters of a series of four circles derived from circle I and related in the divine proportion.

Heights.

Total height = diameter of circle I plus radius of circle III.
Height to top of lid = height of pentagon inscribed in circle I.
Height of lid = diameter of circle III.
Height of vase to junction of lid = radius of circle I plus radius of circle II.
Height of arch in base = radius of circle IV.
Height of base = $\frac{1}{2}$ of radius of circle III, *i.e.* distance A B.
Height of body = radius of circle I plus radius of circle III.

Widths.

Total width = diameter of circle I.
The diameter of the knob and its height, including the neck, are both equal to radius of circle IV plus $\frac{1}{2}$ of radius of circle II, *i.e.* distance C D.
Diameter of bottom = radius of circle I plus radius of circle II.

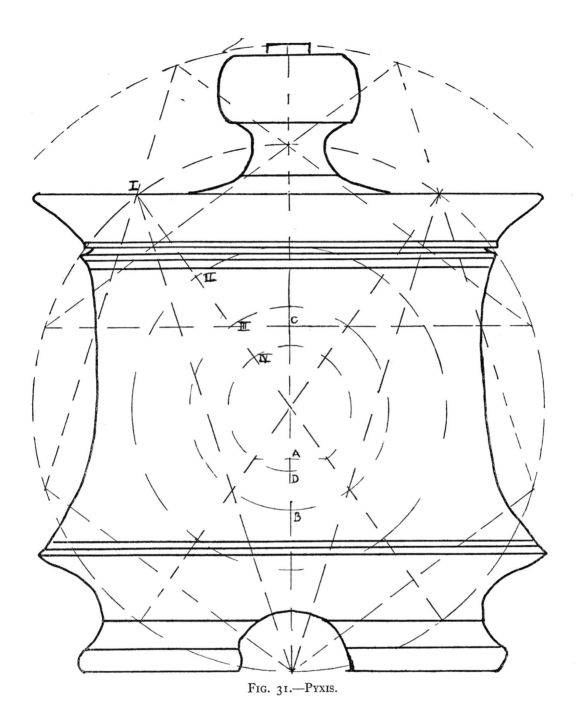

FIG. 31.—PYXIS.

b. *Vase Painting*.

While the shapes of Athenian vases partake of the qualities of architecture, the vase paintings call to mind the sculptured metopes and friezes of Greek temples, and the meander bands and palmettes which serve as framework and decoration are elements which occur also in architecture.

The paintings were generally not carried out by the potter himself, but the painter nevertheless conformed to the scheme which had guided the maker. Thus the position of the bands and lines encircling the vase accentuates the theme of proportions. The figure painting too is in conformity. We have here an instance of close co-operation between the two arts. Painting serves as decoration of architectonic form.

PLATE VI.—Eos Carrying the Body of her Son

Designed by Douris 490–480 B.C. Louvre.

This drawing of a mother carrying the dead body of her son is one of the most famous Greek vase paintings. It decorates the inside of the bowl of a kylix. Encompassed by a circular framework it is more like a self-contained picture than any other part of the decoration. The geometric diagram consists of a pentagon inscribed into a circle. The base of the pentagon coincides with the base of the design. Eos is drawn across the vertical diameter and the diagonals descending on either side of it forming a pyramid with the base. Her head bows down to meet a slanting diameter and a side of the pentagon. The body of her son slants along another diameter, his arms outstretched towards an angle at the base. The diameter of the circle is half the diameter of the bowl which the painting decorates, and the centre of the circle, into which the composition is so beautifully inscribed, coincides with the axis of the kylix. The circle is therefore very closely connected with the structural principle of the vase. It may indeed be conceived as also turning round the axis of the potter's wheel, like the circles of clay which sustain it. Thus the two-dimensioned painting partakes of the same scheme of proportion as the three-dimensional shape which it decorates, and the mysterious rhythm which controlled the whirling circles of clay on the potter's wheel, shaping them into a thing of beauty, penetrated also into the design of the vase-painter.

PLATE VI

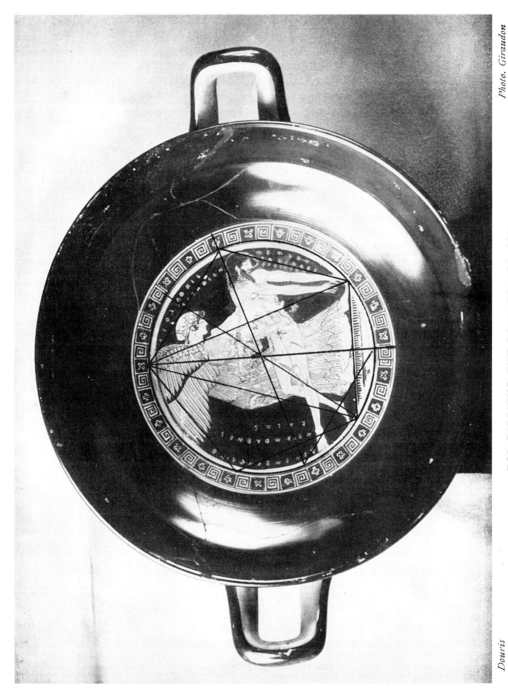

Douris

EOS CARRYING THE BODY OF HER SON

(*Louvre*)

PLATE VII

THE BIRTH OF APHROELITE

(*Museo delle Terme, Rome*)

C. 480-470 B.C.

CHAPTER IX

PLATE VII.—THE BIRTH OF APHRODITE.

A MARBLE relief forming part of the so-called Ludovisi Throne, about 480 B.C. Museo delle Terme. Rome.

The top of the relief is broken.

The subject has lent itself to many interpretations.

In calling it " The Birth of Aphrodite " we are adhering to the commonly accepted title.

The geometric diagram is derived from a series of four concentric circles related in the divine proportion.

The total width of the carved surface is taken as diameter for circle I. A set of four additional circles are inscribed into the diagram from a centre situated above the head of Venus where the vertical diameter is cut by the side of the pentagon inscribed in circle I.

The design contains two movements : the rise of Aphrodite emerging from the sea, and the bending downwards of the two Horæ on either side of her. The lines of these two movements follow the curves of the two sets of circles.

The Museum of Fine Arts at Boston possesses the counterpart to this relief, and its composition conforms to a similar geometric diagram.

There is a passage in Plato's *Republic* which suggests that Greek artists and craftsmen were in the habit of using geometric diagrams :—" Therefore we must employ that fretted sky as a pattern or plan to forward the study which aims at those higher objects, just as we might employ diagrams, which fell in our way, curiously drawn and elaborated by Daidalos * or some other craftsman or painter. For, I imagine, a person acquainted with geometry, on seeing such diagrams, would think them most beautifully finished." . . . (VII. 529 E.)

It may well be that Plato was thinking of diagrams such as this one.

* Daidalos was a well-known sculptor of the earliest period.

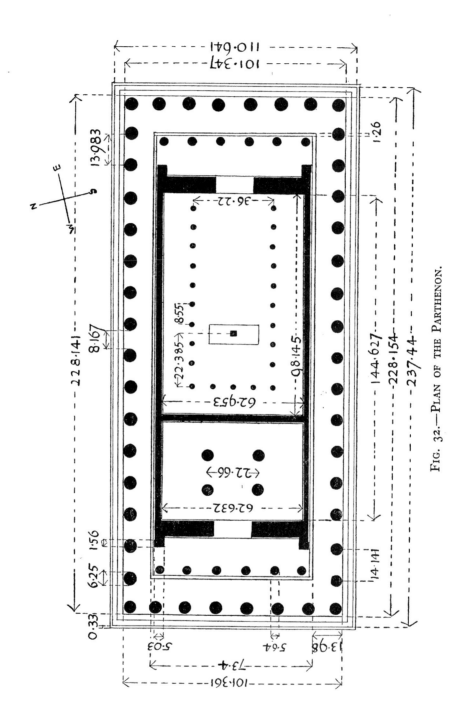

FIG. 32.—PLAN OF THE PARTHENON.

CHAPTER X

THE PARTHENON

GREEK architecture was developed in the service of temple building. The temple was considered to be the dwelling-place of the deity, and it therefore had to be as perfect a building as human effort could achieve. On it architects bestowed all their care and attention. It was built in great blocks of solid stone so as to last throughout the ages. The finest type of human habitation, the megaron or men's hall in a king's palace, served as type, and was enlarged and perfected to form the cella of the temple, and the statue of the deity, carved in as beautiful a human form as the sculptor could conceive, was placed inside. The vestibule was turned into a lofty portico with an impressive range of columns; and this arrangement was repeated at the back. The cella was raised on a stylobate to a commanding height, and was surrounded by a colonnade which sustained the roof and formed a wide passage-way around the main building. The Greek peripteral temple, therefore, consisted of two distinct features, the cella, or enclosed shrine, and the peristyle or colonnade. This was the theme; it had taken centuries to evolve, but when at last found it was adopted once for all as the only possible one, and perfected. Similarly the theme of the massive Doric column with its tapered shaft, with its entasis or slight convex curvature in outline, with the bold curve of the echinus moulding under the abacus of its capital, when once established was retained once for all and perfected. The archaic form as it appeared in the columns at Corinth (650–600 B.C.) was gradually refined. The exaggeration in the entasis disappeared, the tapering was diminished, the height was increased and the overhanging capitals were reduced, till in the Parthenon (447–438 B.C.) the perfect type made its appearance.

Thus after much groping and experiment the Doric style was evolved. To its development and incessant refinement Greek architects devoted their labours. The language is dignified and simple. Each term is expressive of its function and perfect in itself. It also forms an intrinsic part of the harmoniously proportioned whole. Every aspect of the building, the relation of details to the whole, was studied so that there should be perfect harmony. Thus the foundations were laid, the essential elements were fixed, and a standard was set up for all times. The Greek temple became the

school of architecture of the Western world; and long after it had fallen into disuse it lived on in the world of art as a model to be emulated; and the principles which it incorporates are studied and adhered to by architects down to the present day.

The Parthenon represents the climax of Greek architecture, the perfected type of the Doric style. It was built when Athenian art had reached its highest splendour, in honour of the patron goddess Athene, and was placed high up on the Acropolis as the crowning monument of the city. In its design the architects Iktinos and Kallikrates joined forces with the famous sculptor Pheidias. Everything that Athens at the height of her power could give was lavished on this temple. Here the Greek love for harmonious proportions and for unified composition found perfect expression; and even now, in its ruined state, it still evokes the impression of great and beautiful music. Each form seems attuned to an all-pervading harmony.

What then is the foundation of this wonderful harmony? When we examine the various measurements more closely we are puzzled to find variations, which to modern craftsmen would seem inexact and careless. The stylobate is wider on one side than on the other, the steps vary in height. There is not a single intercolumnation of the peristyle which tallies exactly with another. The heights of the columns and their diameters vary and their axes are not perpendicular. The lines of the stylobate and of the entablature are not level. Under the circumstances in which the temple was built we cannot admit that these deviations from mathematical accuracy were due to carelessness.

For modern buildings imitating the antique style like the Madeleine in Paris, for instance, or the Propylæa in Munich, or the British Museum in London, very probably beat the Parthenon in accuracy of detail, but they seem to lack the greater and more important unity of the whole. The modern work seems monotonous, thin, and machine-made. It leaves us cold; and we are led to the conclusion that there is more science in the art of the Parthenon than classicist imitators realized.

The Greeks evidently measured by a different scale and had other standards. They themselves have left no account of their method. All we have to go upon are the works of Vitruvius compiled four to five hundred years later, and his exposition of the subject is not clear.

Various systems were invented to try and fit the case. Interest in the problem is still alive, and only recently two books have appeared on the subject in America.* A brief review of the various theories with caustic comments was published by Prof.

* Jay Hambidge, *The Parthenon.* Yale University Press, 1924. Robert W. Gardner, *The Parthenon.* New York University Press, 1925.

W. B. Dinsmoor in two articles which appeared in *Architecture*.* It seemed presumptuous and almost hopeless, under the circumstances, to make yet another attempt. In so doing I was led by the consideration that the Parthenon at Athens is the work of art by which any theory about Greek proportions must be tested. There was also the further consideration that in choosing the Parthenon I would profit by the careful plans and measurements taken by Francis C. Penrose, without which this investigation could never have been made.† Moreover, the discouraging fact that there had been so many attempts was only realized by me after I had somewhat light-heartedly embarked on my difficult task, and turned out in the end to be a distinct advantage, for I was enabled to profit by them. ‡

The scheme set forth in the following pages is the result of my investigations. Its claim to consideration is that it takes into account the proportions and conception of the building as a whole, and that the various elements are brought into harmony therewith. The methods of construction employed by the ancient Greeks are kept in view. Every single statement about a geometric proportion is verified by arithmetic proof.

Moreover, the application of the scheme is very simple; all that is required by the builders for laying out the plan is the knowledge of the geometry involved in the inscription of a regular pentagon into a circle. By means of a few cords of certain fixed lengths and a peg, circles are drawn from centres located on the line of orientation. Thereby the main elements of the temple are brought into harmony by a geometric scheme similar to that which determined the shape of the Greek vase.

This exposition does not claim to be complete. There are relationships which remain to be established, and missing links which await solution. I cannot flatter myself that I have made no mistakes, no wrong conjectures in such an enterprise. But I submit that the correspondences here brought forward are too numerous to be accounted for as mere coincidences, and that consequently a foundation is here laid which may lead to a complete solution of a much-debated problem.

a. *Euthynteria.*

When Iktinos and Kallikrates were entrusted with the task of building the Parthenon, the site on the Acropolis was occupied by the ruins of an older temple which was begun under Aristeides and Themistokles in memory of the victory over the Persians at Marathon. But this temple was never completed; for the columns were just beginning to rise from the platform when the Persians returned in 480 B.C., destroying the work

* Vol. XLVII, pp. 177 and 241, 1923.
† *Principles of Athenian Architecture*, London Society of Dilettanti, 1888.
‡ My acknowledgments to previous investigators have been made in the text.

and burning the scaffolding. The stones on the Acropolis still tell the tale. We can see the column drums of the older Parthenon which were carried off by order of Themistokles and built into the north wall for the defence of the citadel; we can trace the marks left by the Persian fire, and we can discern, in some places where the masonry is displaced, the steps of the older temple underneath the platform of the later building.*

The new temple then rose on the ruins of this older unfinished Parthenon some thirty years later.† Use was made of some of the material and the foundations were enlarged according to the proportions of the new plan. A rectangular course was constructed to level the ground and serve as base for the steps. This course is a constant feature in Greek temples. It was called εὐθυντηρία, a name suggestive of its function, for it served as a guide and framework for the laying out of the plan.

At this early stage the orientation of the temple had to be considered and the direction of the axis of the temple was finally fixed.‡ The euthynteria therefore constitutes the completion of the foundations and the beginning of the actual building; it joined the temple to the rocky soil. This double aspect of its function is clearly shown in the Parthenon, where marble blocks were used on the western and northern sides, while on the eastern side the rock of the Acropolis was hewn into shape.

On this foundation, then, the temple was raised.

b. *The Stylobate.*

The stylobate rises three steps over the levelling course and forms the base of the temple.

In Fig. 33.§—The rectangle A B C D is the plan of the bottom step of the stylobate. The rectangle F G H I is the upper step.

A B measures exactly 220 Attic feet. ‖

* B. H. Hill, *American Journal of Arch.*, 1912, p. 535.
† Work was begun in 447 B.C. and practically completed in 438 B.C. See W. B. Dinsmoor, " Attic Building Accounts," *American Journal of Arch.*, 1913, p. 77 ff.; 1921, p. 242 ff. ‡ See p. 16.
§ For measures see Fig. 32.
‖ The length of the bottom step, 237·44 English feet, divided by 220, is 1·07904 . . . English feet, or 328·9 millimetres. This measure corresponds to one Attic foot according to Dörpfeld's investigations published in *Athenische Mitteilungen*, 1890, p. 167. It has often been remarked how seldom the Greek foot occurs in integers throughout the Parthenon; and this fact confirms the theory of a geometric scale being used. I believe that the total length has not before been translated into Attic feet. Besides the total length, the height of the entablature is almost the only other clear case which I noticed. It measures exactly ten Attic feet (10·79 English feet). The name Hekatompedon which was applied to the Parthenon has suggested the idea that the measure of 100 Attic feet is to be found in some leading dimension of the temple. Dörpfeld found that the length of the naos inclusive of the thicknesses of its western and eastern walls corresponded to this measure.

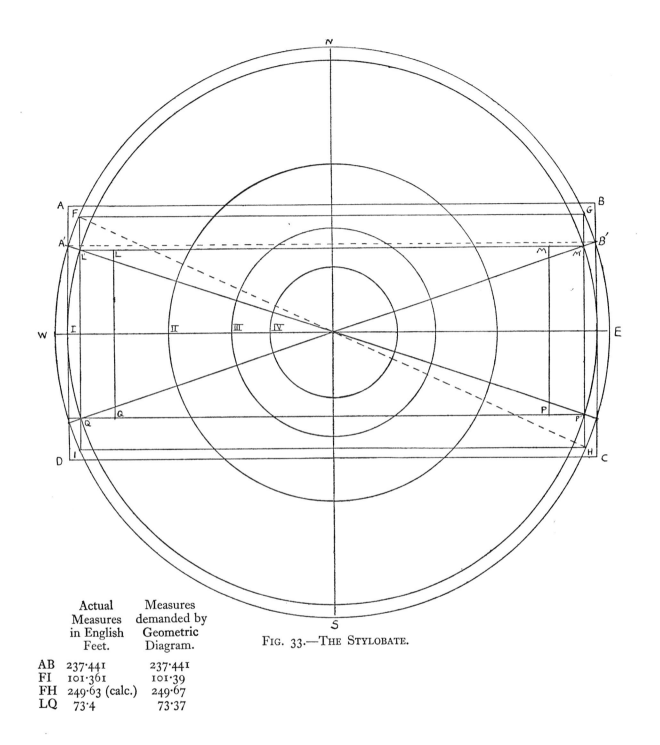

Actual Measures in English Feet.		Measures demanded by Geometric Diagram.
AB	237·441	237·441
FI	101·361	101·39
FH	249·63 (calc.)	249·67
LQ	73·4	73·37

FIG. 33.—THE STYLOBATE.

This length was the first and largest term of a geometric series whereby the various elements of the peristyle were brought into relation with one another ; a scale of measures being obtained by taking A B as the diameter of a circle and inscribing a progressive series of circles related in the divine proportion. The four numbered circles in Fig. 33 are the largest of the series.

The diameter of circle I = A B, the length of the bottom step on the flank.

The sum of the radii of circles II and IV = F I, the length of the upper step in front.

The front length of the upper step forms a continuous base for the eight columns of the façade, and is an important element in the scheme of proportion of the peristyle. A second series of circles, also related in the divine proportion, is derived by taking this measure as a diameter. The various terms of these two geometric progressions, the one founded on A B and the other on F I, are used as measures ; and by their interplay the various elements of the peristyle are brought into harmony. In the following pages the progression founded on A B will be referred to as the major scale, to distinguish it from the minor scale founded on F I.*

There is yet another geometric relation between A B and the rectangle F G H I of the upper step. For A B is equal to A′ B′, the diagonal of a pentagon described in the outer and largest circle whose diameter F H is the diagonal of the rectangle F G H I. †

These calculations may seem intricate and difficult, but a little consideration will show that they are all based on the relatively simple geometrical proposition of a regular pentagon inscribed in a circle. Moreover, the mapping out of the plan was a comparatively simple affair.

Let us take it for granted, for a moment, that the builders of the Parthenon had nothing but the above data to work upon when they started to lay out the plan of the stylobate. Let us suppose that the site had been sufficiently cleared, and that the direction of the line of orientation had been finally established. The builders would then begin by measuring off 220 Attic feet on this line, and through its centre they would draw another line at right angles to it. And let us call these two lines W E and N S according to the points of the compass (Fig. 34). From the same centre they

* For a table giving measures of these two scales see p. 88 ; A B and F I being related to one another as shown in Fig. 33, it follows that the various degrees of the two scales are also related.

† This relation was first found by the Norwegian investigator Lund, who devoted a few pages to the Parthenon in his book *Ad Quadratum*, which appeared in 1921, and deals more in detail with mediæval architecture. His expositions are also based on series of circles related in the divine proportion. The Parthenon is dealt with but summarily and no arithmetical proofs accompany his diagrams. Consequently as far as I could ascertain, his calculations correspond only very approximately with the actual measures. I found, however, one other relation which also appears in my exposition, namely, that of the width of the interior to the width of the stylobate in Fig. 36.

would describe a circle equal to circle II of the minor scale cutting N S at N′ and S′. N′ S′ corresponded to the width of the top of the stylobate. Then another circle would be drawn from the same centre equal to the largest circle in Fig. 33.

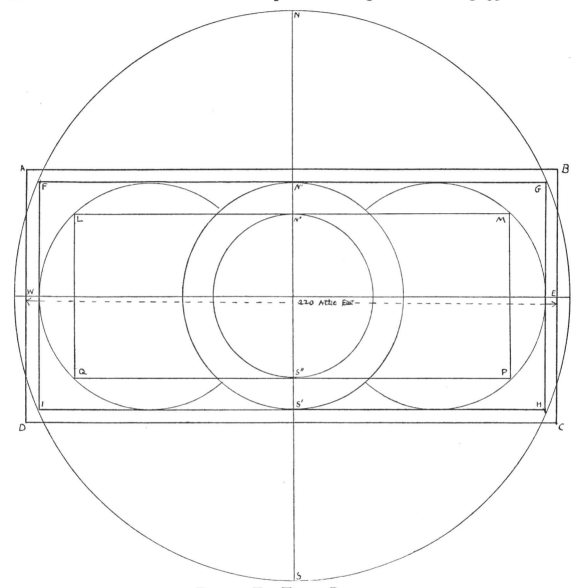

FIG. 34.—THE TEMPLE PLATFORMS.

In order to establish the rectangle F G H I of the upper step or platform of the stylobate, two lines were drawn through the points N′ and S′, parallel to the line of orientation W E, to meet the circumference of this circle at F, G, H and I.

The rectangle A B C D of the bottom step could then be drawn in, allowing for an equal width for the steps all around. This seems quite a simple and straightforward procedure; and it has, moreover, this in its favour, that the result tallies with the actual measures of the stylobate.

The bottom step of the stylobate stands on the euthynteria (as shown in Fig. 32), and its position was carefully defined by setting lines chiselled on this lower course of masonry, so that the rectangles of these two courses are centred one above the other, the lower course protruding ·33 ft. all round. This projection is equal to half the radius XI of the minor scale.*

Over the stylobate a smaller platform was raised which formed the base of the cella. The rectangle L M P Q in Fig. 33 is the plan of the bottom step of this platform. It is centred on the stylobate, leaving a gangway around which is narrower on the sides than on the fronts. The lines L M and P Q coincide with the diagonals L′ M′ and P′ Q′, and the width of the rectangle = radius II.

The length of the rectangle is determined by the section of the lines L M and P Q with the circumferences of two circles II of the minor scale inscribed into either end of the rectangle F G H I.

To see how this was done let us turn again to Fig. 34 and continue our account of the mapping out of the plan. After having established the proportions of the rectangle F G H I as shown above, the builders would describe another circle from the centre of the line of orientation with a diameter equal to radius II of the major scale, and cutting the line N S at N″ and S″ and through the points N″ and S″ they would draw the two lines L M and P Q parallel to W E. Into either end of the rectangle a circle would then be inscribed centred on the line of orientation. The points of section of the circumferences of these two circles with the lines L M and P Q established the position of the corner-stones of the base of the cella.

It will be seen, therefore, that the ways in which the rectangles of the top of the stylobate and of the base of the cella were obtained resemble each other. In both cases the smaller inscribed circles gave the widths; and the lengths were obtained by circumscribing. The circles are all related to each other and are derived from the length of the bottom step, which measures 220 Attic feet.

This concludes our account of the plan of the temple platform.

* The setting lines correspond to the exact measure.

PLATE VIII

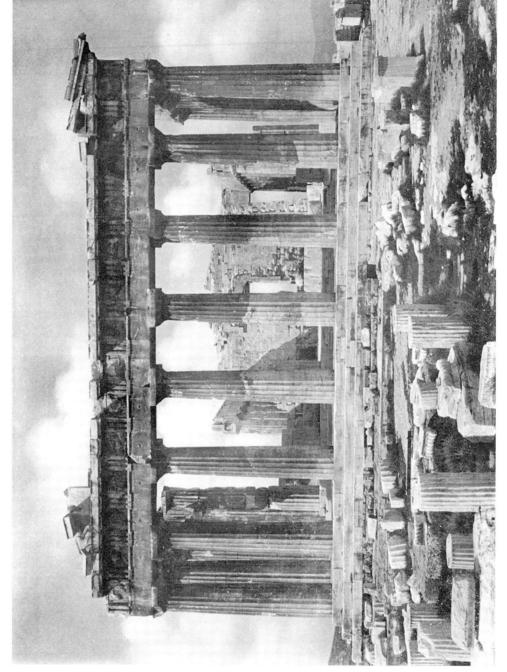

PARTHENON WEST FAÇADE

(Athens)

c. *The Doric Order.*

Raised by a miracle, you may behold
A massive temple in the antique style. . . .

And hark, I hear the spirit's masterpiece;
Melody gathers where the cloud-shapes go;
The airy tones fashion a marvellous strain,
And all is music where their shadows flow.
The fluted shafts, the triglyphs seem to ring,
I could believe I heard the temple sing.
 Goethe, *Faust*, II. Translation by M. Stawell and G. Lowes Dickinson.

The Doric Order consists of the columns, subdivided into shaft and capital, and the entablature, subdivided into epistyle, frieze and cornice. In the frieze the metopes alternate with the triglyphs, forming a long procession round the whole building. One triglyph is placed above each column and one above the centre of each intercolumniation. The vertical division of space as marked by the columns is thus carried upwards into the frieze. The three glyphs echo the flutes of the shafts and at the same time serve as framework to the reliefs carved on the metopes, just as in music the time beat recurs at regular intervals sustaining the melody. Other elements in the entablature accentuate the rhythm. The mutules of the cornice are placed one over each triglyph and one between. The tæniæ and six guttæ mark the beat on the epistyle. Even the masonry conforms. Two huge marble blocks of the epistyle meet above each column centre and two blocks of the stylobate meet below. (Plate VIII.)

For the masonry of the Greeks was not a matter of fitting together stones ready-made all of one size. The marble for the Parthenon was brought down from the quarries of Mount Pentelicus and each stone was carefully proportioned and polished according to the individual function it had to perform.* So that even the joints in the pavement of the peristyle correspond to the columniation (if with Penrose I may be allowed to give this name to the axial spacing of the columns). We may therefore conceive rows of vertical lines drawn all round the peristyle at regular intervals, concurring with the axes of the columns and passing through the centre of each alternate triglyph; and sections of these imaginary lines taking concrete shape in the joints of the stonework.†

* For this reason the stones lying about on the Acropolis can be definitely allocated to the buildings to which they originally belonged, and we can identify the blocks of the old unfinished temple which were utilized in the new building (see p. 68).

† Owing to the inward slope of the columns the columniation at the base is a little more than the distance between the alternate triglyphs. The difference is slight when compared to the size of the building and in no way interferes with the general rhythm. The columniations at the base vary from 13·98 ft. to 14·113 ft.

We shall see that these regular intervals play an important part in the scheme of proportion.

The question arises : How was the spacing of the columns determined ? It seems certain that the columns were ranged in accordance with the frieze of triglyphs. For while the triglyphs continue in uniform procession round the entablature and are set so that at each end of the temple there is a triglyph at the angle, the spacing of the columns is not so regular, the intercolumniations of the angle columns being less than that of the others, so as to conform to the triglyphs at the angles.

The columns then may be said to carry the regular intervals of the triglyphs down to the ground-plan; and in so far as the angle columns help to determine the four corners of the building they take their cue from the angle triglyphs.

But how was the spacing of the triglyphs determined ? This the builders may have obtained by the following calculation. They proposed having an eight-columned façade and they reckoned that the front of the frieze would consist of a procession of fifteen triglyphs and of fourteen intervals between the fifteen triglyphs. They divided the front of the top step * on which the columns were to be raised by fourteen, in order to obtain an approximate measure.

$$14/101.361/7.24.$$

They then divided the quotient by the divine proportion and formed a geometric progression of which the third term equalled exactly the width of the triglyph.

$$7.24 : 4.474 : 2.766.$$

The second term was somewhat too large for the width of the metope. But this measure could remain undetermined until after the erection of the columns, when each piece could be adapted to its proper place.† Meanwhile, the builders could proceed to calculate more or less exactly the location of the triglyphs and to deduce therefrom the spacing of the columns underneath. They had to allow for eight columns on the fronts and seventeen on each flank. This may, indeed, have been a preliminary calculation

The average columniation of the six central columns on the eastern front measured at the base is 14·097 ft. The corresponding distance in the frieze is 13·961 ft. (obtained by taking the average length of the five blocks of the epistyle on the east façade). This is the best way of calculation, as almost in every case the centre of the triglyph is placed exactly over the joint of the epistyle.

* The front of the top step was obtained geometrically from the length of the bottom step as shown above (see p. 70).

† The triglyphs are fairly uniform in width (2·766 ft.); but the widths of the metopes vary considerably, being greater towards the centre of the frieze.

before finally settling on the actual proportions of the stylobate which was to serve as base to these columns. The approximate measures thus obtained could then be attuned to the geometric scale and harmonized.

In an ancient inscription * giving instructions for the building of an arsenal at the Piræus the builders are advised to determine the position of the corner-stones of the building with reference to the triglyph. No details are given and we are left to guess the procedure. The arsenal in question is known to have been the work of Philo, a name cited by Vitruvius in his list of Greek architects who wrote books on the proportions of buildings (*præcepta symmetriarum*).† It is therefore probable that the practice of determining the position of the corner-stones with reference to the frieze was adopted also in other buildings.

The corner-stones of the Parthenon are incorporated in the lowest of the three steps leading up to the platform of the peristyle. The length of this step in front measures 110·64 ft. and is exactly equal to forty times 2·766 ft., the width of the triglyph. We may assume, therefore, that the frontage of the building was obtained by multiplying the width of the triglyph by forty.‡

d. *The Peristyle.*

The raising of the forty-six columns over the stylobate was not as straightforward a task as might be imagined at first sight. For the floor is not level, but curves gently upwards from the angles towards the centre. Its convex surface has been compared to an enormous lens of low magnifying power cut like a rectangle. The entablature which the columns support has a similar but less pronounced curve, so that the columns at the angles are higher than in the middle. Moreover, the axes of the columns are

* B. H. Hill drew my attention to this inscription published in the *Bull. de Corr. Hell.*, VI, p. 540. See also W. Dörpfeld, *Die Skeuothek des Philon*, Mitteilungen des deutschen Arch. Inst. in Athen, VIII, pp. 152–64.

† *De Arch.*, Introduction to Book VII.

‡ These calculations may seem far-fetched. They do not form an integral part of our geometric scheme, and they are here set forth only tentatively after much hesitation, because it seemed unlikely that the measures should agree exactly to the third decimal figure by mere coincidence. Moreover, I was encouraged by reading Prof. Dörpfeld's article on the arsenal at the Piræus. Here the total length and width of the arsenal were given at the beginning of the instructions to the builders, and yet they were advised to determine the corners with reference to the triglyphs. According to Prof. Dörpfeld this must have meant a slight modification later of the given dimensions in order to bring them into harmony with the frieze.

The builders of the Parthenon were in a similar position. They had, as we have seen, the total length given to them and also the frontage of the top of the stylobate. But the actual corner-stones of the temple which were incorporated in the lowest step and formed the base of the building may have been adjusted by reference to the frieze of triglyphs, so as to establish harmony with the elevation.

not perpendicular, but lean gently inwards towards the centre of the building. With the exception of those at the angles, the axes of the columns on each front or flank are parallel to one another; the angle columns, participating in the inclinations of the two contiguous colonnades, have a greater inclination than the ordinary columns. The setting of the huge drums on the slightly convex floor and their adaptation to the inward inclination of the axes must have been a difficult and delicate task. The adaptation of the capitals to the curve of the entablature and the adjustment of the sides of the abaci to the inclination of the axes was likewise difficult and complicated.*

These difficulties were further increased by the entasis or slight swelling which was given to the outline of the tapering shafts. It would indeed have been much easier to align a row of perpendicular columns of exactly the same size on a perfectly level base, and if accuracy of workmanship had been the chief concern of the builders, surely that would have been the way to achieve perfection. Why then were they willing to add these enormous difficulties to their task?

Explanations generally follow two lines of argument. There is the school of thought which believes that variety gives life. In speaking of the Parthenon Prof. Gardner says: " The whole building is constructed so to speak on a subjective basis; it is not intended to be mathematically accurate, but to be adapted to the eye of the spectator. To the eye a curve is a more pleasing form than a straight line, and the deviations from rigid correctness serve to give a character of purpose, almost of life, to the solid marble construction." † When taken out of its context this explanation almost savours of post-impressionism.

It seems indeed that the Greeks were more modern than we generally suppose, for another school of thought suggests that they practised a certain impressionism of form, if I may be allowed to call it so. The inward inclination of the columns was to give an appearance of greater strength. The curvature of the entablature was to obviate a disagreeable effect produced by the contrast of the horizontal with the inclined lines of a flat pediment which gave an apparent dip to the former.‡ The entasis or convex curve given to the outline of the column was to counteract the appearance of hollowness or concavity caused by the tapering shaft.§

These explanations imply that the Greeks were concerned with the correction of optical illusions. Pennethorne's theory is also based on this assumption.‖ The follow-

* The attempts which are now being made to re-erect the fallen columns of the Parthenon have met with many difficulties.　　　　　　† *A Grammar of Greek Art*, p. 39.

‡ F. C. Penrose, *Principles of Athenian Architecture*, 2nd ed., p. 31.

§ W. J. Anderson, R. P. Spiers, W. B. Dinsmoor, *The Architecture of Ancient Greece*, p. 217.

‖ *The Geometry and Optics of Ancient Architecture*.

ing passages from the writings of Vitruvius and Plato show that in ancient times consideration was given to the aspect of proportions viewed at a distance : " When therefore the kind of symmetry and the magnitudes are settled, it is then the part of the judgment to adapt them to the nature of the place, the use or the species, and by diminutions and additions to qualify the symmetry till it appears rightly adjusted and leaves nothing defective in the appearance." * When speaking of the proportions of columns, Vitruvius again advocates the correction of optical illusions : " These proportionate enlargements are made in the thickness of columns on account of the different heights to which the eye has to climb. For the eye is always in search of beauty, and if we do not gratify its desire for pleasure by a proportionate enlargement of these measures, and thus make compensation for ocular deception, a clumsy and awkward appearance will be presented to the beholder." † Plato speaks of a similar practice in the sister arts : " In works either of sculpture or of painting which are of any magnitude there is a certain degree of deception ; for if the artists were to give the true proportion to their fair works, the upper part, which is further off, would appear to be out of proportion with the lower, which is nearer, and so they give up the truth in their images and make only the proportions which appear to be beautiful, disregarding the real ones." ‡

But these gentle curves do more than correct optical illusions and give life to what might otherwise have been rigid and cold ; for they wield the composition into an organic unity which is in keeping with the spatial conception of the architect. The Greeks were willing to deviate somewhat from mathematical accuracy in detail, not for the sake of variety, but with the purpose of emphasizing the greater and more important unity of the whole.

We may conceive of the East and West façades as being inscribed into similar series of circles as the plan ; and we may conjure up a vision of gigantic semicircular disks emerging from the rock of the Acropolis reflecting the rising and the setting sun. The line of orientation joining the centres of these circles passes through the central point of the temple, which lay hidden behind the statue of Athene. From here the circles were drawn on the ground which proportioned the plan. The semicircles of the façades rising perpendicularly from the ground may then be looked upon as elevations on the diameters of circles lying on the ground-plan. They are, so to speak, raised from the floor of the temple and protracted outwards to the East and West front. The inward inclination of the columns is in keeping with this arrangement round a central point. The convex floor of the stylobate rises in accordance. The curvatures of the entablature and the slopes of the pediments are in sympathy ; and so were the compositions of the

* *De Arch.*, VI, 2. † *De Arch.*, III, 3. ‡ *Sophist*, p. 236 in Jowett's translation.

sculptures. Suggestive of the circular motion of heavenly bodies, Helios, the Sun-god, was seen on one side of the East pediment rising out of the sea, guiding with outstretched arms his fiery team, while on the other side the moon goddess was dipping her horses below the horizon.

e. *The Capital.*

The capital of the peristyle column is carved into a block of marble 6·6 ft. square and 2·833 ft. high.

In Fig. 35 * the rectangle A B C D represents the elevation of the block. The abacus above retains the full size of the square and its side A B † serves as the diameter of the first of a series of four circles related in the divine proportion.

The sum of the radii of circles II and IV equals the height of the capital.‡

These proportions are repeated on a gigantic scale in the plan of the building. For the total length of the temple is to the width of the stylobate as the width of the abacus is to the height of the capital.§

Beneath the abacus the circular moulding of the echinus forms the transition to the shaft.

The lower part of the capital takes the shape of the shaft with twenty flutes. The plan of these flutes radiating from one centre repeats the geometric diagram used in the scheme of proportions. The capital therefore by its proportion and shape constitutes a variation on a smaller scale of the harmony contained in the plan. It may be regarded as a keynote to which all modulations of the peristyle may be referred. It is placed aloft on a shaft whose height corresponds to radius III of the minor scale. Twenty flutes run down to the temple floor where the bottom drum marks its circular plan. The radius at the base is equal to the diameter X of the major scale.‖ And the width across two flutes is equal to the diameter XI, across four flutes to the diameter IX of the same scale.

* For measures see p. 89.

† Equal to the radius of circle VII of the major scale.

‡ Equal to the radius of circle VIII of the minor scale.

§ A B : A D in Fig. 35 = A B : F I in Fig. 33.

‖ Vitruvius sets forth a rule which is often referred to in descriptions of ancient architecture. He said that a columned building was designed with reference to the lower diameter of the column. By means of this measure the proportions of the other parts of the composition were regulated and brought into harmony. The so-called module was usually the half-diameter of the bottom of the shaft—that is to say, its radius. In the column of the Parthenon this measure corresponds to the diameter X of the major scale. It may therefore very well have served as module ; but the module was the tenth term of a geometric progression of which the total length of the building was the first.

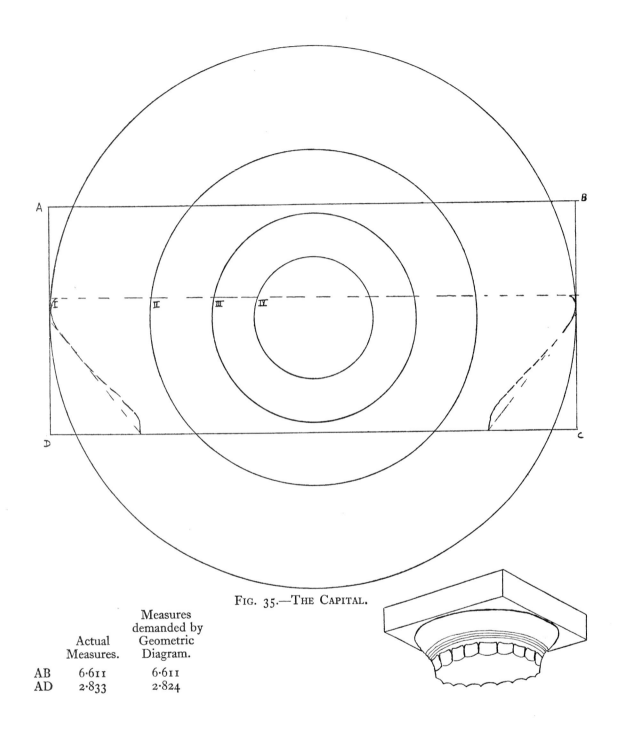

FIG. 35.—THE CAPITAL.

	Actual Measures.	Measures demanded by Geometric Diagram.
AB	6·611	6·611
AD	2·833	2·824

79

f. *The Façade.*

The distance between two column axes corresponds to one-half the radius of circle IV of the major scale, a procession of three columns corresponds to the radius, of five columns to the diameter of the same circle.*

When the builders proceeded to set the lowest column drums on the upper step of the stylobate they found the column centres already marked for them. For the blocks were cut so that each column came to stand over a joint in the pavement, and the angle columns were centred on squares.

The vertical division of space set by the columns is carried up into the frieze by the alternate sequence of triglyphs and metopes (see p. 73).

Moreover, the width of the metope corresponds to the radius VIII of the major scale. And the width of each glyph to half the radius of circle X of the minor scale.

Horizontal lines.—The horizontal lines are attuned to the vertical division of the space.

The most important line is the division between the supporting members (columns) and their load (entablature). The total height from the apex to the bottom of the euthynteria is divided into the divine proportion by this line.†

Within this main division the subordinate elements are ranged with measures set in the major and minor scales.

The height of the building from the upper step to the apex of the pediment corresponds to half the radius I of the major scale.

The height of the flanks from the upper step to the cymatium equals the radius III of the major scale.

The height of the pediment equals half the radius IV of the major scale.

The height of the cornice equals the diameter XI of the same scale, while its projection equals the diameter X of the minor scale.

The height of the frieze is equal to one-third of the diameter VII of the major scale.

The average rise of each of the three steps of the stylobate is equal to the radius of circle IX of the minor scale.

The open spaces between the columns partake of the rhythm ; and their outlines may be likened to the contours of a row of gigantic Greek vases. One of the greatest pleasures, when standing inside the ruins of a Greek temple, is the views of the landscape through the peristyle. The architecture seems to belong to the scenery, and there can be no more befitting framework to the clear and delicate lines of the Hymettus and of the Bay of Salamis than the tall silhouettes of the Parthenon columns.

* For measures see pp. 89–90. † Hambidge, *Parthenon*, p. 11.

PLATE IX

BATTLE BETWEEN CENTAUR AND LAPITH

(Metope from the Parthenon in the British Museum)

C. 447-443 B.C.

All the lines are gently curved. The delicate entasis adds to the beauty of the tapering shaft. The stylobate on which the columns stand and the entablature which they support rise slightly from the angle to the centre. The heights of the columns vary accordingly. No column is exactly like another. Each one is delicately adjusted to its particular place and function. The men who carved them were not mere masons in the modern sense, they were sculptors who gave to the marble the vitality and individuality of a work of art.

It is of interest here to quote the explanation given by Penrose for the increased size of one of the fallen capitals of the north side, as it throws some light on the quality of Greek workmanship. He says, " I have no hesitation in assigning its position to the fifth column of the north-east angle near to which it lies, where the intercolumniation on each side being for some reason or other unusually great, it was thought desirable to reduce by a delicate accommodation of ·02 the difference between these and the contiguous intercolumniations, which otherwise in the architrave might have seemed too palpable. The amount of this adjection testifies, quite as much as their attention to the circumstance itself, the artistic propriety of the Greeks. An architect of a less careful school would probably have either omitted the adjustment altogether or humoured, as it was called, the capital to a greater extent. The Greeks, however, understood the value of *ne quid nimis*." *

g. *The Metope.*

PLATE IX.

The metopes were decorated with sculpture in very high relief, representing battles between centaurs and Lapiths. The metope here reproduced was removed from the Parthenon with other sculptures by Lord Elgin and is now in the British Museum. The arrangement of the figures seems to conform to a geometric scheme of spacing. The three circles are related in the divine proportion. The height of the block of marble which corresponds to the height of the frieze and is equal to one-third of the diameter VII of the major scale (see p. 88) is taken as the diameter of circle I. The cavity of the shield corresponds exactly to circle III.

This concludes the analysis of the peristyle. We shall now turn to the description of the cella. In doing so we are following the procedure of the ancient builders, for there is evidence that, contrary to what would be the modern practice, the peristyle was erected first and the cella built into it afterwards. In the temple of Segesta, for instance, which was left unfinished and has no cella, the peristyle is practically complete

* *Principles of Athenian Architecture*, p. 16.

but for the flutes of the columns, which were done last, being most liable to injury during building.

h. *The Cella.*

The cella is the most important part of the temple, for here the deity was supposed to dwell. It stands on a platform of its own inside the peristyle, and a portico forms the entrance at either end. It was therefore a self-contained building. The peristyle was but an enclosure and a setting for this dwelling-place of the goddess.

The base of the cella.—A smaller platform two steps high is raised over the stylobate and constitutes the base of the cella.

In Fig. 36.*—The rectangle F G H I is the plan of the top step of the stylobate.

The rectangle L M P Q is the plan of the bottom step of the cella.

The distance between the lines L M and P Q was determined in Fig. 33 (see p. 72), where it was found that L Q = radius II in the major scale.

Two circles II of the minor scale were inscribed at either end, from centres located on the line of orientation W E. The points of section of the circumferences with the lines L M and P Q established the four corners of the base of the cella (see p. 72).

The rise of the cella platform equals half the radius of circle VII of the minor scale (2·291 ft.).

The tread of the step in front of the naos equals half the radius of circle IX of the major scale (1·26 ft.).

The diameter at the base of the Posticum columns (5·675 ft.) = the diameter VIII of the minor scale.

The Interior.—The upper step of the cella platform constitutes the floor of the temple. The walls of the cella rise from this floor, and underneath them, in order to support them, heavier blocks were used than for the pavement of the floor. These heavy foundation blocks serving as sills protrude on either side of the walls. Their exact position was carefully defined by setting lines chiselled on the course of masonry underneath. These lines constituted the original layout for the proportions of the interior. They were buried half an inch under the edges of the superimposed stones, and are now visible wherever these stones have been displaced.†

* For measures see Fig. 32.

† The West doorway does not correspond exactly to its eastern counterpart. The wall is narrower, and stands a little further away from the centre. The tread leading up to the platform is wider (1·39 as against 1·26), so that the edge of the platform is slightly nearer the centre of the building on the western side. Various explanations have been given for these irregularities. Penrose suggested that the east porch was completed first and proved to be unsatisfactory. The west porch, therefore, would constitute a departure from the original plan. The measures here given correspond to the setting lines and show the proportion of the interior as planned before the foundation blocks for the walls were put in position. Compare Hambidge, *Parthenon*, p. 38.

In Fig. 36.—The rectangle A B C D corresponds to the setting lines for the sills of the cella walls.

The width A D is equal to the diameter of circle III of the minor scale.

The length of the rectangle A B is equal to the diameter of circle III plus the radius of circle I. The length of the interior could, therefore, be obtained by describing a

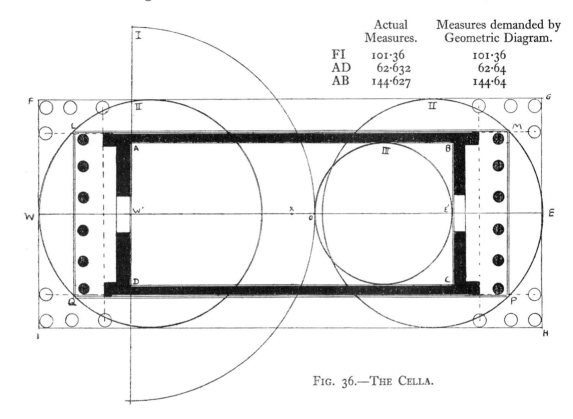

	Actual Measures.	Measures demanded by Geometric Diagram.
FI	101·36	101·36
AD	62·632	62·64
AB	144·627	144·64

FIG. 36.—THE CELLA.

circle with a radius equal to half that distance from the centre X of the temple, cutting the line of orientation at W′ E′. The proportions of the whole interior of the cella could, therefore, be established by drawing two related circles from the centre of the line of orientation.

If circle III be inscribed into the eastern end of the rectangle A B C D its circumference cuts the line of orientation at the point O.

This point marks the centre of the base of Athene's statue. The distance between O and the western wall of the cella A D corresponds to the radius of circle I.

The Side Walls.—The courses of masonry running along the lines A B and C D serve as sills for the side walls of the cella.

The line joining the axes of the second columns on the façades coincides with the exterior of these walls; while a line joining the axes of the third columns on the flanks coincides with the fronts of the antæ.*

The length and position of the side walls of the cella are therefore in harmony with the columniations of the peristyle. Their length corresponds to twelve columniations of the flank; and their outside distance apart to five columniations of the front.

The breadth of the exterior face of the anta (1·56 ft.) equals the radius of circle X of the major scale (see p. 88); while the front and inside faces (5·03 and 5·02 ft.) correspond to the diameter IX in the same scale.

The height of the Panathenaic frieze = $\frac{1}{2}$ radius VII of the major scale.

The height of the walls from floor to ceiling (41·00 ft.) equals half the radius I in the minor scale.

This concludes our analysis of the side walls of the cella. By their foundations, by their size and position they are in harmony with the dominating theme of proportions as enunciated in the peristyle. They run parallel to each other, like two gigantic screens along the flanks of the building, linking the cella to the colonnade outside it.

So far our account has dealt with one geometric scheme which was based on the total length of the stylobate (see p. 70) and to which all measures were shown to conform.

i. *Naos.*

We now enter the eastern chamber where the statue of Athene stood which Pheidias carved in ivory and gold. The Naos was specially built as a shrine for the image of the Goddess. Unfortunately only the floor remains to tell the story of its arrangement in former days; but on this floor of smooth Pentelic marble we can still discern the plan as it was drawn more than two thousand years ago. The proportions of the room, the position of the statue inside it, and of the colonnade surrounding it were carefully planned, for the floor was paved accordingly, heavier blocks being used in the course which supported the columns, and poros blocks in the rectangle underneath the base of the statue.

Let us first examine the proportions of the room. The width from wall to wall seems to have served as the measure by which these were determined.

In Fig. 37.†—A B C D is the rectangle made by the walls.

The three circles are related in the divine proportion and are centred on the line of orientation W E.

* W. B. Dinsmoor, *Architecture*, Vol. XVII, p. 243.　　　　† For measures see p. 90.

The diameter of circle III corresponds to the width A D and is inscribed into the East end of the room.*

The West wall A D then concurs with the side F G of a pentagon inscribed in circle I.

The interior was surrounded on three sides by a colonnade. Ten columns stood on each long side; three more columns completed the western end, twenty-three in all, and in the middle stood the statue of Athene, erected on a great rectangular base.

	Actual Measures.	Measures demanded by Geometric Diagram.
AD	62·953	62·953
AB	98·145	98·142

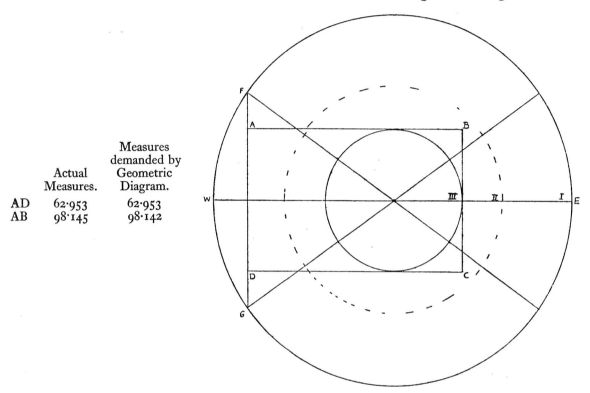

FIG. 37.—THE PROPORTIONS OF THE NAOS.

In Fig. 38.†—The rectangle A B C D is the plan of this base.

Its centre O is situated on the line of orientation W E over a point already fixed in the general outlay of the plan (see Fig. 36). The numbers 1 to 23 indicate the centres of the columns. From centre O a series of circles are described related in the divine proportion.

* This circle corresponds to circle III in Fig. 36. The difference in size of 0·3 ft. of the diameters is due to the fact that in Fig. 36 the sills of the walls were determined, while in Fig. 37 the circle touches the actual wall surfaces in order to determine the proportions of the room.

† For measures see p. 90. I am much indebted to Mr. Hambidge's careful analysis of the naos in his book on the *Parthenon*, pp. 52–54. The above is another interpretation based on his analysis.

The radius of circle III is equal to the distance between the point O and the column centre 12.

The twenty columns of the two long sides are centred on the diagonals F G and H J of regular pentagons inscribed in circle I.

The average columniation, excepting that of the two corner columns, corresponds to the radius of circle V.

The marble blocks of the pavement were cut to fit the columniation. The two corner columns were centred on squares, all the others on the joints between two stones,

	Actual Measures.	Measures demanded by Geometric Diagram.
Columniation	8·55	8·55
FH	36·22	36·22
Column centre 12 to 0	22·385	22·385

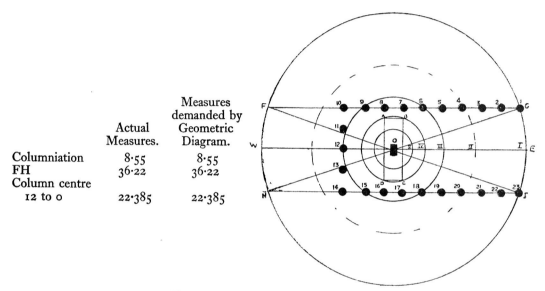

FIG. 38.—THE COLONNADE IN THE NAOS.

and the rest of the pavement was made to conform. Thus every detail in the room was attuned; and over the centre of the circles stood the Goddess dominating the spaces around.

Here the climax of the composition is reached. As in a fugue the theme is stated by one voice after another in that part of the scale which suits its compass, so in this temple the divine proportion appears with augmentation and diminution of itself in all the various parts. The artistic design is made by passing the theme from one form to another. As we enter through the peristyle into the interior the measure gradually contracts n accordance with the decreasing widths. All subjects are connected and balanced on the line of orientation whence the organization of space proceeds. Standing in the centre then, we can best reconstruct in our mind the symmetry of the work. The regular intervals of the procession of triglyphs all around set the beat. By means

PLATE X

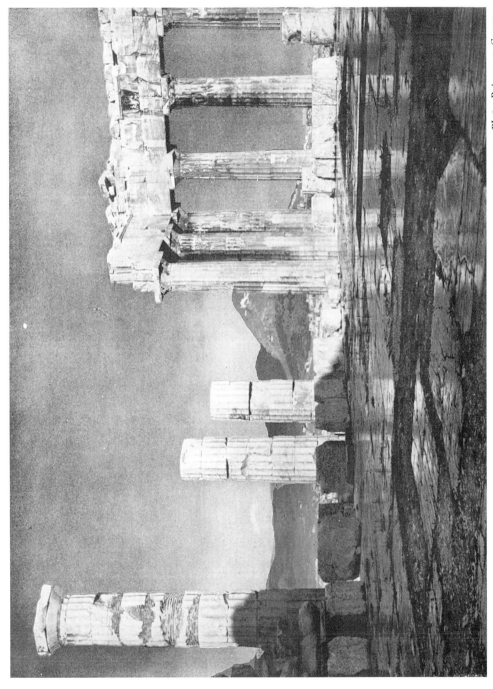

Photo. Boissonnas Geneva

PARTHENON VIEWED FROM INSIDE

(Athens)

of the fluted column shafts this rhythm is transferred to the ground where the main theme makes its appearance. It is repeated on a lighter scale and raised aloft on the capital of each column, and harmoniously sustained by the façades.

The cella constitutes a diminished subject. Its entry into the general harmony is graceful and less massive. It culminates in the frieze of the Panathenaic festival, where the youth of Athens is represented moving in procession round the building.

We are then led to the climax in the naos. After this, the preservation of the main theme became necessary also in the interior. Four mighty columns were grouped around the centre of the western chamber and their columniation once more enunciated the main theme.*

Standing thus inside the Parthenon, high up on the Acropolis, we view the landscape through the rhythmic spaces between its massive columns, and the world outside seems attuned to the same harmony, for the sun rises and sets in accordance, and the hills and sea of Attica surround us. (Plate X.)

* The distance between the column centres from north to south is 22·66 ft. and is exactly equal to half the radius of circle III in the major scale (see p. 88 and Fig. 32).

APPENDIX.

Proof by arithmetic of the statements and of the geometric diagrams in the text.

The measurements are taken from Penrose's *Principles of Athenian Architecture*, except when otherwise stated. They are quoted in English feet and decimal fractions thereof. In testing the degree of accuracy it must be borne in mind that the dimensions which are being dealt with are often enormous and that the second figure after the decimal point stands for the hundredth and the third figure for the thousandth part of a foot.

Table of Major Scale.

The divine progression based on the length of the bottom step of the Parthenon.

Diameter.		Radii.		Half-Radii.	
I.	237·44 (Length of bottom step)	118·72		59·36 (Height of façade from upper step of stylobate to apex)	
II.	146·73	73·37 (Width of base of cella)		··	
III.	90·70	45·35 (Height of columns and entablature on flanks)		22·67 (Columniation in · Parthenon chamber)	
IV.	56·04 (Quadruple columniation in Peristyle)	28·02 (Double columniation in Peristyle)		14·01 (Columniation in Peristyle and height of pediment)	
V.	34·64	··		··	
VI.	21·41	10·71 (Height of entablature)		··	
VII.	13·22	6·61 (Width of abacus in Peristyle capital)		3·31 (Height of the Panathenaic frieze) *	
VIII.	8·16 (Intercolumniation at base)	4·08 (Width of metope)		··	
IX.	5·05 (Breadth of anta)	··		1·26 (Tread of step in front of naos)	
X.	3·13 (Radius of Peristyle column at base)	1·56 (North face of anta)		··	
XI.	1·92 (Height of Cornice)	··		··	

* The height of the frieze of the Peristyle = ⅓ of the diameter VII.

Table of Minor Scale.

The divine progression based on the length of the upper step on the East front of the Parthenon.

Diameter.		Radii.		Half-Radii.	
I.	164·00	82·00		41·00 (Height of interior)	
II.	101·36 (Upper front step)	50·68		··	
III.	62·64 (Width of interior)	31·32 (Height of column shaft in Peristyle)		··	
IV.	38·71	··		··	
V.	23·91	··		··	
VI.	14·79	7·40 (Clear space between the abaci in the Peristyle)		··	
VII.	9·12	··		2·28 (Height of cella platform)	
VIII.	5·64 (Diameter of positicum column)	2·82 (Height of capital in Peristyle)		··	
IX.	3·48	1·79 (Rise of steps of stylobate)		··	
X.	2·15 (Projection of cornice)	··		·54 (Width of each glyph)	
XI.	1·33	··		·33 (Tread of euthynteria)	

Fig. 35.

The average length of the abacus on the North flank is 6·611. On the South flank and the West front the abaci are 6·57, but Penrose noticed that these capitals were reduced about ·036 ft. from the breadth they were intended to have.*

The abaci of the angle columns are naturally wider to correspond to the greater thickness of the shaft; they measure 6·858 to 6·718. The abaci on the Eastern front average 6·753.

The height of the capital is 2·833 ft.

	Diameters.	Radii.
I.	6·611	3·305
II.	4·078	2·043
III.	2·522	1·262
IV.	1·556	·781

$$2·043 + ·781 = 2·824$$

List of Measures in the Peristyle.

Height of the capital of the columns of the peristyle 2·833
The diameter of the column at the base 6·25
The radius of the column base 3·125
Columniations at the base vary from 13·98 to 14·11
Widths of the metopes on the East façade vary from 4·05 to 4·2
Width of triglyph 2·766
Breadth of glyph ·54

An exact measurement of the total height of the building cannot be given, as the tops of both pediments were destroyed. Penrose calculated that the height of the pediment equalled one columniation.

Height from the bottom of the euthynteria to the top of the columns . . 40·276
Total height from the bottom of the euthynteria to the apex of the pediment
 (calculated) 65·171
Height from the upper step to the apex of the pediment (calculated) . . 59·127
Height above the pavement attained by columns and entablature on flanks . 45·336
Height of angle column inclusive of capital (the columns in the middle are
 somewhat shorter) 34·253

* *The Principles of Athenian Architecture*, p. 49.

Height of the cornice 1·92

Projection of the cornice 2·145

Height of the frieze round the cella (the Panathenaic frieze) . . . 3·324

Height of the frieze round peristyle 4·410

The rise of the three steps of the stylobate :

> Top step 1·81
> Second step 1·69
> Bottom step 1·70

<p style="text-align:center">Fig. 37.</p>

Dimensions of the naos from wall surface to wall surface.

> Width = 62·953 ft. (Dörpfeld).*
> Length = 98·145 ft.

	Diameters.	Radii.	Half-Radii.
I.	164·81	82·405	41·202
II.	101·857	50·928	25·464
III.	62·953	31·476	

The length of the room = radius of circle III plus the sum of half the radii of circles I and II.

<p style="text-align:center">Fig. 38.</p>

Distance from the centre of the statue base to the centre of column number 12 = 22·385.†

Average columniation = 8·55.

Distance between column centres 1 and 23 = 36·22 (Dörpfeld).

<p style="text-align:center">Table of Radii.</p>

> I. 58·603
> II. 36·218
> III. 22·385
> IV. 13·833
> V. 8·552

* According to Penrose, 63·01. † Hambidge, *Parthenon*, pp. 101–2.

CHAPTER XI

THE MIDDLE AGES

a. *Chartres.*

WITH the growth of Christianity, architecture readjusted itself to the changing conditions of time and space. "The Lord of Heaven and Earth dwelleth not in temples made with hands," as St. Paul said to the Athenians. The place of worship was no longer the exclusive shrine of the deity, but a hall where large congregations assembled and where ample space was required. A new type of building was therefore gradually evolved to correspond to the requirements of the ritual of the Church. The temple was transformed. The altar took the place which the statue of the deity had occupied as the centre to which worshippers gathered. It was placed on the longitudinal axis and the variform parts of the building were grouped round it. The Byzantine dome, the Christian basilica, the Roman abbey, the Gothic cathedral, the Renaissance and the Baroque churches were creations invented to meet the case, and while reflecting the religious and artistic aspirations of the age and country in which they were built, are all based on the same principle.

At no time except in the great days of Greece was artistic production more wonderful and splendid than in the Gothic period. It was an age when all humanity felt united by one faith in one great spiritual world-empire. The high aspirations in the minds of men found expression in the lofty vaultings of their churches. The altar stood over the crypt which contained sacred relics. The semicircles of the choir and of the apse were described behind it, the nave led up to it. The aisles and the ambulatory of the apse formed a passage-way around it from which chapels opened out like a widespread wreath. Thus all spaces were organized and balanced from the axis with special reference to the high altar. This axis was generally orientated so that the altar was touched by the morning and evening rays of the sun. The plan of a Gothic cathedral with its apse forming half a regular polygon was obviously based on circle geometry. It resembles the patterns made by the traceries of the arched windows which pierce the walls, transforming them into luminous pictures of stained glass. The compositions of these pictures were adapted to the geometric curves of the traceries, and display the great measure of dependence of other arts on architecture. Painters, sculptors and miniaturists, all

worked under the sway of the architect. All the beautiful things made were intended for use in the cathedral and were in harmony with it. Just as the glass-painters fitted their designs into the tracery, so the sculptors adapted their carvings to the mouldings of the building. This seemed natural to them, for they were architects, sculptors and masons at one and the same time, the distinction now made between the three professions being then non-existent.

The Cathedral of Chartres is one of the greatest achievements of French mediæval art. As all the great churches of the time, it symbolizes man's faith in the divine order of things, and in the permeating influence of Christ throughout all human life. This belief was expressed in the sculptures of the three porches by which access is gained from west, north and south into the interior. The three West doors, known by the name of Portail Royal, are the oldest of the Cathedral (Plate XI). Archæologists in trying to distinguish the style of various sculptors have ascribed the tympanum over the central door to the master-mason of the old cathedral which preceded the thirteenth-century structure. It represents Christ in Glory. He is the central feature round which all the other sculptures of the Western façade are ranged. The symbols of the four evangelists surround Him. In the archivolts, are the twenty-four elders of the Apocalypse and the angelic choir. On the lintel below stand the Twelve Apostles. The tympana over the two side doors show on one side the Virgin and Child, and on the other the Ascension into Heaven—the beginning and the end of Christ's life on earth. The story of this life is told in a long row of reliefs carved into the imposts; while below, standing on brackets supported by the column shafts, the Ancestors of Christ flank the three entrances. Both the Old and New Testament are therefore represented. Moreover, the Signs of the Zodiac, the Occupations of the Months and the Seven Arts and Sciences which decorate the voussoirs over the side doors show that the kingdom of the Saviour extends over the time and over the wisdom of this world. Thus everything is ranged around Christ in Glory. His strictly frontal attitude and the aureole which encircles Him represent Him as outside the conditions of time and space.

The geometric diagram consists of a progressive series of six circles related in the divine proportion.

The width of the base of the tympanum is taken as the diameter of circle III ; the centre of the circle coincides with the bottom of Christ's aureole. The figures are symmetrically arranged on either side of the vertical axis which passes through the centre of the aureole.

The diameter of the nimbus = radius of circle VI.

PLATE XI

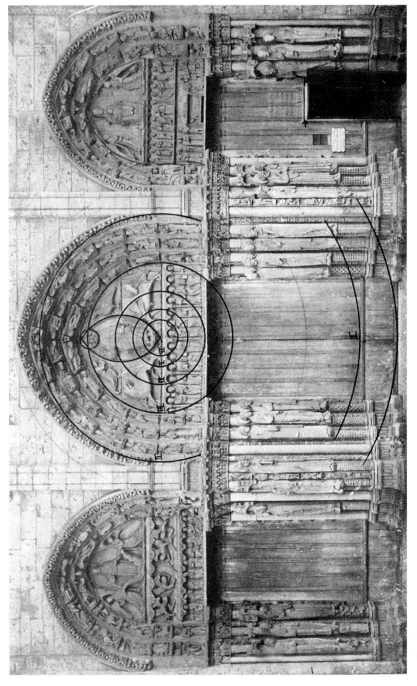

CHRIST IN GLORY, PORTAIL ROYAL
(Chartres)

1150–1175

The width of the aureole = radius of circle IV.

The measurements of the nimbus and of the aureole and of the base of the tympanum are therefore related to one another.

b. *Aureoles and Nimbi.*

In the picture by Francesco Traini (Plate III) the geometric relation of nimbi and aureoles is more obviously displayed than would perhaps be the case in the work of a greater master.

Taking the interior circle of the nimbus round the head of St. Thomas Aquinas as the first of a series of six circles related in the divine proportion we find that—

Circle II = exterior ring of the nimbus of the saint.

The radius of circle II = diameter of the six smaller nimbi above.

The diameter of circle II = length of the blade of St. Paul's sword. Circle III is inscribed in the aureole of Christ.

The diameter of circle III = the distance from the base of the picture of the horizontal plane on which Plato and Aristotle are standing.

Circle V corresponds to the exterior circumference of the dark ring round the figure of St. Thomas.

The circles are drawn from three centres situated on the vertical axis which divides the picture into two symmetrical parts.

The base of the picture = the diameter of a pentagon inscribed into circle VI, and this serves as the largest diameter of the aureole behind St. Thomas.

It will be seen that also in the pictures reproduced below the sizes of the nimbi are related ; being circular in shape they are, so to speak, akin to the concentric circles of the geometric diagram which underlies the composition. *These disks are indeed the most tangible manifestation of the invisible geometric foundation. Moreover, they seem to belong to a different world than the rest of the picture ;* for they are made to represent a substance which does not occur elsewhere. In Christian iconography the nimbus * stands for a cloud of light and is used to adorn the heads of persons of divine or saintly nature like rays of light emanating from one centre. The term " halo," which is derived from the Greek ἅλως, and denotes the luminous ring round the sun or moon due to the presence of ice-crystals in the air, is therefore more expressive than the Latin word nimbus—a cloud.

The aureole is but a larger form of nimbus, which is used almost exclusively as an attribute of divinity or of the Virgin Mary, who ranked immediately after the Trinity,

* See A. N. Didron, *Christian Iconography*, I, Part 1.

and was honoured first among human beings. The substance of the aureole was conceived as heavenly fire. The Deity being purely spiritual could not be represented, and therefore, wherever men desired a picture of the Immaterial and Invisible, they compassed Him with the most ethereal element, namely fire.

Pseudo-Dionysius the Areopagite, whose semi-oriental system of speculative mysticism came to be accepted as the work of a convert of St. Paul and invested with semi-apostolic authority, enumerates the properties which the celestial substance has in common with fire. " Fire exists in everything, penetrates into everything and is nevertheless independent of everything. Although it sheds a full light, still it is at the same time hidden. Its nature is unknown, unless some material be given to induce the exertion of its power. It is invisible, as well as unquenchable, and it has the faculty of bringing under its own energy everything it touches. . . . It renews everything by its vital heat; it illumines everything by its flashing beams; it can neither be confined nor intermingled . . . it sets in motion everything around it. It has the power of comprehending, but cannot itself be comprehended. It needs no other. It increases silently and breaks forth in majesty upon all receptive material. It generates, it is powerful, invisible, and omnipresent. If neglected, its existence might be forgotten; but on friction being applied, when as it were we seek to find it, it flares up and shines resplendent in its own nature, soaring into the air. For this reason those who are wise in the things of God depict the celestial Beings under the image of Fire showing their godlike nature." . . .* In the guide-book to painters found at Mount Athos, artists were advised to inscribe the three letters ὁ ὤν on the nimbus of God. " For it is by these words that God was pleased to reveal Himself to Moses in the burning bush : ' I am that I am.' "† So, in pictures the all-pervading and invisible heavenly fire took the shape of disks of shining gold or of rings of subtle ether, whose proportions were in harmony with the all-pervading and hidden rhythm of the spacing.

Plate XII shows a very decorative way in which nimbi and aureoles were combined into expressive designs. The illumination is taken from a Gospel manuscript of the tenth century, executed at the monastery of Reichenau,‡ where during the reigns of the Saxon emperors a distinguished school of miniaturists flourished. Byzantine traditions were freely adapted to suit the taste of the period. The four evangelists of whom St. Luke is here represented are shown enframed in archways in ecstatic attitudes against backgrounds of burnished gold. Head and figure are encircled by aureoles. Ranged

* *De Cælesti Hierarchia*, XV.
† Translation by G. Schäfer, Trier, 1855, p. 419.
‡ See Adolf Goldschmidt, *Die Deutsche Buchmalerei*, II.

PLATE XII

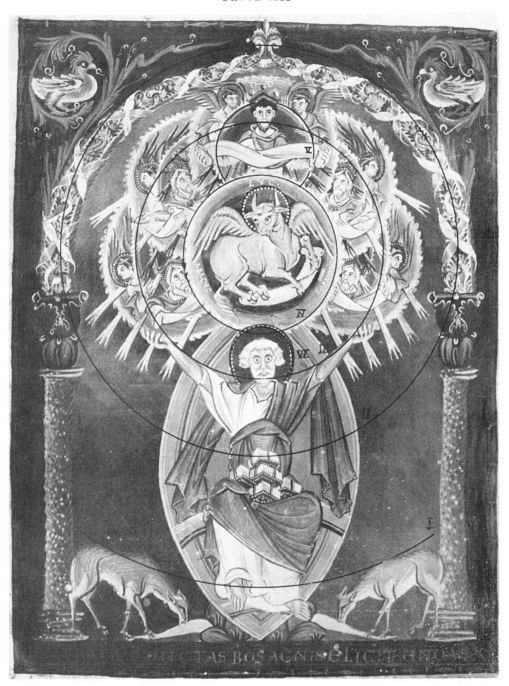

Reichenau, 10th century *Photo. Benno Filser, Augsburg*

ST. LUKE
(State Library, Munion. Cod. Lat. 4453)

around in circles are the prophets and angels who inspired them. Firelike rays are darting in all directions. It is as if the artist had seen a supernatural vision. Rhythmic motion flows through the compositions, and on examining the various measures we find that they are related in the divine proportion.

The diameter of circle II = distance between the axes of the columns.
The six circles of the diagram are related in the divine proportion.
The width of the aureole round the figure of St. Luke = radius II.
The diameter of the nimbus round the head of the ox = radius V.

In Gothic cathedrals the Western façade is often pierced by an immense circular opening, which is called the rose-window. This opening is divided by a geometric pattern of stonework into four, five or six concentric rings, which are decorated with designs in coloured glass. In the innermost circle God is represented seated on His throne, or the Virgin holding the Infant Saviour in her arms. A choir of angels surrounds this central group ; then come rings with patriarchs, apostles, martyrs and confessors of the faith ; and finally a wreath of virgins. These figures are all designed in glass of glowing colours, and the light shining through transforms the whole gigantic rose into one resplendent halo. These rose-windows are aureoles encircling the Christian world.

We have seen that the sculptures which decorate the porches are arranged on a similar plan. The archivolts are sections of concentric rings of stone carved with figures, each ring being ascribed to one particular feature or rank in Christian cosmography. Indeed all mediæval Christendom was ranged in concentric circles around one centre.

c. *Dante's Zones of Heaven.*

The age of Chartres was also the age of St. Thomas Aquinas and of Dante. The mystic literature of the time gives expression to the same philosophy of space as the architecture of the cathedrals. Dante, who was a philosopher and a theologian as well as the greatest poet of his time, and who was conversant with all the literature then accessible and all the science hitherto attained, gives the following description of the Tenth Heaven in the *Convivio :*

" This is the sovereign edifice of the world, in which the whole world is included and outside of which nothing is." (II. 4.)

In the *Paradiso* he conceived this heaven as a gigantic rose, built of circular expansions of light similar in arrangement to the rose window of a Gothic cathedral. Innumerable hosts of angels and souls rise tier above tier to the Central Source and Fountain of

Light, revealing Himself in three luminous circles. In one of these there appeared the image of Christ. The poet, wondering, tries to fathom how the human form is adapted to the divine circle, as a geometrician vainly attempts to measure the circle.

O isplendor di Dio, per cu'io vidi
l'alto triunfo del regno verace,
dammi virtù a dir com'io il vidi.

Lume è lassù, che visibile face
lo creatore a quella creatura,
che solo in lui vedere ha la sua pace ;
e si distende in circular figura
in tanto, che la sua circunferenca
sarebbe al sol troppo larga cintura. . . .

sì, soprastando al lume intorno intorno,
vidi specchiarsi in più di mille soglie
quanto di noi lassù fatto ha ritorno. . . . XXX. 97-114.

In forma dunque di candida rosa
mi si mostrava la milizia santa,
che nel suo sangue Cristo fece sposa ; . . . XXXI. 1-3.

Nella profonda e chiara sussistenza
dell'alto lume parvemi tre giri
di tre colori e d'una continenza ;
e l'un dall'altro, come iri da iri,
parea reflesso, e 'l terzo parea foco
che quinci e quindi egualmente si spiri. . . . XXXIII. 115-20.

Quella circulazion, che sì concetta
pareva in te, come lume riflesso,
dagli occhi miei alquanto circonspetta,
dentro da sè, del suo colore stesso,
mi parve pinta della nostra effige,
per che 'l mio viso in lei tutto era messo.

Qual è 'l geometra, che tutto s'affige
per misurar lo cerchio, e non ritrova,
pensando, quel principio ond'egli indige ;
tal era io a quella vista nuova :
veder voleva come si convenne
l'imago al cerchio e come vi s'indova ; . . . XXXIII. 127-38.

O splendour of God ! by means of which I saw
The lofty triumph of the realm veracious,
Give me the power to say how it I saw !

PLATE XIII

DANTE'S PARADISO
(*Kupferstichkabinett, Berlin*)

Botticelli

There is a light above, which visible
Makes the Creator unto every creature,
Who only in beholding Him has peace,
And it expands itself in circular form
To such extent, that its circumference
Would be too large a girdle for the sun. . . .

So, ranged aloft all round about the light,
Mirrored I saw in more ranks than a thousand
All who above there have from us returned. . . . XXX. 97–114.

In fashion then as of a snow-white rose
Displayed itself to me the saintly host,
Whom Christ in His own blood had made His bride. . . . XXXI. 1–3.

Within the deep and luminous subsistence
Of the High Light appeared to me three circles,
Of threefold colour and of one dimension,
And by the second seemed the first reflected
As Iris is by Iris, and the third
Seemed fire that equally from both is breathed. . . . XXXIII. 115–20.

That circulation which being thus conceived
Appeared in thee as a reflected light,
When somewhat contemplated by mine eyes,
Within itself, of its own very colour
Seemed to me painted with our effigy,
Wherefore my sight was all absorbed therein.

As the geometrician, who endeavours
To mete the circle, and discovers not,
By taking thought, the principle he wants,
Even such was I at that new apparition;
I wished to see how the image to the circle
Conformed itself, and how it there finds place. . . . XXXIII. 127–38.

Translation by H. W. Longfellow.

Botticelli, a leading artist of the Florentine Renaissance, illustrated Dante's *Divina Commedia ;* and we reproduce on Plate XIII one of his drawings of the *Paradiso* showing the souls circling like flames around the central deity. A picture, now in the National Gallery, and mentioned by Vasari as having been painted by Botticelli for S. Pietro Maggiore in Florence, gives an interesting representation of heaven, which corresponds to Dante's conception. Above the tomb of the Virgin the sky is opened and displays a gigantic golden dome which is divided into three zones. In the centre of the highest Christ is seated encircled by a threefold aureole. Cherubim and Seraphim surround Him and the Virgin kneels in front of Him. The two zones below are occupied by angels, apostles and saints. (Plate XIV.)

Vasari in describing the picture says : " The zones or circles of heaven are there painted in their order. The patriarchs, the prophets, the apostles, the evangelists, the martyrs, the confessors, the doctors, the virgins and the hierarchies, all which was executed by Sandro according to the design furnished to him by Matteo Palmieri, who was a very learned and able man." * Palmieri, the donor of the picture, was an admirer of Dante and is known to have written a book of verses entitled *La Città di Vita*, in imitation of the great poet. After the author's death this book gave rise to much controversy, as it was thought to contain certain heresies and the picture was then covered from view.†

PLATE XIV.—THE ASSUMPTION OF THE VIRGIN

By Botticelli ‡ (1444–1510), National Gallery, London.

The geometric diagram consists of four concentric circles related in the divine proportion. The diameter of circle I = the width of the picture. The composition is symmetrically disposed on either side of the vertical axis, which passes through the figure of Christ above and the tomb of the Virgin below. The dome-shaped opening in the sky rests on the highest point of circle IV. The group of apostles by the tomb is enclosed in circle III and the donor and his wife kneel just outside circle II.

* Vasari, *Lives of the Most Eminent Painters*, trans. by Mrs. T. Foster, Vol. II, p. 233.
† Richa, *Chiese Fiorentine*.
‡ The painting is now sometimes attributed to Botticini. It is not in its original state and bears evidence of wilful injury, subsequent restoration and much over-painting.

PLATE XIV

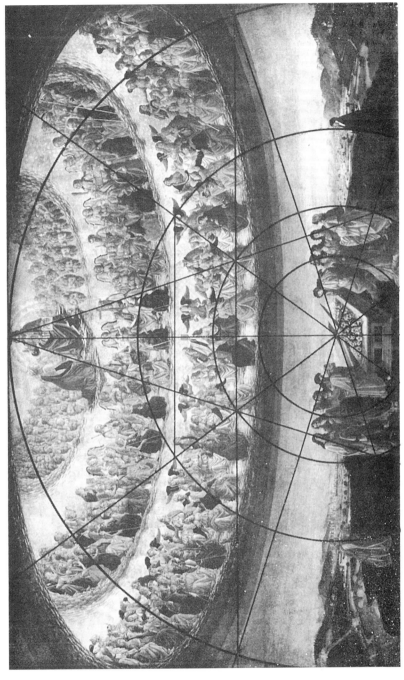

THE ASSUMPTION OF THE VIRGIN
(*National Gallery, London*)

Botticelli?

PLATE XV

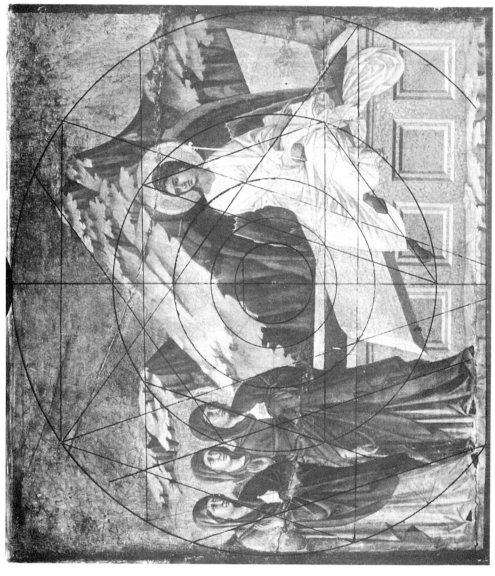

Duccio

Photo. Anderson

THE THREE MARIES AT THE TOMB OF CHRIST

(Opera del Duomo, Siena)

CHAPTER XII

ITALIAN PAINTING

a. *The Origin.*

VASARI begins his history of Italian art with Cimabue, whose appearance in Florence during the latter half of the thirteenth century marked the beginning of a great artistic revival. He was held in high esteem by his contemporaries, and Dante refers to him as holding the field in painting.

> " Credette Cimabue nella pittura
> Tener lo campo."—*Purg.* XI. 94–95.

Unfortunately no authentic picture by the master has survived, and the works attributed to him cannot be proved to be by him with any degree of certainty. There is, however, an interesting passage in the *Codex Gaddiano* * which throws some light on the style of his painting. It says that Cimabue rediscovered the true proportion, called by the Greeks symmetry, and that he used the Greek method in his works.

" Esso fu che ritrovo la vera proportione da Grecj chiamata Simetria . . . e teneva nell' opere sue la maniera Greca." †

We are able to study the " maniera Greca " in the work of a contemporary of Cimabue. Duccio at this time painted his great masterpiece for the Cathedral of Siena which has come down to us in good condition. We do not know where Duccio learned his art. But both Ghiberti and Vasari agree that he too painted in the " maniera Greca," ‡ and it is believed that his training derived directly from Byzantine sources. He may be called the last and greatest representative of the Byzantine tradition, which for the space of eight hundred years preserved and handed down to posterity principles of ancient Greek art.

Duccio then stands between two eras. His art represents on the one hand the consummation of ancient traditions, and on the other hand the dawn of new developments.

* *Codice Magliabechiano*, XVII. 17, edited by Carl Frey, 1892, p. 49.

† The *Codex Gaddiano* was written about 1542–50 and contains a collection of extracts about the lives and works of Italian artists from Cimabue to Michelangelo. These extracts are probably made from the *Libro di Antonio Billi*, which also served as a source for Vasari's *Vite*.

‡ Vasari, ed. Milanesi, I. 655. Lorenzo Ghiberti *Commentarii*, II. See also *Cod. Magliab.* XVII. 17, edited by Carl Frey, 1892, p. 86.

PLATE XV.—THE THREE MARIES AT THE TOMB OF CHRIST

By Duccio di Buoninsegna, 1260–1319. Opera del Duomo. Siena.

This panel forms part of the Maestà, painted for the Siena Cathedral in 1308–11. The geometric diagram is based on a progressive series of five concentric circles related in the divine proportion. The width of the picture is taken as the diameter of circle I.

The height of the picture corresponds to the diameter of the pentagon inscribed in circle I.

Outstanding Measurements.

The height of the angel from head to toe and that of the front Mary are equal to the height of the pentagon inscribed in circle II.

The diameters of the nimbi of the Maries are equal to the radius of circle IV.

The diameter of the nimbus of the angel corresponds to the height of a pentagon inscribed in circle V.

The length of the lid of the sarcophagus on which the angel is sitting is equal to the diameter of circle II.

The positions of the figures are determined by the lines of the diagram.

The figure of the angel is inscribed into a section of circle II, while the three Maries on the other side occupy a corresponding section of circle I further away from the centre. Thus the two sides of the picture balance each other.

Although the composition conforms very closely to the geometric diagram, the genius of the artist was not tramelled by it; on the contrary, the restrained and impressive attitude of the figures which is to some extent due to the geometric basis contributes to the beauty of this art.

b. *The Quattrocento.*

PLATE XVI.—THE HOLY TRINITY

By Masaccio, 1401–28. Santa Maria Novella. Florence.

The geometric diagram is based on a progressive series of five concentric circles related in the divine proportion. Circle III fits into the arch.

The height of the archway = radius of circle I plus radius of circle II.

Height of capitals of columns = radius of circle V.

The radius of the outside curve of the arch = diameter of circle IV.

The outside distance of the two pillars = diameter of circle II.

Width of the pillars = radius of circle V.

PLATE XVI

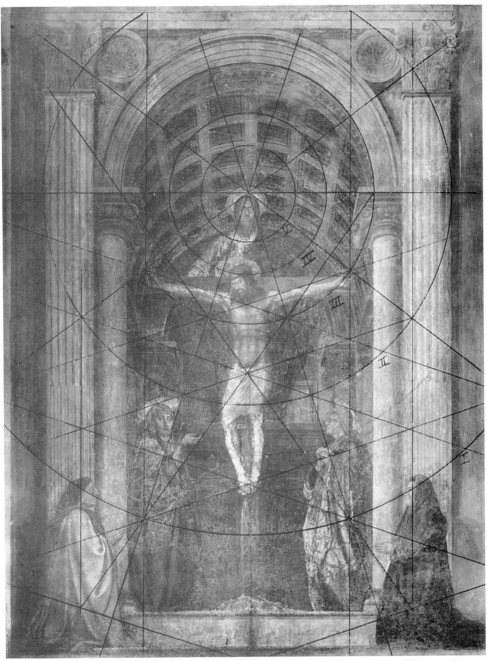

Masaccio

Photo. Anderson

THE HOLY TRINITY
(S. Maria Novella, Florence)

PLATE XVII

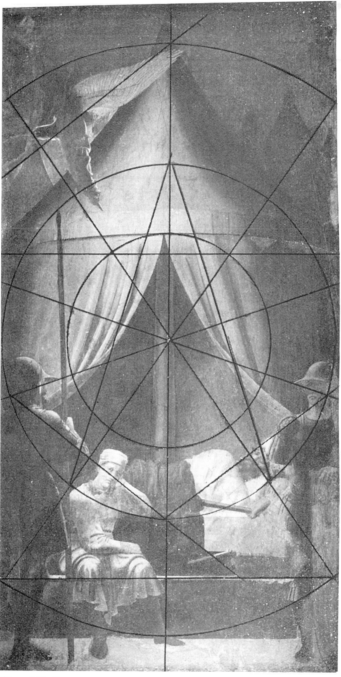

THE DREAM OF CONSTANTINE

(S. Francesco, Arezzo)

The vanishing point, to which the receding lines of the vaulted ceiling converge, coincides with the lowest point of section of the diagram at the bottom of the fresco.

The Holy Trinity is inscribed into the inner circles, while the outer circles are occupied by human beings.

The centre of the circles is situated inside the nimbus of God the Father. The Dove is suspended on the circumference of circle V.

The circumference of circle IV passes through the nimbus of Christ. His outstretched arms follow the sides of pentagons inscribed in circle III. The Virgin and St. John standing close by underneath the Cross occupy the space between circles I and II; and the two donors kneel outside circle I.

With Masaccio began the search for the rendering of three-dimensional space, and for the placing therein of figures, plastically conceived. These qualities were foreshadowed tentatively in Giotto's work, but with Masaccio they became a science eagerly pursued. Vasari says that he recognized that the art of painting consisted in the rendering of things as they are.* This, of course, does not mean that the artist favoured the naturalistic tendency of more modern days when it was thought that a picture must rival the products of a photographic camera. Such things were unheard of in those times.

But Vasari meant that for the first time a picture was conceived as a stage, where men, trees and buildings take their relative places. This was an innovation and a great discovery, for during the Middle Ages painting was more or less symbolic in character. It was thought impossible to represent three-dimensional objects on a flat surface. At any rate the idea does not seem to have occurred to the painters of that time. In developing it the artists of the Renaissance were inspired by the architectural remains of classical antiquity. Masaccio's figures stand within a three-dimensional space which is attuned by architecture. The recently established rules of perspective are correctly applied and depth is thereby given to the pictured space. The vaulted archway is so perfectly designed according to Roman models that one is forcibly reminded of Brunelleschi's studies in Rome (see p. 2). In the pursuit of their new aims, artists did not discard the geometric scheme which Duccio had applied with such fine results, but adapted its use to the new style. The position of the figures, the architectural setting, and the perspective scheme are all co-ordinated by the geometric diagram, which welds these various elements into unity as far as the representation of things as they appear permitted. For form and space could not be so easily adapted to a geometric pattern, as Duccio's two-dimensional symbolic painting.

* Vasari, *Le Vitæ*, ed. Milanesi, II. 288.

PLATE XVII.—THE DREAM OF CONSTANTINE

By Piero della Francesca, 1416–92. Fresco in the choir of San Francesco at Arezzo.

The geometric diagram is based on three concentric circles related in the divine proportion. The width of the picture = diameter of circle II which encircles the opening of the tent.

The design of the figures and of the drapery of the tent follows very closely and deliberately the geometric diagram.

PLATE XVIII.—BAPTISM OF CHRIST

By Piero della Francesca. National Gallery, London.

The geometric diagram is based on a progressive series of four concentric circles, related in the divine proportion. The width of the painting is taken as diameter of circle I. The height of the painting = diameter of circle I + radii of circles II and IV.

The placing of the Dove in the centre of the concentric circles gives mystic significance to the composition.

Outstanding Measurements.

Height of Christ and St. John = $\frac{1}{2}$ radius of circle III, plus diameter of circle II.
The height of St. John is divided into the divine proportion by his girdle.
Height of two of the angels on the left = diameter of circle II.

Piero della Francesca was born in Borgo San Sepolcro in Umbria. He served apprenticeship under Domenico Veneziano in Florence, and was there introduced to the art world of the Early Renaissance. The problems on which the attention of artists was then focused appealed to his mathematical mind, and he carried investigations further than Brunelleschi and Alberti; for he was a mathematician and applied his science to his art.

Vasari, who speaks of him with great admiration, does not fail to underline Piero's twofold accomplishment and calls him the greatest geometrician of his time. In his native town of Arezzo he must indeed often during his youth have had opportunities of studying the master's frescoes, which were then still in prime condition. Piero's scientific bent led him to experiment in problems of perspective and proportion and his pictures reveal clearly the mathematical mind of their author, for they obviously are carefully and scientifically composed arrangements, the result of theories and calculations. He dreamed of an art which might proceed, like science, by pure calculation to

PLATE XVIII

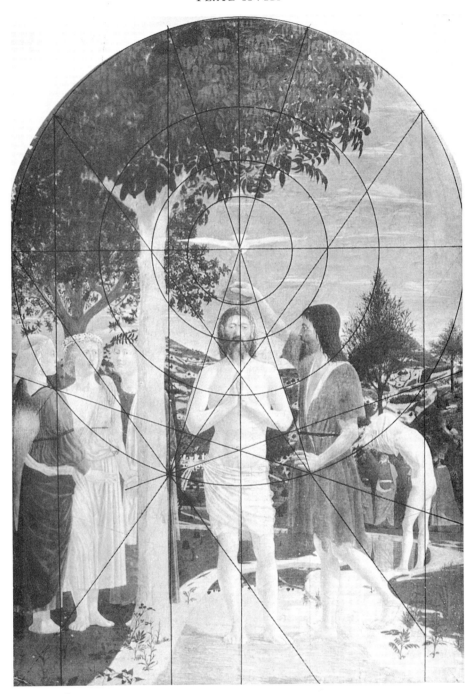

Piero della Francesca

THE BAPTISM OF CHRIST
(National Gallery, London)

PLATE XIX

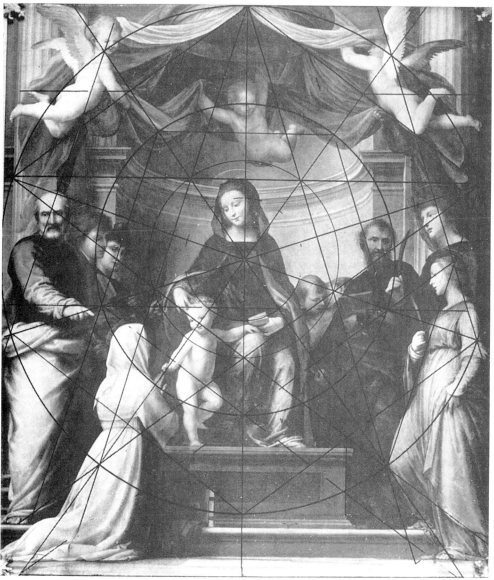

VIRGIN AND CHILD WITH SAINTS

(Louvre)

discover the quantities which command beauty ; moreover, he was interested in effects of light and of " plein air " ; and in more than one respect evinced a tendency which may be called naturalistic when compared with that of his predecessors. But his naturalism was a translation of nature into design of a very fine character, for he had a keen eye for the decorative quality in things which was developed and trained by the painting of large frescoes. Natural form was simplified and co-ordinated into an all-embracing organization of space.

In his art " a kind of spiritual geometry served to express the tension of his inner exaltation." *

At the end of his life, considering his work completed, Piero retired to his native town in Umbria, where in quiet concentration he wrote two treatises, one on perspective † and another on the five regular solids,‡ with the object of providing a mathematical foundation for the coming generation of artists. Fra Luca Pacioli, who as we have seen above (p. 6) was mathematical adviser to artists of his time, claimed him as his master. Thus Piero's mathematical theories proved to be an important factor in the development of Italian art. He was indeed a typical exponent of a school of thought which during the Early Renaissance laid the foundations for the great age which was to follow.

c. *The Cinquecento.*

PLATE XIX.—VIRGIN AND CHILD WITH SAINTS

By Fra Bartolommeo, 1472–1517. Louvre, Paris.

The geometric diagram is based on a progressive series of four concentric circles related in the divine proportion.

The width of the picture is taken as the diameter of circle I.

The height of the picture = diameter of circle I + radius of circle IV.

This picture is typical of Fra Bartolommeo's compositions. Speaking in terms of architecture one may say that concentric circles govern both the elevation and the plan of the picture. For the baldachin and the niche are conceived on a circular plan. The placing of the figures conforms to the scheme. The Virgin is the centre, round her the saints are standing and the angels above are floating round the same pivot.

Fra Bartolommeo may be called the architect among the painters of the Florentine School. His spatial arrangements are clear, simple, and three-dimensional. There are no superfluous details. Everything is combined to form an integral whole.

* Roger Fry, *The Nation*, January 19, 1930.
† Petrus Pictor Burgensis, *De prospectiva pingendi*. Codex in the Royal Library at Parma.
‡ *Libellus de quinque corporibus regularibus*. The Vatican Library is in possession of this MS.

During his stay in Florence Raphael learned much from Fra Bartolommeo's style which afterwards served him to good purpose in his Roman compositions as we shall see below.

Outstanding Measures.

Height of platform inclusive of bottom step = diameter of pentagon inscribed in circle IV.

Height of platform = $\frac{1}{2}$ radius II.

Diameter of nimbi = $\frac{1}{2}$ radius III.

Height of St. Peter = radius I + $\frac{1}{2}$ radius II.

Height of the Saint standing on the extreme right = radius I + $\frac{1}{2}$ radius III.

Height of Virgin's head = $\frac{1}{2}$ radius III.

PLATE XX.—THE " ANSIDEI MADONNA "

Painted by Raphael in 1506. National Gallery, London.

The geometric diagram is based on a series of four concentric circles, related in the divine proportion.

The width of the altarpiece = diameter II.

The centre of the circles coincides with the vanishing point towards which the lines receding at right angles to the picture plane converge.

The semicircular arch behind the throne = half of circle III.

The horizontal divisions of the throne correspond to the divisions of the vertical diameter.

Christ is inscribed in the inmost circle, while the Virgin and saints are placed between the circumferences III and IV.

PLATE XXI.—THE SCHOOL OF ATHENS

By Raphael. 1483–1520. Fresco in the Stanzas of the Vatican.

The School of Athens by Raphael is a glorification of Greek philosophy. That such a subject was chosen with the assent of the Pope for the decoration of one of the walls of his palace is characteristic of the spirit of the times. The admiration with which the Renaissance humanists regarded classic antiquity was nowhere better expressed. The scene is enacted in a lofty hall of harmonious proportions. Three imposing archways are seen receding into the picture.

The geometric diagram is based on a progressive series of five concentric circles

PLATE XX

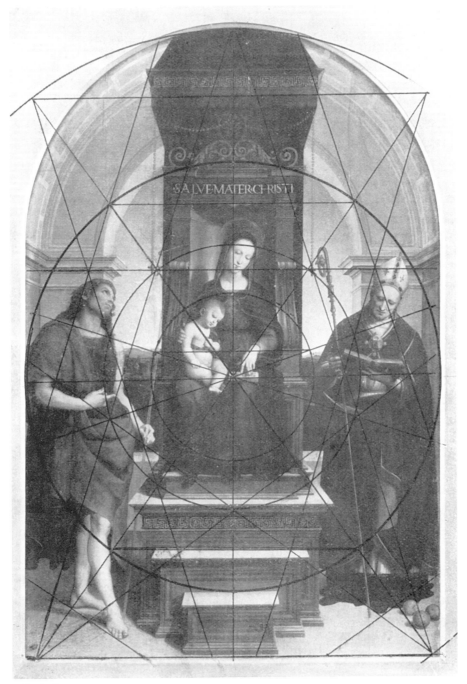

Raphael

THE "ANSIDEI MADONNA"
(National Gallery, London)

PLATE XXI

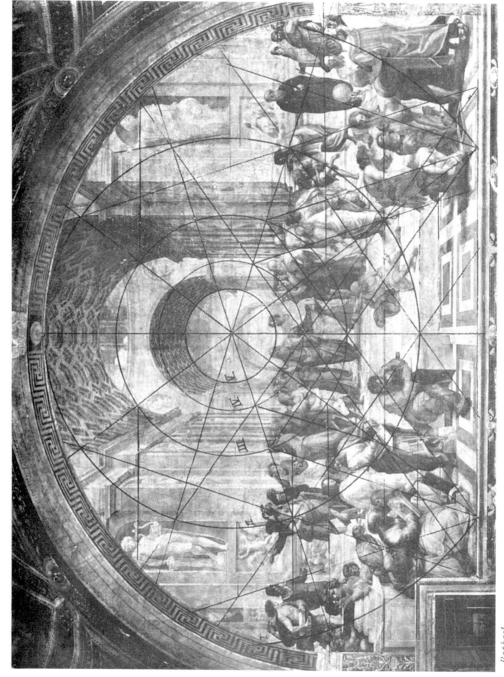

Raphael

THE SCHOOL OF ATHENS

(Vatican)

Photo. Anderson

related in the divine proportion. The diameter of circle I is equal to the width of the fresco, and a section of the circumference of this circle corresponds with the arch that enframes the fresco. The diagram is described so that circle II touches the apex of this arch. Circle V fits into the second archway in the background.

Two of the semicircles in the archway correspond to the halves of circles III and V of the diagram, while the diameter of another equals the radius of circle III. The vanishing point towards which the lines receding into the picture converge coincides with a point where the circumference of circle IV cuts the vertical diameter. So that the motion of the perspectively converging lines towards that particular point accentuates the geometric disposition which controls the composition. Plato and Aristotle occupy the centre of the composition. Their height corresponds exactly to the diameter of circle V. Plato is seen holding the *Timæus* in one hand, pointing heavenwards with the other. Aristotle holds the *Ethics* and lowers his right hand seemingly to emphasize the importance of the laws of nature. This hand touches the vertical axis. Around these two are grouped the various representatives of Greek philosophy. Four steps lead down towards the foreground where the dignified figure of Pythagoras is seated on the left, forming the centre of a group representative of music. The corresponding group on the right is devoted to astronomy and geometry. Here Ptolemy and Zoroaster are seen standing, each displaying a sphere, while Archimedes, to whom Raphael has given the features of the architect Bramante, is bending over a board and demonstrating a geometric problem with a pair of compasses in his hand to a group of eager disciples. The various groups are beautiful arrangements in themselves, and they are ranged symmetrically on either side of the vertical diameter, the figures which are placed near the centre of the circles being smaller than those further away. The figure of Diogenes sitting on the steps with his legs turned towards the right is balanced by the figure of the philosopher seated on the other side of the vertical diameter with his leg turned towards the left. The vast hall in which the scene is staged is an important feature of the composition. Indeed, without this architectural background the whole arrangement would fall to pieces.

The beauty of Raphael's frescoes in the Vatican depends primarily on their composition. Instead of partitioning the wall into a number of separate compartments as was the practice in the Quattrocento he boldly decorated the whole wall with one composition. In so doing he identified the space occupied by his pictures with the architecture of the room; he related the spatial proportions of his compositions to the proportions of the interior.

PLATE XXII.—THE MASS OF BOLSENA

By Raphael. Fresco in the Stanzas of the Vatican.

This fresco decorates another wall of the same apartment. It was painted later and the composition is simpler. The geometric diagram, based on a progressive series of five concentric circles related in the divine proportion, is placed, as in the preceding plate, so that the circumference of circle II touches the apex of the arch which enframes the composition. This arch is equal to a section of the circumference of circle I. The window frame which cuts awkwardly into the picture space is utilized as a platform on which the altar is placed. The top of the platform coincides with a horizontal diagonal of circle III and the steps correspond to other horizontal lines of the diagram. Similarly, the architecture of the background, the height of the choir stall and of the altar are determined by the horizontal divisions of the vertical diameter. The figures are ranged on either side of the vertical axis. The officiating priest is kneeling inside circle III, his hand is resting on a side of the pentagon inscribed into circle IV. The Pope is kneeling on the other side inside circle II with his hand resting on the corresponding side of the pentagon inscribed into circle III. The lay attendants are ranged on either side and below. The group of clergy kneeling behind the Pope on the right between the circumferences of circles I and II is balanced by the smaller group of kneeling acolytes placed nearer the centre between the circumferences of circles II and III.

PLATE XXIII.—THE SYBILS

By Raphael. Fresco in S. Maria della Pace, Rome.

The geometric diagram is based on two concentric circles, related in the divine proportion. The outside diameter of the arch is taken as the diameter of circle II.

The height of the fresco = radius of circle I.

Two additional circles are drawn passing through important points of section.

The diameter of the larger of these circles = the length of the base of the fresco = diameter II plus radius I.

The curve of the arch sets the tune to the composition. Angels and sybils are grouped around it in graceful movement. The figures stand out from the uniform dark background like statuary. They are classical in conception and might indeed be seated on the pediment of some ancient temple. While the paintings in the Vatican were composed inside the arch, here the figures are ranged around it ; but here too the spatial

PLATE XXII

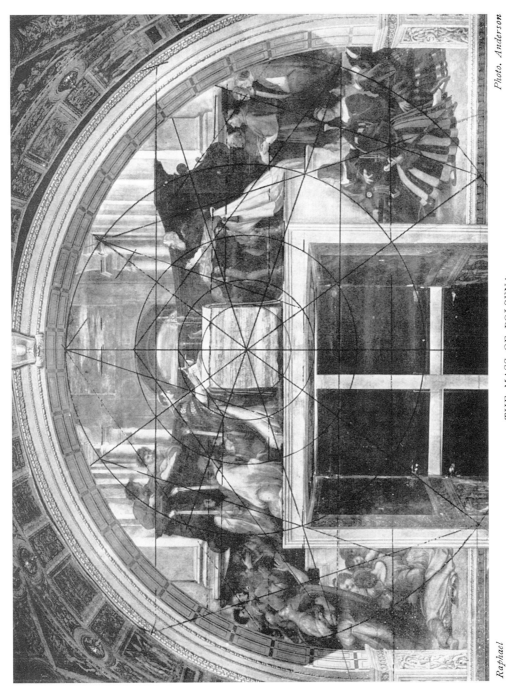

Photo. Anderson

Raphael

THE MASS OF BOLSENA
(Vatican)

PLATE XXIII

Photo. Alinari

Raphael

THE SYBILS

(S. Maria della Pace, Rome)

arrangement of the composition is identified with the architectural spacing of the interior. For the arch over which the fresco is composed, and which coincides with the circumference of circle II of the geometric diagram, forms an important feature in the construction of the nave of the church ; and the same rhythmic movement which pervades the church interior is echoed in the painting on the wall.

d. *Venice.*

The art of Venice developed apart from the rest of Italy. The interests of the city on the Adriatic were turned away from the mainland to the East and her extensive commerce and conquests there kept her in direct touch with the Byzantine tradition. They prized their connection with the Eastern Empire more highly than their relationship to the Italian States. The intellectual pursuits of Florence and the spiritual contemplation of Umbria must have seemed remote to the merchants and seafaring men who thronged the Rialto. Before they developed an art of their own, they looked to Byzantium to supply their needs. They sent there for craftsmen to decorate the cupolas of St. Mark's with mosaics, and they filled the treasury of their church with Byzantine enamel work. Finally, after the conquest of Constantinople, the Venetian galleys sailed home heavy laden with spoils from the church of St. Sophia, and if they could have transferred its world-famous dome bodily to Venice, they surely would have brought it home with them.

The conception of the sphere as a perfect shape had found a beautiful expression in this cupola. Rising high above the centre of the building, it forms its crowning feature. All other shapes lead up to it and are potentially contained in it. In the interior the great concave hemisphere resplendent in gold mosaic suggested the vault of heaven.

The five cupolas of St. Mark's are reflections of those on the Bosphorus. The artists who made them hailed from Byzantium and the arrangement and designs are Greek in conception. The three central cupolas are dedicated to the Triune God. In each of them One of the Trinity is represented in the zenith of a golden vault of heaven and rays of light descending downwards bring inspiration to the prophets, disciples, apostles and evangelists aligned in circles below.

It was natural that the art which developed under the shadow of these luminous domes was essentially a painter's art. Moreover, the ever-changing and iridescent sea, the vast expanse of space, the free horizon, and the colourful reflections of the palaces in the canals all conduced to awaken and inspire a love for colour ; and the painters in their pictures mirrored the glowing colours and the glittering architecture of the city on the lagoons. Again and again they place their figures into golden niches suggestive of the

smooth and mysterious hemispheres of St. Mark's. And so Venetian painting became the world's great school of colour just as Florentine art was its great school of form. While the rest of Italy during the course of the sixteenth century was being submerged in petty warfares and subjected to foreign invaders, the Venetian republic led by skilled statesmanship escaped unscathed; and the Venetian art of the sixteenth century enjoyed a pre-eminence equal to that which the Florentine art had obtained in the fifteenth.

PLATE XXIV.—THE VIRGIN AND CHILD

A Byzantine relief in the Church of St. Mark's, Venice.

This relief was brought from Byzantium and given a place of honour in St. Mark's. It is fastened to a pillar in the transept and illuminated by two candles. The belief is current that prayers addressed here are heard; and the form is partly effaced and the marble polished by the constant touch of worshippers. The diagram is composed of a series of seven circles related in the divine proportion.

The nimbus of the Virgin = circle III. The centre of this circle is situated in the pupil of the eye. The head of the Virgin is inscribed into circle IV drawn from the same centre.

The diameter of Christ's nimbus = the sum of the radii IV and VI.

The height of the relief = twice the diameter III.

The width of the relief = diameter of the pentagon inscribed in circle II.

PLATE XXV.—THE VIRGIN WITH SAINTS

Altarpiece painted in 1488 by Giovanni Bellini for the Church of the Frari in Venice.

The geometric diagram is based on a progressive series of five concentric circles with diameters related in the divine proportion. Circles IV fits into the semicircular vault of the niche; and its diameter is equal to the width of the central panel.

The distance between the vertical axes of the two wings = radius I.

The distance between the axes of the pillars flanking the side panels = radius III.

The Virgin is seated high upon a platform inside a golden niche, the size of which determines the proportions of the altarpieces shown above.

The altarpiece is composed of three distinct parts joined together in a carved frame. The three pictures are co-ordinated into one composition, and the architectural features of the framework conform to the painted architectural elements in the background of the pictures.

PLATE XXIV

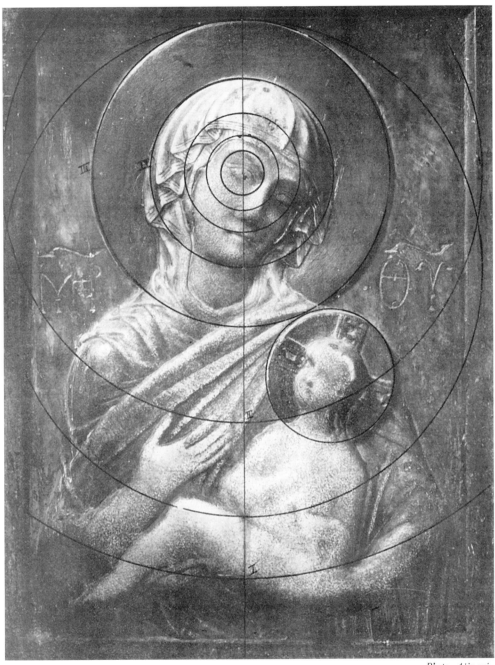

Byzantine Relief *Photo. Alinari*

THE VIRGIN AND CHILD
(S. Marco, Venice)

PLATE XXV

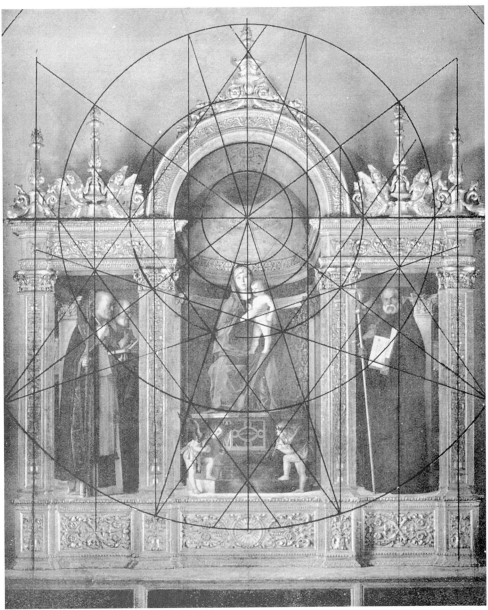

Giovanni Bellini

Photo. O. Böhm, Venice

THE VIRGIN AND SAINTS
(Frari, Venice)

PLATE XXVI

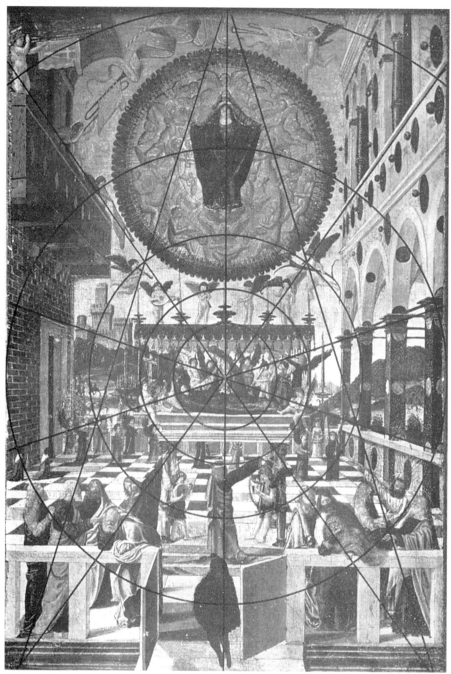

Carpaccio

DEATH AND ASSUMPTION OF THE VIRGIN
(National Gallery, London)

PLATE XXVI.—DEATH AND ASSUMPTION OF THE VIRGIN

Attributed to Carpaccio (*c.* 1450–1522). National Gallery (Layard Bequest), London.

The geometric diagram consists of a series of five circles related in the divine proportion. The width of the picture = diameter II. In this little panel the vanishing point of the lines receding at right angles to the picture plane coincides with the centre of the circles and the architecture of the room conforms to the diagram. The vertical axis is marked somewhat obtrusively by two figures placed one above the other in the foreground. The circumference of circle IV rests on the head and arm of the top figure. Above, the vertical axis is accentuated by the figure of the risen Virgin inscribed between two rising diagonals whose height equals diameter V in an aureole whose diameter is equal to radius II. It is curious to notice how ostentatiously the outstretched hands of the various figures and the trumpets of the angels point in directions prescribed by the diagram. The height of the balustrade in the foreground is equal to radius IV. The distance between its pillars is equal to radius V.

PLATE XXVII.—BACCHUS AND ARIADNE

By Titian, painted for Duke Alfonso of Ferrara, about 1520. National Gallery, London.

The geometric diagram is based on a series of five concentric circles related in the divine proportion and described from the centre of the picture. The width of the picture = diameter of circle I. The list of measurements which conform with the diagram is long. We note here only a few outstanding ones. The diameter of the chariot wheel = diameter of pentagon in circle IV. The diameter of the crown of stars over Ariadne's head = diameter V. The distance between the centres of the cymbals held by the Bacchante = diameter IV. The length of the vase lying in the foreground = radius V. The gap between the clouds = radius IV. The gap between the head of Bacchus and the uplifted hand of Ariadne = radius III. The gap between the advancing feet of Bacchus and Ariadne = radius II; and in the foreground, the gap between the foot of Ariadne and the foot of the Bacchante with the cymbals = radius I. The total length of the Silenus advancing behind Bacchus = radius I; the height of the little faun in the foreground = $\frac{3}{4}$ diameter III; and so on. The vertical diameter passing through the centre of the picture is marked by the rose-coloured mantle of Bacchus floating over circumference III, and by the right arm of Bacchus resting on circumference IV. In the foreground the same diameter determines the position of the flower and of the little faun whose head touches circumference IV. The top of Bacchus' chariot, on which the God's left foot is resting, touches the circumference of circle V. The calf's head that the

little faun is dragging behind him is balanced on the left by the dog whose muzzle touches the diameter of circle II. The line of the left leg of the advancing Silenus on the right is balanced within the circumference of circle II by the back of the leopard on the left. Ariadne on the extreme left is balanced by the bacchanal swinging the goat's leg on the extreme right. These two figures, both turning their backs on the spectator, are placed inside the circumference of the outer circle. The elements of the composition analysed so far are symmetrically disposed on either side of the vertical axis, giving stability to the design, the main feature of which is the impetuous advance of Bacchus and his followers towards the lonely figure of Ariadne. The direction of this advance is determined by the diameter sloping from the uplifted goat's leg on the extreme right, over the heads of the procession, towards the hand of Ariadne on the extreme left of the picture. The same direction is maintained by the disposition of the foliage, by the floating drapery of Bacchus and by his uplifted arm. All these follow parallel lines sloping downwards from right to left. A second series of lines are drawn on our diagram parallel to the vertical axis and coinciding with the sides of pentagons inscribed in the circles. These lines determine the position of the trees and figures. They seem to counteract the sweeping movement from right to left giving it rhythmic division. The more we analyse the picture the more we admire the ingenious way in which the geometric diagram was made to serve the artistic purpose of the master.

Our list of pictures might be continued indefinitely—indeed the difficulty has been to limit the choice. There were so many telling examples. Moreover, the scheme was not known to the Italians only. We can trace it in the works of other masters, though their knowledge of it seems only to have been partial. They may have learned it from Italy or from the stonemasons of their own cathedrals or from the illuminators of manuscripts, or it may have survived from the time when their own Romanesque churches were decorated with wall paintings. We cannot tell, for Byzantine influences came to Europe through various channels; but one thing seems certain; the real source of the geometric scheme was Byzantine.

Almost universal as was its use, how varied its application! Every artist could draw on it in his own way. It served Duccio for his impressive designs, Masaccio for his plastic conceptions, Raphael for his balanced compositions and Titian for his colour harmonies. El Greco used it for his mystic visions and Fragonard in his scenes of flirtation. For just as in music the rhythmic division of time can be made to express an allegro or an andante, a maestoso or a scherzo, so the rhythmic division of space can be made the foundation of different styles.

PLATE XXVII

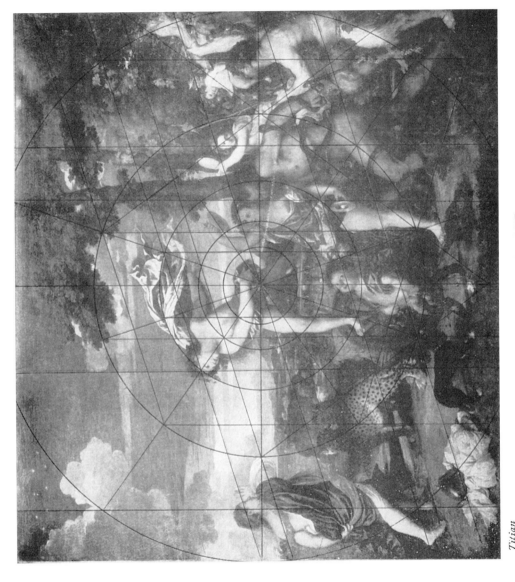

BACCHUS AND ARIADNE
(National Gallery, London)

Titian

PLATE XXVIII

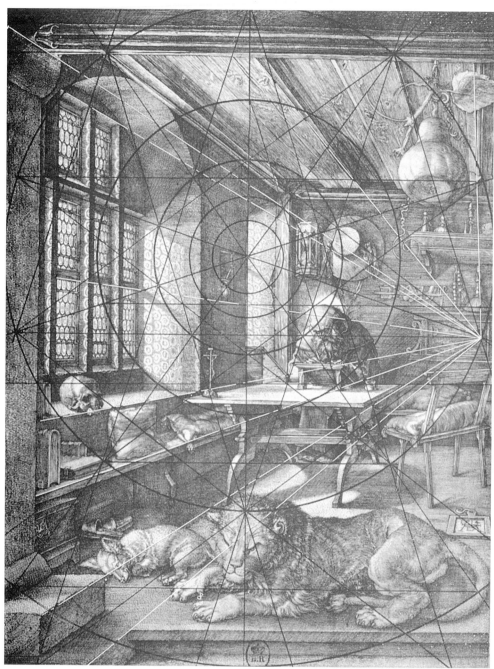

Dürer

ST. JEROME IN HIS CHAMBER

Photo. Giraudon

CHAPTER XIII

SOME MASTERPIECES OF OTHER SCHOOLS

PLATE XXVIII.—ST. JEROME IN HIS CHAMBER

Engraving by Dürer, dated 1514.

THE geometric diagram is based on a progressive series of six concentric circles related in the divine proportion. The width of the picture is taken as the diameter of circle II and the height is equal to the radius of circle I + radius of circle II.

Dürer's approach to art differed from that of the Italians; he was, however, fully alive to the new ideas which inspired them. He went to Italy twice and stayed some time in Venice, where he painted a large altarpiece for the church attached to the " Fondaco de Tedeschi." In a letter from Venice dated the 13th of October 1506 he wrote : " I shall have finished here in ten days ; then I mean to go on horseback to Bologna to learn the secrets of perspective which some one there is willing to teach me." Indeed, he was as keen as any Italian on the study of proportion, perspective and geometry (on the fly-leaf of an edition of Euclid which was in his possession he wrote that he had bought it in Venice in the year 1507), and yet his approach was different. He had not the classic background, and his philosophic mind, searching after truth independently, did not find Leon Battista Alberti's explanation of beauty (see p. 4). He said in despair, " Die Schönheit, was das ist, das weiss ich nicht." He thought that art must be true to nature ; and he strove to master completely the power of representation. His forms were not so constantly controlled by the architectonic sense inherent in all Italian art. The interior of the room represented in the engraving here reproduced is obviously drawn from nature. The figure of the aged saint absorbed in his writing takes its place unobtrusively in the corner of the comfortable room, which is filled with furniture and objects of daily use. The sun is shining through the window-panes and is playing on the casement and the floor. There can be no doubt these things are studied from nature although in a different spirit from the Italian.

The artist's interest is centred on the rendering of things rather than on their relation to each other. He had, however, attained the object for which he rode to Bologna

III

eight years before and had mastered the secrets of perspective. The construction of the chamber is perfect. All the lines receding at right angles to the picture plane converge towards one vanishing point. The beams of the ceiling, the horizontal bars of the window-frame, the bench and the step along the wall all point that way. Also the table is placed at right angles and shares in the same vanishing point. Moreover, the vanishing point towards which all these lines converge coincides with an important point of section on the circumference of circle II. So that the scheme of perspective is related to the geometric diagram and the motion of the perspectively converging lines towards that particular point concurs with five lines of the geometric diagram.

Outstanding Measurements.

The circumference of the large gourd hanging from the ceiling corresponds to the circumference of the innermost circle.

St. Jerome's hat hanging behind him on the wall is formed by two circles; the diameter of the larger one round the brim is equal to the diameter of a pentagon inscribed into the innermost circle; while the diameter of the smaller circle round the crown equals the radius of the same pentagon.

The length of the table-top is equal to radius III $+ \frac{1}{2}$ radius V.

PLATE XXIX.—THE DESCENT OF THE HOLY GHOST

By El Greco, 1545–1614. Prado, Madrid.

The geometric diagram is based on a progressive series of six concentric circles related in the divine proportion. The width of the painting is taken as the diameter of circle III.

The room in which the scene is taking place is undefined, and its architecture remains a mystery, yet we are conscious of a feeling of space. The Dove hovering over the centre in the top of the vault is the only source of light. Its wings are suspended underneath the circumference of circle III. The figures emerge out of darkness, lit up by a supernatural blaze. Tongues of fire are flaring over their heads and their expression and attitude are those of mystic ecstasy.

The Virgin occupies the centre and the tongue of fire over her head springs from the centre of the concentric circles. Her praying hands close on the vertical diameter and rest on the circumference of circle IV. Her limbs follow the direction of diagonals and her foot rests on the circumference of circle II. The disciples are gathered around

PLATE XXIX

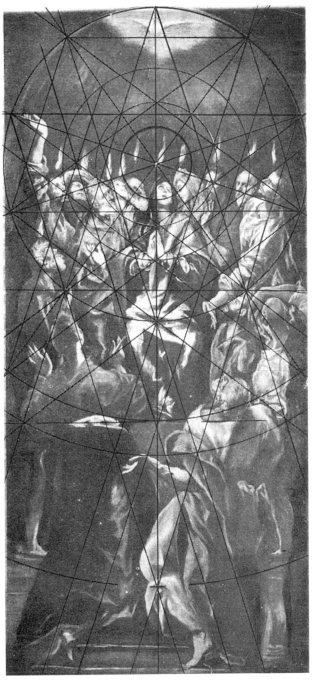

El Greco *Photo. Franz Hanfstaengl*
THE DESCENT OF THE HOLY GHOST
(Prado, Madrid)

PLATE XXX

Nicolas Poussin

A DANCE TO THE MUSIC OF TIME
(Wallace Collection)

her. Their heads are placed closely together forming a frieze which extends horizontally across the picture; below, two figures complete the ring by turning their backs on the spectator. To the extreme left a hand is raised in adoration, and its position is determined by the section of two sides of the pentagon inscribed in circle III. On the right side of the picture an outstretched arm rests on the circumference of circle III. The figures create a rhythmic ensemble. By touching the live wires of the spacing they seem to connect with a magnetic, unifying energy.

El Greco was a great exponent of the Baroque in the art of painting, when after a period of naturalism artists became conscious again of the beauty of abstract design. Every element in his composition forms part of a continuous theme. His colours and forms do not pretend to render nature as it is. The forms of nature were but the means by which to give shape to his idea; he strove by his art to stir the religious emotion of the onlooker. His chief work was done at Toledo in Spain, at the most Roman Catholic town, in the most Roman Catholic country, at the time of the Counter-Reformation. A quotation from the writings of his contemporary, St. Theresa, the great mystic of Spain, will help to explain the trend of El Greco's art. " I see a white and a red of a quality as one finds nowhere in nature, for they shine more brightly than the colours we perceive; and I see pictures, as no painter has as yet painted, whose models one finds nowhere in nature; and yet they are nature itself, and life itself, and the most perfect beauty imaginable."

PLATE XXX.—A DANCE TO THE MUSIC OF TIME

By Nicolas Poussin, 1594–1665. Wallace Collection.

The geometric diagram is based on four concentric circles related in the divine proportion.

The width of the picture = diameter of circle I.

The counterblast to the exuberance and abandonment of Baroque art came from France in the person of Nicolas Poussin. His art was reasoned and intellectual and he selected and combined what he admired in the classic art of the past, ranging his statuesque figures with subtle rhythm parallel to the picture plane as in an antique relief. In the picture here reproduced the artist's refined feeling for balance is admirably displayed.

Four female figures, sometimes identified as the four seasons, are dancing with their hands entwined in a ring to the sound of a lyre played by an old man with wings who personifies Time. The centre of the picture is occupied by one of the dancers

whose head touches the centre of the circles and whose arms follow the direction of two diameters. Turning their backs on her, two dancers are symmetrically arranged on either side. Below, the two infants in opposite corners balance each other; the herm on the left is balanced by the base on the right. A fourth dancer is placed between the circumferences of circles II and III; and in balance with her the figure of Time is seated between the circumferences I and II. His right foot and her left are placed on the horizontal base of a pentagon inscribed in circle I. Phoebus encircled marks the vertical diameter above. The heads of his coursers touch the side of the pentagon inscribed in circle II, and so does Aurora who precedes his chariot.

A treatise * written in Latin verse by Charles A. Dufresnoy throws light on the theories about artistic composition current at that time, and will help to explain the art of Poussin and of the classicists who followed him. The book was well known and was translated into English prose by Dryden in 1695. We are quoting here from the translation by William Mason which appeared in 1811 with notes by Sir Joshua Reynolds.

> In Egypt first the infant art appear'd,
> Rude and unform'd; but when to Greece she steer'd
> Her prosperous course, fair fancy met the maid,
> Wit, Reason, Judgment, lent their powerful aid;
> Till all complete the gradual wonder shone,
> And vanquish'd Nature own'd herself undone.
>
> Lines 129–34.

> Witness those marble miracles of grace,
> Those tests of symmetry where still we trace
> All art's perfection: with reluctant gaze
> To these the genius of succeeding days
> Looks dazzled up, and, as their glories spread,
> Hides in his mantle his diminish'd head.
> Learn then from Greece, ye Youths, Proportion's law,
> Inform'd by her, each just Position draw.
>
> Lines 139–46.

> Fair in the front, in all the blaze of light,
> The hero of thy piece should meet the sight.
> Supreme in beauty: lavish here thine art,
> And bid him boldly from the canvas start:
> While round that sov'reign form th' inferior train
> In groups collected fill the pictur'd plane;
>
> Lines 181–86.

* C. A. Dufresnoy, *De Arte Graphica*, 1695.

In every figur'd group the judging eye
Demands the charms of contrariety :
In forms, in attitudes, expects to trace
Distinct inflections, and contrasted grace,
Where art diversely leads each changeful line,
Opposes, breaks, divides the whole design :
Thus when the rest in front their charms display,
Let one with face averted turn away ;
Shoulders oppose to breasts, and left to right,
With parts that meet and parts that shun the sight.
This rule in practice uniformly true
Extends alike to many forms or few,
Yet keep thro' all the piece a perfect poise :
If here in frequent troops the figures rise,
There let some object tower with equal pride ;
And so arrange each correspondent side,
That, thro' the well-connected plan, appear
No cold vacuity, no desert drear.

Lines 193–210.

Judgment will so the several groups unite,
That one compacted whole shall meet the sight.

Lines 223–24.

This shows that the ancient laws of unity and balance still hold. Students are advised to group the subsidiary figures around the central motive and to study the Greek law of proportion and symmetry. They are told the old tale that these originally derived from Egypt ; but when the proportions referred to are specified, they turn out to be those of the human figure, and no mention is made of the divine proportion. On examining Poussin's composition it will be found that, although the figures are beautifully balanced within the circumferences of the concentric circles, their actual sizes are not related to the geometric proportions of the diagram, as was the case in Titian's Bacchanal, for instance. On the other hand, Poussin and the Classicists affected a learned, literary style unknown in former days. It seems, indeed, as if they were trying to make up for the gradual disappearance of the divine proportion by theorizing about the proportions of Græco-Roman sculpture and architecture.

In a letter to his friend A. M. de Chantelou dated November 1647 Poussin compares his painting to Greek architecture : " Nos braves anciens Grecs, inventeurs de toutes les belles choses, ont trouvés plusieurs modes par les moyens desquels ils ont produit des merveilleux effets. Ici cette parole ' mode ' signifie proprement la mesure et la forme dont nous nous servons pour faire quelque chose. . . .

" Les modes des anciens étant une composition de plusieurs choses mises ensemble, de la variété et différence qui se rencontrent dans l'assemblage de ces choses naissoit la varieté et difference des modes ; tandis que de la constance dans la proportion et l'arrangement des choses propres à chaque mode procédoit son caractère particulier c'est à dire sa puissance d'induire l'âme à certaines passions. De là vient que les sages anciens attribuèrent à chaque mode une propriété spéciale analogue aux effets qu'ils l'avaient vu produire. Ils appliquèrent le mode Dorien aux matières graves, sevères et pleines de sagesse . . . ils inventèrent l'Ionien pour peindre les émotions vives, les scènes joyeuses telles que les danses, les fêtes, les bacchanales.

" Les bons poètes ont également usé d'une grande diligence et d'un merveilleux artifice, non seulement pour accommoder leur style aux sujets à traiter, mais encore pour régler le choix des mots et le rythme des vers d'après la convenance des objets à peindre. Virgile surtout s'est montré, dans tous ses poëmes, grand observateur de cette partie, et il y est tellement éminent, que souvent il semble, par le son seul des mots, mettre devant les yeux les choses qu'il décrit."

Plate XXXI.—Heureux Hasards de l'Escarpolette

Painted in 1766 by Fragonard, 1732-1806. Wallace Collection, London.

The geometric diagram is based on a progressive series of four concentric circles related in the divine proportion. Two additional circles are described passing through points of section.

The width of the picture is taken as diameter for the circle II.

The lady is gracefully balanced on either side of the vertical diameter which she touches with her right hand. The sweep of her hat follows the curve of circle IV.

The swing of her pose that of circle III. Her left leg and the boy's arm stretch out along diagonals of circle I to touch the circumference of circle II.

The French art of the eighteenth century developed in the artificial atmosphere of a refined and mundane court. Its aim was to enchant and delight the senses by soft colour harmonies and graceful lines. Delicate effects of colour and flowing lines sufficed for the suggestion of form and all tectonic elements were discarded. Painting finally freed itself from its agelong subordination to architecture. But the general principles of geometric spacing were not discarded ; although, just as in Poussin's work, the sizes of the figures and accessories no longer correspond to the geometric proportions of the diagram.

PLATE XXXI

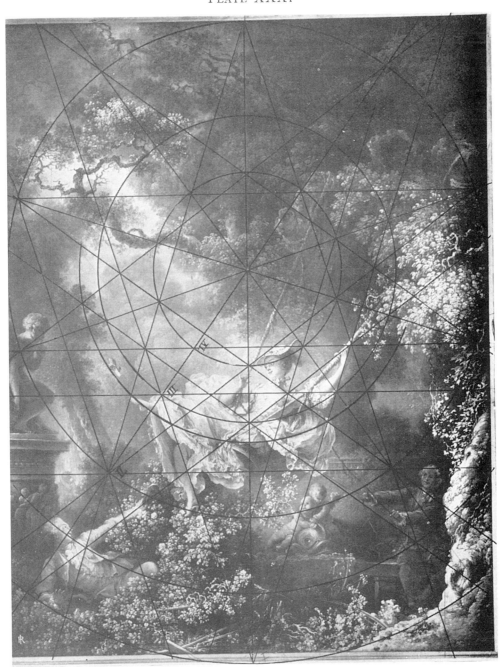

Fragonard

Photo. Anderson

HEUREUX HASARDS DE L'ESCARPOLETTE

(Wallace Collection)

PLATE XXXII

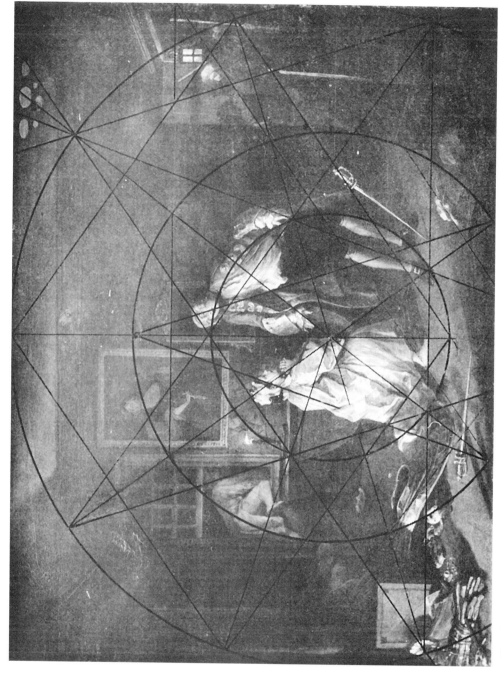

Hogarth

SCENE FROM "MARIAGE À LA MODE"
(Tate Gallery)

Fragonard was one of the greatest artists of the Louis Seize period. He was a native of Provence and a pupil of Boucher; five years spent in Italy as a student of the French Academy at Rome were devoted to the study of the Italian Baroque. Yet he remained essentially French. Indeed his conception is as different as it can be from that of his Italian models.

Pythagoras and the court of Marie Antoinette! There could be no greater contrast; nevertheless, the two opposing elements are blended in Fragonard's art. The fleeting sensations and the coquettish amusements of the Dix-huitième Siècle are grafted on the impersonal and eternal ideas of a world which had long ago disappeared, and they thereby acquire something of the greatness of Greece.

Modern painting then started with this heritage.

The tradition had survived to some extent in Holland, as is proved by a passage from the poem on the education of the artist by Carel van Mander, a Dutch artist of the seventeenth century: " Many painters pay special attention in their composition to a matter which I do not wish to oppose. They inscribe the chief subject of their historic composition in a circle, so that the chief actors of the story occupy the centre, forming a picture in itself which those outside admire and pray to." *

In England we meet with the old tradition somewhat unexpectedly at the beginning of the British school of painting in the work of Hogarth, who is generally believed to be independent of foreign influences.

PLATE XXXII.—THE DUEL AND THE DEATH OF THE EARL.

Scene from " MARIAGE À LA MODE."

By William Hogarth (1697-1764). Tate Gallery, London.

The geometric diagram consists of a series of three concentric circles related in the divine proportion. The diameter of circle I equals the width of the picture. The principal action takes place in the centre, where the dying peer leans against the circumference of circle III. The kneeling Countess is placed in the same circle. Her foot rests on the horizontal base of a pentagon inscribed in circle III and touches the vertical axis. " Silver-tongue," with whom she was surprised by her husband, escapes through the window on the left. His action and position is determined by the circumference of circle II. On the right the watch is entering; the foreman's hand rests on a slanting

* Carel van Mander, *Den Grondt der Edel Vry Schilder Const*, V. 23.

diagonal. However, the sizes of the figures and accessories do not conform to the geometric proportions of the diagram.

Hogarth seems not to have known the divine proportion, for only a part of the Greek tradition had survived. That he knew of the existence of a Greek law of proportion is, however, proved by his well-known book, the *Analysis of Beauty*. In the preface he relates how he came across an English translation of a treatise by Ten Kate, a learned Dutchman,* who claimed to have " the true key for finding all harmonious proportions in painting, sculpture, architecture, music, etc., brought to Greece by Pythagoras." Hogarth quotes extensively from this treatise :

" After Pythagoras the Grecians by the help of this Analogy began (and not before) to excel other nations in Sciences and Arts. . . . They carried on their improvements in Drawing, Painting, Architecture, Sculpture, etc., till they became the Wonders of the World . . . for which all other nations were afterwards obliged to the Grecians without being able so much as to imitate them. For when the Romans had conquered Greece and Asia and had brought to Rome the finest artists, we don't find that they discovered the great Key of Knowledge, the Analogy ; but their best performances were conducted by Grecian artists, who it seems cared not to communicate their secret of the Analogy ; because either they intended to be necessary at Rome, by keeping the secret among themselves, or else the Romans, who principally affected universal dominion, were not curious enough to search after the secret, not knowing the importance of it nor understanding that without it they could never attain to the excellency of the Grecians ; though it must be owned that the Romans used well the proportions which the Grecians long before had reduced to certain fixed rules according to their ancient Analogy ; and the Romans could arrive at the happy use of the proportions without comprehending the Analogy itself."

Two centuries ago, therefore, Hogarth in England and Ten Kate in Holland were searching for the lost key to " the secret " of Greek Harmony. They came to different conclusions. Hogarth thought he had found the solution in a precept attributed to Michelangelo, that a figure should be always " Pyramidall, serpent-like, and multiplied by one, two and three." By his adherents this thesis was praised as a final deliverance upon æsthetics, and by his rivals it was made the subject of endless ridicule.

Ten Kate, on the other hand, never published his solution. The essay on the *Beau Ideal* ends very disappointingly with some notes on the generally accepted pro-

* *The Beau Ideal*, by L. H. Ten Kate, translated from the original French by J. C. Le Blon, 1732. The original version, entitled *Discours préliminaire sur le Beau Idéal des Peintres, Sculpteurs et Poètes*, served as preface to *Traité de la Peinture et de la Sculpture* by Messrs. Richardson, père et fils, published in 1728.

portions of the human figure, based on simple numerical relations. The translator, Le Blon, does not reproduce these in his English version; but we are allowed to glean the following particulars from his preface:

"Mr. Ten Kate many years ago wrote an excellent book of the Grecian Analogy, but I could never persuade him to publish it to the world. I hope the manuscript is preserved among his valuable remains and I wish his surviving relatives may bless the world with it. But seeing that he has long ago communicated that secret to me, and I, knowing that he never intended to deprive posterity of such a treasure, am resolved as soon as my business permits me to publish a separate treatise of the said Analogy as it is applicable to painting, to which I intend to annex what Mr. Ten Kate hath said of the proportions of the human figure in the French edition of the *Beau Idéal*." We do not know whether he ever published his secret and are left to wonder what it was.

Hogarth claimed that everyone had a right to conjecture what this discovery of the ancients might be; and since then there has been no lack of theories, some intricate and others more or less plausible, claiming to solve the secret of Greek harmony. Meanwhile, in the art of painting, the practice of basing compositions on a geometric foundation fell more and more into disuse, and practically disappeared with the advent of Realism, Naturalism and Impressionism, until Cézanne and Seurat revived the interest in the art of building up compositions.

PLATE XXXIII.—BACCHANALS

A sketch in pencil and water-colour by Paul Cézanne, 1839–1906. Reber Collection.

The geometric diagram consists of four circles related in the divine proportion. The width of the picture is taken for diameter of circle I. The composition is drawn on the same principles as those adopted by the old masters. The landscape and the figures are balanced on either side of the vertical axis and seem to conform to the network of geometric lines. Note especially the action of the central groups, which follows the circumference of circle IV; and the dog on the right advancing towards the centre between the lines of two diagonals.

Roger Fry in his recent book on Cézanne suggested that the artist, perhaps unconsciously, followed similar rules of composition to those of Poussin: "The forms are held together by some strict harmonic principle almost like that of the canon of Greek architecture." *

How true that is, is disclosed by this composition, which accords so well with the

* Roger Fry, *Cézanne*, p. 48.

ancient formula as to make it difficult to believe that the process was unconscious. The rhythmic form which the artist used in his imaginative inventions he applied also to his studies from nature; as for instance, to the " Card-players " here reproduced.

PLATE XXXIV.—THE CARD-PLAYERS

By Paul Cézanne. Louvre.

The geometric diagram consists of three circles related in the divine proportion The width of the picture is taken for the diameter of circle I. The composition is symmetrically balanced on either side of the central axis. The lines of the arms, the collars, the pipe, the table-top all converge towards the centre. While the curves of the backs and hats rise like an arch over the central theme.

In contemplating this composition, Cézanne's saying that he wished to " do Poussin again after nature " acquires a new meaning.* His painting combined the Impressionist technique with the Classicist tradition. He did not rest content with the merely truthful rendering of Nature's fleeting effects, but used these as motives, deliberately emphasizing certain aspects. He selected clearly defined forms which by simplification were made to resemble geometric shapes; and he co-ordinated all elements into a harmonious whole. The space into which his compositions were set was a subjective space where figures had to conform to the laws of rhythm. " J'ai besoin de connaître la géometrie " is one of his sayings as reported by his friend, the poet Joachim Gasquet, who watched him painting in the fields near Aix. At another time he explained : " L'œil s'éduque au contact de la nature. Il devient concentrique à force de regarder et de travailler. Je veux dire que dans cette orange, dans une pomme, une boule, une tête il y a un point culminant et ce point est toujours le plus rapproché de notre œil. Les bords des objets fuient sur un autre placé à notre horizon."

The same friend reports a conversation about Kant which throws light on the philosophic speculations of the artist : " Il me semble que je serais la conscience subjective de ce paysage, comme ma toile en serait la conscience objective. Ma toile, le paysage, tous les deux hors de moi, mais l'un chaotique, fuyant, confus, sans vie logique, en dehors de toute raison, l'autre permanente, sensible, catégorique, participant à la modalité, au dramedes idées. . . . Dans ce tableau n'y aurait-il pas une philosophie des apparances plus accessible à tous que toutes les tables de catégories. . . . On sentirait en le

* See page v.

PLATE XXXIII

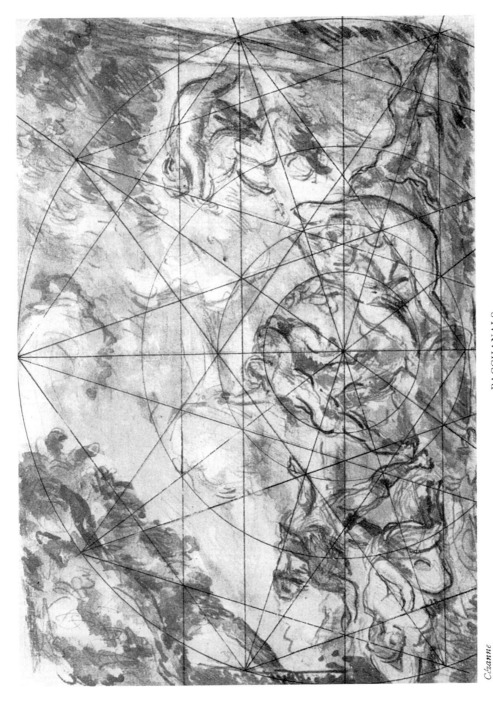

Cézanne

BACCHANALS
(*Reber Collection, Lausanne*)

PLATE XXXIV

Cézanne

Photo. Giraudon

THE CARD-PLAYERS

(Louvre)

voyant la relativité de toutes choses à soi, à l'homme. Je voudrais peindre l'espace et le temps pour qu'ils deviennent les formes de la sensibilité des couleurs, car j'imagine parfois les couleurs comme de grandes entités noumènales, des idées vivantes, des êtres de raison pure. . . . Si ma toile est saturée de cette vague religiosité cosmique, qui m'émeut, moi, qui me rend meilleur, elle ira toucher les autres." *

It may be interesting in this connection to refer to some conceptions regarding space in more recent philosophy.† Here a distinction is drawn between the abstract space of Euclidian geometry which is everywhere and in all directions constituted alike, which is unbounded and infinite, and space as perceived by the senses. In this *physiological* space everything is related through the sense-organs to the physical body of the percipient. Thus arise the distinctions of right and left, above and below, in front and behind. These three cardinal directions are distinctly marked on the body, together with the principle of symmetry. Therefore, in imprinting these conceptions on his work, an artist is shaping things in his own image ; he is deliberately or instinctively reacting to laws by which Nature works, and by which he himself has been framed. This, moreover, may also be the case when he is using the divine proportion, since that relation is to be found in the anatomy of the human body,‡ and is associated with fundamental principles of growth and energy.§ The diagram which has served in our analyses of compositions embodies these principles ; it is at the same time a simple yet subtle device for establishing relations of symmetry and balance, and, therefore admirably suited as a guide in artistic work.

This completes the list of typical examples selected from works of great painters of various countries. A much larger number of masterpieces have been examined by me, but it proved impossible to reproduce them all. The examples given may serve to provide and illustrate a method by which the principles of artistic composition may be studied from many other instances. It will be found a fascinating occupation.

* J. Gasquet, *Cézanne*, 1921.

† E. Mach, *Space and Geometry*, 1906. C. Henry, *Eléments d'une Théorie Générale de la Dynamogénie*, 1889.

‡ A. Zeising, *Die neue Lehre von den Proportionen des menschlischen Körpers*, 1854.

§ T. A. Cook, *The Curves of Life*, 1914.

CHAPTER XIV

RETROSPECT

I HAVE in these pages sought to place before my readers some evidence for the belief that a certain geometric diagram formed the basis for compositions of great works of art of the past. In the course of my studies I was led further afield. The discovery that the diagram in question was a symbol of the Pythagorean brotherhood gave rise to interesting speculations. It led me to the study of Plato's *Timæus* with its mythical account of the Creation by geometry, and to the discovery that our diagram was connected with the fifth Platonic solid which stood for heaven and the all-permeating ether. In reading Plato I seem to myself to have been groping my way towards the problem of Unity. To see things together, to recognize relationships, was the aim of that philosopher, and he created a perfectly ordered cosmos from the chaos of the phenomenal world. And was not the Greek search for cosmic harmony in conformity with the striving by artists and craftsmen after fixed relations, clear proportions, and concentration towards a powerful unity of effect ? Viewed thus, artistic creation seems to become a matter of infinite importance. The explanation of modern psychology, that our reaction to harmonious arrangements of form may be a matter of mere sensation, a mere tickling of the nerves so to speak, seems very inadequate. The deep emotion seems, to those who experience it, to have a peculiar quality of reality remote from the superficial sensations of daily life. Any attempt to account for this would land us in the depths of metaphysics. At the edge of that gulf I stop ; resting content meanwhile with the poetical explanation offered by the beautiful Pythagorean myth which dates back to the beginnings of philosophy.

In conclusion let me give a quotation from Rabindranath Tagore, where Eastern mysticism is combined with the Greek ideal :

" It is the magic of mathematics, the rhythm which is in the heart of all creation, which moves in the atom, and, in its different measures, fashions gold and lead, the rose and the thorn, the sun and the planets. These are the dance-steps of numbers in the arena of time and space, which weave the maya, the patterns of appearance, the incessant flow of change, that ever is and is not. It is the rhythm that churns up images from the vague and makes tangible what is elusive. This is maya ; this is the art in creation, and art in literature which is the magic of rhythm." *

* *The Religion of Man.* The Hibbert Lectures for 1930, p. 171.

INDEX

Dover Books on Art & Art History

DE RE METALLICA, Georgius Agricola. One of the most important scientific classics of all time, this 1556 work on mining was the first based on field research and observation and the methods of modern science. 289 authentic Renaissance woodcuts. Translated by Herbert Hoover. Reprint of English (1912) edition. 672pp. 6¼ x 10¾. 0-486-60006-8

THE UNIVERSAL PENMAN, George Bickham. Famous treasury of English roundhand calligraphy of 1740. Alphabets, decorated pages, scrolls, frames, cupids, and similar material. 212pp. 9 x 13¾. 0-486-20616-5

THE ART OF BOTANICAL ILLUSTRATION: AN ILLUSTRATED HISTORY, Wilfrid Blunt. Surveys the evolution of botanical illustration from the crude scratchings of paleolithic man down to the highly scientific work of 20th-century illustrators. With 186 magnificent examples, more than 30 in full color. "A classic"–*The Sunday Times* (London). 372pp. 5⅜ x 8¼. 0-486-27265-6

IDOLS BEHIND ALTARS: MODERN MEXICAN ART AND ITS CULTURAL ROOTS, Anita Brenner. Critical study ranges from pre-Columbian times through the 20th century to explore Mexico's intrinsic association between art and religion; the role of iconography in Mexican art; and the return to native values. Unabridged reprint of the classic 1929 edition. 118 b/w illustrations. 432pp. 5⅜ x 8½. 0-486-42303-4

THE BOOK OF KELLS, Blanche Cirker (ed.). 32 full-color, full-page plates from the greatest illuminated manuscript of the Middle Ages; painstakingly reproduced from rare facsimile edition. Publisher's Note. Captions. 32pp. 9⅜ x 12¼. 0-486-24345-1

CHRISTIAN AND ORIENTAL PHILOSOPHY OF ART, Ananda K. Coomaraswamy. Nine essays by philosopher-art-historian on symbolism, traditional culture, folk art, ideal portraiture, etc. 146pp. 5⅜ x 8½. 0-486-20378-6

THE SECRET LIFE OF SALVADOR DALÍ, Salvador Dalí. One of the most readable autobiographies ever! Superbly illustrated with more than 80 photos of Dalí and his works, and scores of Dalí drawings and sketches. "It is impossible not to admire this painter as writer . . . (Dalí) communicates the snobbishness, self-adoration, comedy, seriousness, fanaticism, in short the concept of life and the total picture of himself he sets out to portray."–*Books.* 432pp. 6½ x 9¼. (Available in U.S. only) 0-486-27454-3

LEONARDO ON ART AND THE ARTIST, Leonardo da Vinci (André Chastel, ed.). Systematic grouping of passages of Leonardo's writings concerning painting, with focus on problems of interpretation. More than an anthology, it offers a reconstruction of the underlying meaning of Leonardo's words. Introduction, notes, and bibliographic and reference materials. More than 125 b/w illustrations. 288pp. 9¼ x 7⅝. 0-486-42166-X

LEONARDO ON THE HUMAN BODY, Leonardo da Vinci. More than 1,200 of Leonardo's anatomical drawings on 215 plates. Leonardo's text, which accompanies the drawings, has been translated into English. 506pp. 8⅜ x 11¼. 0-486-24483-0

A TREATISE ON PAINTING, Leonardo da Vinci. The great Renaissance artist's practical advice on drawing and painting techniques covers anatomy, perspective, composition, light and shadow, and color. A classic of art instruction, it features 48 drawings by Nicholas Poussin and Leon Battista Alberti. vii+182pp. 5⅜ x 8½. 0-486-44155-5

THE BOOK BEFORE PRINTING: ANCIENT, MEDIEVAL AND ORIENTAL, David Diringer. Rich authoritative study of the book before Gutenberg. Nearly 200 photographic facsimiles of priceless documents. 604pp. 5⅜ x 8½. 0-486-24243-9

GAUGUIN'S INTIMATE JOURNALS, Paul Gauguin. Revealing documents, reprinted from rare, limited edition, throw much light on the painter's inner life, his tumultuous relationship with van Gogh, evaluations of Degas, Monet, and other artists; hatred of hypocrisy and sham, life in the Marquesas Islands, and much more. 27 full-page illustrations by Gauguin. Preface by Emil Gauguin. 160pp. 6½ x 9¼. 0-486-29441-2

THE GEOMETRY OF ART AND LIFE, Matila Ghyka. Revealing discussion ranging from Plato to modern architecture. 80 plates and 64 figures, including paintings, flowers, shells, etc. 174pp. 5⅜ x 8½. 0-486-23542-4

A MANUAL OF HISTORIC ORNAMENT, Richard Glazier. Hundreds of detailed illustrations depict painted pilasters from Pompeii, early Gothic stone carvings, a detail from a stained glass window in Canterbury Cathedral, and much more. Unabridged reprint of the 6th edition (1948) of *A Manual of Historic Ornament,* originally published in 1899 by B. T. Batsford, Ltd., London. Over 700 b/w illustrations. 16 plates of photographs. x+230pp. 6⅜ x 9¼. 0-486-42148-1

THE DISASTERS OF WAR, Francisco Goya. This powerful graphic indictment of war's horrors–inspired by the Peninsular War and the following famine–comprises 80 prints and includes veiled attacks on various people, the Church, and the State. Captions reprinted with English translations. 97pp. 9⅜ x 8¼. 0-486-21872-4

GREAT DRAWINGS OF NUDES, Carol Belanger Grafton (ed.). An impressive sampling of life drawings by 45 of the art world's greatest masters displays the styles of figure drawing across five centuries, from Dürer and Michelangelo to Modigliani and Derain. Featured artists include Raphael, Rubens, van Dyck, Hogarth, Constable, Ingres, Gauguin, Matisse, Rodin, and others. Captions. 48pp. 8¼ x 11. 0-486-42766-8

GREAT SELF-PORTRAITS, Carol Belanger Grafton (ed.). Unique volume of 45 splendid self-portraits encompasses pen, ink, and charcoal renderings as well as etchings and engravings. Subjects range from such 15th-century artists as da Vinci and Dürer to a host of 19th-century masters: Whistler, Rodin, van Gogh, Beardsley, and many more–Rembrandt, Rubens, Goya, Blake, Pissarro, and numerous others. 45 b/w illustrations. 48pp. 8¼ x 11. 0-486-42168-6

HAWTHORNE ON PAINTING, Charles W. Hawthorne. Collected from notes taken by students at famous Cape Cod School; hundreds of direct, personal aperçus, ideas, suggestions. 91pp. 5⅜ x 8½. 0-486-20653-X

MODERN MEXICAN PAINTERS, MacKinley Helm. Definitive introduction to art and artists of Mexico during great artistic movements of '20s and '30s. Discussion of Rivera, Orozco, Siqueiros, Galvan, Cantú, Meza, and many others. 95 illustrations. 228pp. 6½ x 9¼. 0-486-26028-3

MODERN ARTISTS ON ART, SECOND ENLARGED EDITION, Robert L. Herbert (ed.). Sixteen of the twentieth century's leading artistic innovators talk forcefully about their work–from Albert Gleizes and Jean Metzinger's 1912 presentation of Cubist theory to Henry Moore's comments, three decades later, on sculpture and primitive art. Four essays by Kurt Schwitters, Max Ernst, El Lissitzky, and Fernand Léger. 192pp. 5⅜ x 8½. 0-486-41191-5

A HISTORY OF ENGRAVING AND ETCHING, Arthur M. Hind. British Museum Keeper of Prints offers complete history, from 15th century to 1914: accomplishments, influences, and artistic merit. 111 illustrations. 505pp. 5⅜ x 8½. 0-486-20954-7

ART AND GEOMETRY, William M. Ivins. Stimulating, controversial study of interrelations of art and mathematics, Greek disservice and contribution. Renaissance perspective, Dürer and math, etc. 123pp. 5⅜ x 8½. 0-486-20941-5

A TREASURY OF BOOKPLATES FROM THE RENAISSANCE TO THE PRESENT, Fridolf Johnson (ed.). 759 of the finest specimens including Dürer, Beardsley, Kent, and others, from many traditions, selected by the former editor of *American Artist.* 151pp. 8⅜ x 11¼. 0-486-23485-1

CONCERNING THE SPIRITUAL IN ART, Wassily Kandinsky. Pioneering work by father of abstract art. Thoughts on color theory and nature of art. Analysis of earlier masters. 12 illustrations. 80pp. of text. 5⅜ x 8½. 0-486-23411-8

POINT AND LINE TO PLANE, Wassily Kandinsky. Seminal exposition of role of line, point, and other elements of non-objective painting. Essential to understanding 20th-century art. 127 illustrations. 192pp. 6½ x 9¼. 0-486-23808-3

LANGUAGE OF VISION, Gyorgy Kepes. Noted painter, designer, and theoretician analyzes effect of visual language on human consciousness: perception of line and form, perspective, much more. Over 300 photos, drawings, and illustrations. 224pp. 8⅛ x 11¼. 0-486-28650-9

*Write for **free** Fine Art and Art Instruction Catalog to*
Dover Publications, Inc., Dept. ABI, 31 East 2nd Street, Mineola, NY 11501
*Visit us online at **www.doverpublications.com***

Dover Books on Art & Art History

GOTHICK ARCHITECTURE: A REPRINT OF THE ORIGINAL 1742 TREATISE, **Batty Langley and Thomas Langley.** The architectural designs of Batty Langley greatly influenced England's Gothic Revival movement in the second half of the eighteenth century. This volume, which completely reproduces the author's most famous and influential work (beautifully engraved by his brother Thomas), displays columns, entablatures, windows, mantels, pavilions, and a host of other architectural features. This collection of permission-free illustrations will be welcomed by students and aficionados of eighteenth-century architecture, as well as designers and artists in search of period elegance. 80pp. 9 x 12. 0-486-42614-9

THE ART-MAKERS, **Russell Lynes.** Eakins, Hunt, French, Morse, Trumbull, and others, and their heroic struggle to make art respectable in 19th-century America. 211 illustrations. 526pp. 6⅜ x 9. 0-486-24239-0

RELIGIOUS ART IN FRANCE OF THE THIRTEENTH CENTURY, **Emile Mâle.** Classic by noted art historian focuses on French cathedrals of the 13th century as apotheosis of medieval style. Iconography, bestiaries, illustrated calendars, gospels, secular history, and many other aspects. 190 b/w illustrations. 442pp. 5⅜ x 8½. 0-486-41061-7

VINCENT VAN GOGH: A BIOGRAPHY, **Julius Meier-Graefe.** Utterly engrossing account of legendary artist's entire life from birth to his suicide. Essential readings for anyone interested in van Gogh's life and art. 160pp. 5⅜ x 8½. 0-486-25253-1

THE NEW VISION: FUNDAMENTALS OF BAUHAUS DESIGN, PAINTING, SCULPTURE, AND ARCHITECTURE, **László Moholy-Nagy.** Valuable introduction to aims and methods of the Bauhaus movement. Generously illustrated with examples of students' experiments and contemporary achievements. 257 illustrations. 240pp. 8¼ x 10⅞. 0-486-43693-4

THE GOLDEN AGE OF THE STEAM LOCOMOTIVE: WITH OVER 250 CLASSIC ILLUSTRATIONS, **J. G. Pangborn.** Long a collector's item, this book was originally conceived as a record of the Baltimore and Ohio Railroad's exhibit at the world's Columbian exposition of 1893 in Chicago. More than 250 illustrations showcase the locomotives and cars that existed from 1765 to 1893, among them, the *John Hancock, Londoner, Mud Digger, Old Ironsides, Robert Fulton, Tom Thumb,* and others. Unabridged reprint of the classic 1894 edition. 251 black-and-white illustrations. 176pp. 9⅜ x 12¼.
0-486-42824-9

PAINTERS OF THE ASHCAN SCHOOL, **Bennard B. Perlman.** Lively, beautifully illustrated study of 8 artists who brought a compelling new realism to American painting from 1870 to 1913. Henri, Glackens, Sloan, Luks, 4 more. 142 b/w illustrations. Bibliography. Introduction. 224pp. 9⅜ x 11¼.
0-486-25747-9

ROBERT HENRI: HIS LIFE AND ART, **Bennard B. Perlman.** A compelling new biography of the founder of the "Ashcan School," tracing Henri's life and art from his boyhood to his rise as an influential painter, teacher, and activist in the politics of art, and astutely appraising his pivotal role in American art. 79 illustrations, including 21 full-color and 9 black-and-white photos. Index. 208pp. 8⅜ x 11¼. 0-486-26722-9

COMPOSITION IN ART, **Henry Rankin Poore.** Learn principles of composition, classical and modern, through analysis of works from Middle Ages to present. 148 illustrations, 9 in color. 104pp. 8⅛ x 11.
0-486-23358-0

PAINTERS ON PAINTING, **Eric Protter.** Fascinating insights as da Vinci, Michelangelo, Rubens, Rembrandt, Hogarth, Manet, Degas, Cézanne, van Gogh, Matisse, Pollock, Johns, and many other artists comment on their artistic techniques, objectives, other artists, and more. 68 illustrations. 312pp. 5⅜ x 8½. 0-486-29941-4

SHAKESPEARE'S A MIDSUMMER NIGHT'S DREAM, **illustrated by Arthur Rackham.** Shakespeare's romantic comedy takes on a new and vivid life with these brilliant images by one of the twentieth century's leading illustrators. This faithful reprint offers a quality of printing and sharpness of reproduction that rivals the limited and first editions of 1908. Includes the complete text of the play, along with 40 full-color and numerous black-and-white illustrations. 176pp. 8⅜ x 11. 0-486-42833-8

THE ILLUSTRATOR AND THE BOOK IN ENGLAND FROM 1790 TO 1914, **Gordon N. Ray.** Combining essays, bibliographical descriptions, and 295 illustrations, this book by one of America's leading literary scholars and book antiquarians definitively chronicles a golden era in the art of the illustrated book. Artists range from Blake, Turner, Rowlandson, and Morris to Caldecott, Greenaway, Beardsley, and Rackham. 384pp. 8⅜ x 11¼.
0-486-26955-8

RHYTHMIC FORM IN ART, **Irma A. Richter.** In this captivating study, an influential scholar-artist offers timeless advice on shape, form, and composition for artists in any medium. Irma Richter illuminates the connections between art and science by surveying works of art from classical antiquity through the Modernist era. 38 figures. 34 plates. 192pp. 8⅜ x 11.
0-486-44379-5

THE NOTEBOOKS OF LEONARDO DA VINCI, **Jean Paul Richter (ed.).** These 1,566 extracts reveal the full range of Leonardo's versatile genius. Volume I is devoted to various aspects of art: structure of the eye and vision, perspective, science of light and shade, color theory, more. Volume II shows the wide range of Leonardo's secondary interests: geography, warfare, zoology, medicine, astronomy, and other topics. Dual Italian-English texts, with a total of 122 plates and hundreds of additional drawings. 7⅞ x 10¾. Vol. I: 64 plates, xxix+367pp. 0-486-22572-0
Vol. II: 58 plates, xv+499pp. 0-486-22573-9

RODIN ON ART AND ARTISTS, **Auguste Rodin.** Wide-ranging comments on meaning of art; great artists; relation of sculpture to poetry, painting, music, philosophy of life, and more. 76 illustrations of Rodin's sculpture, drawings, and prints. 119pp. 8⅜ x 11¼. 0-486-24487-3

THE SEARCH FOR FORM IN ART AND ARCHITECTURE, **Eliel Saarinen.** Important philosophical volume by foremost architectural conceptualist emphasizes design on an organic level; interrelated study of all arts. 377pp. 5⅜ x 8½. 0-486-24907-7

THE SENSE OF BEAUTY, **George Santayana.** Masterfully written discussion of nature of beauty, form, and expression; art, literature, and social sciences all involved. 168pp. 5⅜ x 8½. 0-486-20238-0

PICASSO, **Gertrude Stein.** Intimate, revealing memoir of Picasso as founder of Cubism, intimate of Apollinaire, Braque, and others; creative spirit driven to convey reality of twentieth century. Highly readable. 61 black-and-white illustrations. 128pp. 5⅜ x 8½. 0-486-24715-5

ON DIVERS ARTS, **Theophilus (translated by John G. Hawthorne and C. S. Smith).** Earliest (12th century) treatise on arts written by practicing artist. Pigments, glass blowing, stained glass, gold and silver work, and more. Authoritative edition of a medieval classic. 34 illustrations. 216pp. 6½ x 9¼. 0-486-23784-2

VAN GOGH ON ART AND ARTISTS: LETTERS TO EMILE BERNARD, **Vincent van Gogh.** 23 missives—written during the years 1887 to 1889—radiate their author's impulsiveness, intensity, and mysticism. The letters are complemented by reproductions of van Gogh's major paintings. 32 full-page, b/w illustrations. xii+196pp. 8⅜ x 11. 0-486-42727-7

VASARI ON TECHNIQUE, **Georgio Vasari.** Sixteenth-century painter and historian on technical secrets of the day: gilding, stained glass, casting, painter's materials, etc. 29 illustrations. 328pp. 5⅜ x 8½. 0-486-20717-X

RECOLLECTIONS OF A PICTURE DEALER, **Ambroise Vollard.** Art merchant and bon vivant Ambroise Vollard (1867–1939) recounts captivating anecdotes from his professional and social life: selling the works of Cézanne; partying with Renoir, Forain, Degas, and Rodin; the studios and personalities of Manet, Matisse, Picasso, and Rousseau; and encounters with Gertrude Stein, Zola, and other noteworthies. 33 illustrations. 384pp. 5⅜ x 8½. 0-486-42852-4

ETCHINGS OF JAMES MCNEILL WHISTLER, **James McNeill Whistler (selected and edited by Maria Naylor).** The best of the artist's work in this genre: 149 outstanding etchings and drypoint, most in original size, all reproduced with exceptional quality. Popular individual prints include "Portrait of Whistler," "Old Battersea Bridge," "Nocturne," plus complete French set, Thames set, and two Venice sets. Introduction and an explanatory note for each print. 149 b/w illustrations. xviii+157pp. 9⅜ x 12¼.
0-486-42481-2

THE GENTLE ART OF MAKING ENEMIES, **James McNeill Whistler.** Great wit deflates Wilde, Ruskin, and Swinburne; belabors inane critics; also states Impressionist aesthetics. 334pp. 5⅜ x 7½. 0-486-21875-9

PRINCIPLES OF ART HISTORY, **Heinrich Wölfflin.** Seminal modern study explains ideas beyond superficial changes. Analyzes more than 150 works by masters. 121 illustrations. 253pp. 6⅛ x 9¼. 0-486-20276-3

Art Instruction

CALLIGRAPHY, Arthur Baker. Generous sampling of work by foremost modern calligrapher: single letters, words, sentences, ventures into abstract and Oriental calligraphy, and more. Over 100 original alphabets. Foreword by Tommy Thompson. 160pp. 11⅜ x 8¼. 0-486-40950-3

THE ARTIST'S GUIDE TO ANIMAL ANATOMY, Gottfried Bammes. A systematic approach to learning proportion, rules of repose and motion, and basic forms. Students learn how to modify drawings of a horse and cow to portray a dog, lion, and other subjects–in poses ranging from static to rapidly moving. 78 figures in color; 71 b/w illustrations. 143pp. 8⅜ x 11. 0-486-43640-3

PRACTICAL GUIDE TO ETCHING AND OTHER INTAGLIO PRINTMAKING TECHNIQUES, Manly Banister. Detailed illustrated instruction in etching, engraving, aquatint, drypoint, and mezzotint–from preparing plate to mounting print. No better guide for beginners. 128pp. 8⅜ x 11¼. 0-486-25165-9

ILLUSTRATING NATURE: HOW TO PAINT AND DRAW PLANTS AND ANIMALS, Dorothea Barlowe and Sy Barlowe. Practical suggestions for the realistic depiction of natural subjects. Includes step-by-step demonstrations using a variety of media. More than 400 illustrations; great for pros or amateurs. 128pp. 8¼ x 10½. 0-486-29921-X

ACRYLIC WATERCOLOR PAINTING, Wendon Blake. Excellent step-by-step coverage of painting surfaces, colors, and mediums as well as basic techniques: washes, wet-in-wet, drybrush, scumbling, opaque, and more. 75 paintings demonstrate extraordinary variety of techniques. 105 black-and-white illustrations. 32 color plates. 152pp. 8⅜ x 11¼. 0-486-29912-0

FIGURE DRAWING STEP BY STEP, Wendon Blake. Profusely illustrated volume provides thorough exposition of figure drawing. More than 175 illustrations accompany demonstrations, showing how to establish major forms, refine lines, block in broad shadow areas, and finish the work. 80pp. 8⅜ x 11. 0-486-40200-2

OIL PORTRAITS STEP BY STEP, Wendon Blake. A wealth of detailed, practical advice and valuable insights on basic techniques; planning, composing, and lighting the portrait; working with other media, and more. More than 120 illustrations (including 57 in full color) act as step-by-step guides to painting a variety of male and female subjects. 64pp. 8⅜ x 11¼. 0-486-40279-7

PEN AND PENCIL DRAWING TECHNIQUES, Harry Borgman. Manual by acclaimed artist contains the best information available on pencil and ink techniques, including 28 step-by-step demonstrations–many of them in full color. 256pp., including 48 in color. 474 black-and-white illustrations and 73 color illustrations. 8⅜ x 11. 0-486-41801-4

CONSTRUCTIVE ANATOMY, George B. Bridgman. More than 500 illustrations; thorough instructional text. 170pp. 6½ x 9¼. 0-486-21104-5

DRAWING THE DRAPED FIGURE, George B. Bridgman. One of the foremost drawing teachers shows how to render seven different kinds of folds: pipe, zigzag, spiral, half-lock, diaper pattern, drop, and inert. 200 b/w illustrations. 64pp. 6½ x 9¼. 0-486-41802-2

ANIMAL SKETCHING, Alexander Calder. Undisputed master of the simple expressive line. 141 full body sketches and enlarged details of animals in characteristic poses and movements. 62pp. 5⅜ x 8½. 0-486-20129-5

CHINESE PAINTING TECHNIQUES, Alison Stilwell Cameron. The first guide to unify the philosophical and imitative methods of instruction in the art of Chinese painting explains the tools of the art and basic strokes and demonstrates their use to represent trees, flowers, boats, and other subjects. Hundreds of illustrations. 232pp. 9¼ x 9. 0-486-40708-X

LEARN TO DRAW COMICS, George Leonard Carlson. User-friendly guide from 1930s offers wealth of practical advice, with abundant illustrations and nontechnical prose. Creating expressions, attaining proportion, applying perspective, depicting anatomy, simple shading, achieving consistency, characterization, drawing children and animals, lettering, and more. 64pp. 8⅜ x 11. 0-486-42311-5

CARLSON'S GUIDE TO LANDSCAPE PAINTING, John F. Carlson. Authoritative, comprehensive guide covers every aspect of landscape painting; 34 reproductions of paintings by author. 58 explanatory diagrams. 144pp. 8⅜ x 11. 0-486-22927-0

YOU CAN DRAW CARTOONS, Lou Darvas. Generously illustrated, user-friendly guide by popular illustrator presents abundance of valuable pointers for both beginners and experienced cartoonists: pen and brush handling; coloring and patterns; perspective; depicting people, animals, expressions, and clothing; how to indicate motion; use of comic gimmicks and props; caricatures; political and sports cartooning; and more. viii+152pp. 8⅜ x 11. 0-486-42604-1

PATTERN DESIGN, Lewis F. Day. Master techniques for using pattern in wide range of design applications including architectural, textiles, print, and more. Absolute wealth of technical information. 272 illustrations. x+306pp. 5⅜ x 8½. 0-486-40709-8

COLOR YOUR OWN DEGAS PAINTINGS, Edgar Degas (adapted by Marty Noble). Excellent adaptations of 30 works by renowned French Impressionist–among them *A Woman with Chrysanthemums, Dancer Resting,* and *The Procession (At the Race Course).* 32pp. 8¼ x 11. 0-486-42376-X

METHODS AND MATERIALS OF PAINTING OF THE GREAT SCHOOLS AND MASTERS, Sir Charles Lock Eastlake. Foremost expert offers detailed discussions of methods from Greek and Roman times to the 18th century–including such masters as Leonardo, Raphael, Perugino, Correggio, Andrea del Sarto, and many others. 1,024pp. 5⅜ x 8½. 0-486-41726-3

THE ART AND TECHNIQUE OF PEN DRAWING, G. Montague Ellwood. Excellent reference describes line technique; drawing the figure, face, and hands; humorous illustration; pen drawing for advertisers; landscape and architectural illustration; and more. Drawings by Dürer, Holbein, Doré, Rackham, Beardsley, Klinger, and other masters. 161 figures. x+212pp. 5⅜ x 8½. 0-486-42605-X

ART STUDENTS' ANATOMY, Edmond J. Farris. Long a favorite in art schools. Basic elements, common positions and actions. Full text, 158 illustrations. 159pp. 5⅜ x 8½. 0-486-20744-7

ABSTRACT DESIGN AND HOW TO CREATE IT, Amor Fenn. Profusely illustrated guide covers geometric basis of design, implements and their use, borders, textile patterns, nature study and treatment. More than 380 illustrations include historical examples from many cultures and periods. 224pp. 5⅜ x 8½. 0-486-27673-2

PAINTING MATERIALS: A SHORT ENCYCLOPEDIA, R. J. Gettens and G. L. Stout. Thorough, exhaustive coverage of materials, media, and tools of painting through the ages based on historical studies. 34 illustrations. 333pp. 5⅜ x 8½. 0-486-21597-0

LIFE DRAWING IN CHARCOAL, Douglas R. Graves. Innovative method of drawing by tonal masses. Step-by-step demonstrations and more than 200 illustrations cover foreshortening, drawing the face, and other aspects. 176pp. 8¼ x 11. 0-486-28268-6

A GUIDE TO PICTORIAL PERSPECTIVE, Benjamin R. Green. Meeting the challenge of realistic drawing involves the application of science to an individual design sense. Here is a clear, jargon-free primer on recreating objects from nature by using perspective techniques. Its straightforward approach teaches artists and students at all levels how to visually rationalize the differences between form and appearance. 64pp. 5⅜ x 8½. 0-486-44404-X

CREATING WELDED SCULPTURE, Nathan Cabot Hale. Profusely illustrated guide, newly revised, offers detailed coverage of basic tools and techniques of welded sculpture. Abstract shapes, modeling solid figures, arc welding, large-scale welding, and more. 196 illustrations. 208pp. 8⅜ x 11¼. 0-486-28135-3

HAWTHORNE ON PAINTING, Charles W. Hawthorne. Collected from notes taken by students at famous Cape Cod School; hundreds of direct, personal, and pertinent observations on technique, painting ideas, self criticism, etc. A mine of ideas, aperçus, and suggestions for artists. 91pp. 5⅜ x 8½. 0-486-20653-X

HAWTHORNE ON PAINTING, GEOMETRIC PATTERNS AND HOW TO CREATE THEM, Clarence P. Hornung. Rich collection of 164 permission-free geometric patterns includes guidelines for creating hundreds of eye-catching graphics. Each basic design is followed by three dazzling variations. 48pp. 8¼ x 11. 0-486-41733-6